PAUL KLEE Life and Work

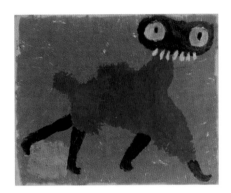

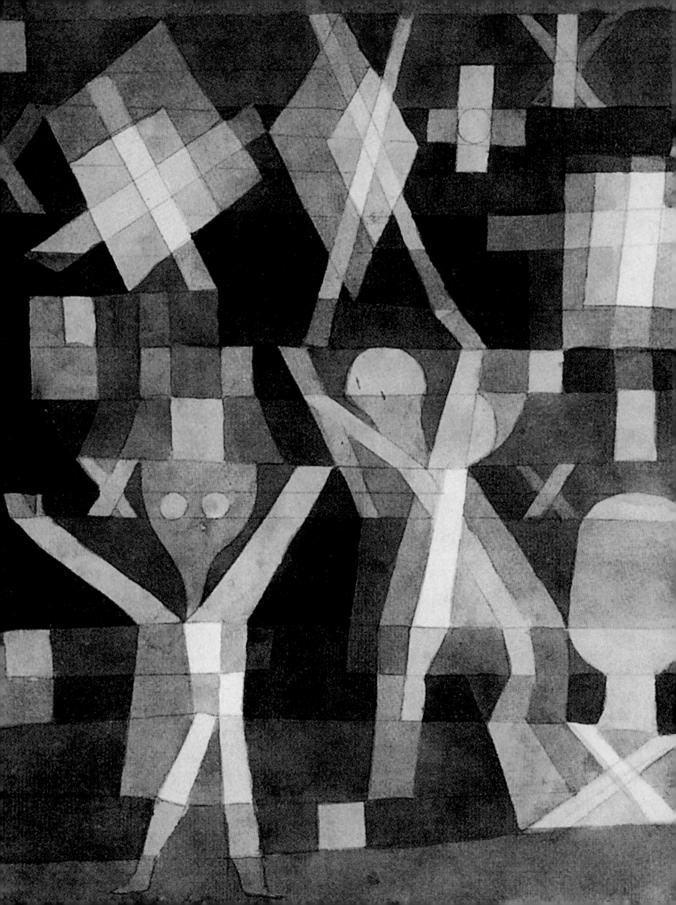

BORIS FRIEDEWALD

PAUL KLEE
LIFE AND WORK

PRESTEL Munich · London · New York

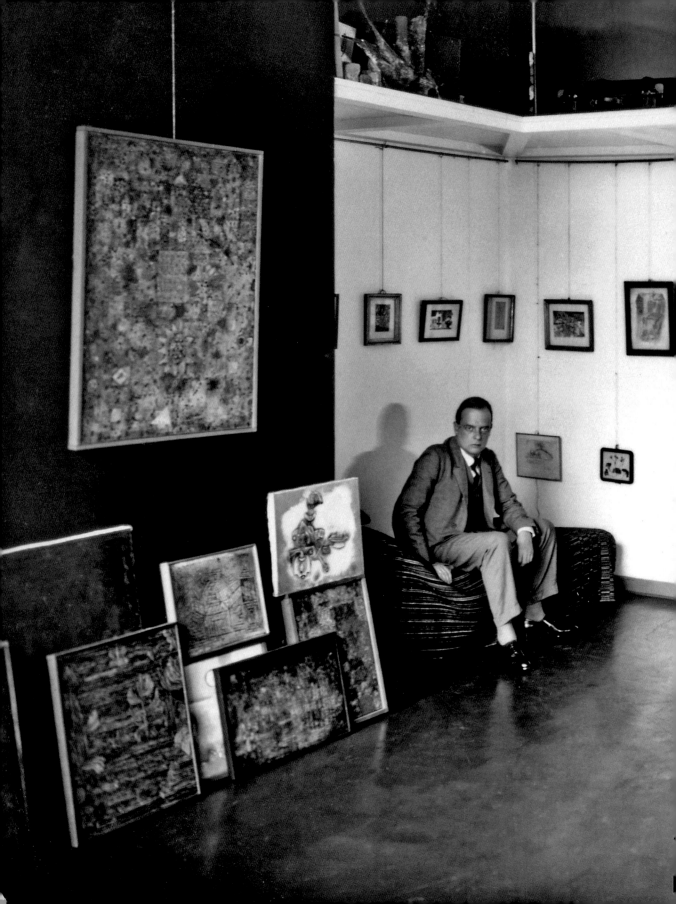

TABLE OF CONTENTS

CHILDHOOD AND YOUTH

1879–1898

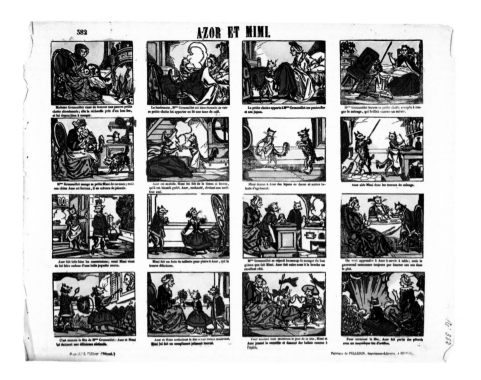

IN A COLD WINTER

It was freezing cold out when the child with the unusually large, dark eyes was born. Paul Klee first saw the light of day on December 18, 1879, in the Münchenbuchsee schoolhouse near Berne. His father, Hans Klee (1849–1940), who had been born into a humble home in the small Hessian town of Tann in the Rhön Mountains, had studied to be an elementary school teacher. Thanks to the patronage of a baroness, the musically gifted Hans received a scholarship to the Stuttgart Conservatory, where he studied organ, piano, violin, and voice. It was during these studies that he met and fell in love with the choral student Ida Frick (1855–1921).

The young soprano came from a well-to-do family. She had been born in Besançon, France, but had grown up in Basel and possessed a Swiss passport. When Ida was born, her mother had long been divorced from her husband, and she never revealed the identity of Ida's father. Soon, rumors circulated within the family that he had been from North Africa—a story that Klee would later repeat with pride.

The musical couple married in 1875, and the following year their first child, Mathilde (1876–1953), was born; her parents called her Mimi. In 1878, Hans

Epinal print **Azor et Mimi**, *c.* 1860

Little Paul was fascinated by the comic-like popular prints from Epinal. He was especially taken by this story about the two dogs Mimi and Azor.

Klee started teaching music at the state teachers' college in Hofwil near Berne, where he remained for fifty years. Shortly after Paul's birth, the family, including several pet cats, moved to the regional capital, Berne—the main reason was probably that Ida Klee thought the move from the countryside to the vibrant city would have a positive effect on her voice. After several moves within the city, in 1897 the Klee family finally settled into a house with a garden at Obstbergweg 6 in Berne's old town.

GRANDMA'S COLORED PENCILS

The joy Paul found in drawing was awakened and nurtured by his maternal grandmother, who gave the boy a set of colored pencils when he was around three years old. With Grandma Frick, who spent her free time doing embroidery and sometimes created paintings and drawings in the Biedermeier style, little Paul could give his fantasy free rein. He soon became fascinated by French popular prints, which, like comics, featured short illustrated stories accompanied by brief captions. Paul often drew his own copies of the stories' illustrations. These childhood prints remained important to Klee even many years

Childhood drawing (**Mimi Presents a Bouquet to Mme. Grenouillet**), no date

Paul incorporated the characters and stories from popular prints into his own drawings. This picture is a reference to the story of Azor and Mimi.

"Dream. I was flying home, where the beginning is. It began with brooding and the chewing of fingers. Then I smelled something or tasted something. The scent released me. At once, I was fully released, melting away like sugar in water." Paul Klee, 1906

later when he was a master at the Bauhaus, where such illustrated stories hung from the walls of his studio.

For the young boy, who also occasionally enjoyed playing with puppets, drawings were sometimes transformed into a menacing reality, as he confessed later: "The evil spirits that I drew suddenly took on tangible form. I sought refuge with Mother, crying that the little devils were looking in through the window."

THE TALENTED VIOLIN STUDENT

When Paul was five years old, his beloved grandmother passed away. At age seven, the tender child received his first violin lesson. His teacher, Karl Jahn (1846–1912), was first concertmaster with the Berne Municipal Orchestra. Klee later called him "Tonvater Jahn" (Tone-Father Jahn)—a reference to the pioneer of the German physical fitness movement, "Turnvater Jahn" (Gym-Father Jahn).

Jahn was passionate about more than music; he was also deeply interested in the history of art. He greatly admired the Basel-based historian of art and culture Jacob Burckhardt, and collected monographs on famous artists such as Raphael and Leonardo da Vinci published by painter and art historian Hermann Knackfuss. These books soon captured the attention of Jahn's talented violin student. At the time, however, Paul felt an even greater fascination for the mythological paintings of the Swiss symbolist Arnold Böcklin (1828–1901); he was also attracted to the kitschy illustrations from his mother's magazines. He himself was drawing constantly now. Once, when visiting the restaurant belonging to his uncle Frick—the "fattest man in Switzerland," as Klee wrote

Childhood drawing, 1883/1984

Paul painted this picture between age three and five. Since he did not know how to write numbers yet, he simply marked the church clock with invented symbols.

later—he discovered grotesque figures within the fossils encased in the marble tables, which, with a fine sense for the bizarre, he captured on paper.

Paul was soon a brilliant violinist, and at the age of eleven was allowed to perform with the Berne Musical Society as a special orchestral members at its oratorios and subscription concerts. He first visited the opera at age ten, seeing Giuseppe Verdi's *Il Trovatore*. Klee later recalled this visit: "...I noticed how much these people suffered; that they were never serene and rarely gay. Nevertheless, I soon found myself captivated by this lofty style. I began to take a liking to the mad Leonora..." Klee's love for the opera would accompany him throughout his life.

THE DILIGENT YOUNG ILLUSTRATOR

After completing primary school, Paul attended a lower *gymnasium*, followed by a literature-oriented *gymnasium*. During all his years at school, Klee passionately created highly skilled drawings that clearly showed his talent despite his lack of any special training. At first the young pupil, applying an acute power of observation, mostly made copies of other artists' tear-off calendars and landscape drawings, but soon he was depicting highly naturalistic landscapes with a sharpened pencil or quill.

At age twelve, Paul began to draw in sketchbooks. By the time he graduated from school, he had filled ten such notebooks with drawings. Again and again, he would draw the natural scenery he encountered while traveling with his family through the Swiss mountains, as well as the landscape outside Berne and the sights of his hometown. The young artist was diligent: his works from this period are exact studies, most of which he painstakingly identified by title, date, his signature, and—until the year 1897—even a series number.

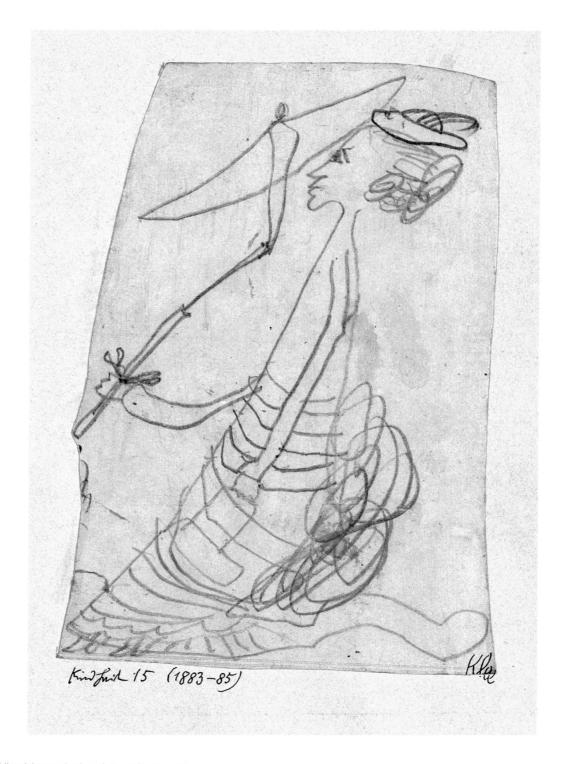

Childhood drawing (**Lady with Parasol**), 1883–1885

Paul drew this charming lady sometime between age four and six. He signed
the picture in 1902, excited about having rediscovered his childhood pictures in
his parents' attic.

THE ASSES IN WAISENHAUSSTRASSE

Although little Paul had been an excellent pupil during his early school years, school became increasingly less important for him while he was at the *gymnasium*.

As his academic performance continued to decline, he felt himself "more ill-at-ease [as a pupil] with each successive year." Only the study of French and Greek literature managed to captivate the vibrant young Klee, who wrote poems and novels at home. Another subject he was enthusiastic about was natural history—zoology and botany, which included identifying and describing various plants. In addition to taking classroom notes, Klee—who wrote with his right hand and drew with the left—was soon filling the margins and empty pages of his notebooks with a profusion of whimsical figures and caricatures. His geometry notebook from his final school year alone is decorated with 300 such scribblings. A few years before graduating, Klee saw so little meaning in school that he wanted to quit—a decision prevented by his parents. Shortly before taking his school-leaving exam, Klee's academic performance took such a sharp turn for the worse that he was excluded from a

Childhood drawing, 1890

Paul Klee drew this picture when he was eleven years old.

Childhood painting, *c.* 1889

Klee's love for plants stayed with him throughout his entire life. As a result, plants, gardens, and parks hold a special place within his work. Paul painted these flowers between age eight and ten. Just a few years later, nature would be the most important motif in young Klee's drawings, and also a comforting friend.

> *"Klee's peaceful essence emanated a tender childishness that remained true to him over the course of his life, for he remained true to it."* Max Pulver, 1959

class trip. Instead of studying, however, he undertook his own artistic study trip—with his sketchbook in his bag—to see nature on St. Peter's Island on Lake Biel.

With time, nature would in fact prove to be more than a model for the young man's ever more loosely composed drawings—it also became an increasingly intimate confidant. Writing as if he were a child of the Romantic Era, the sensitive eighteen-year-old confides: "Outside right now, the first storm of the year is playing itself out. A fresh westerly wind is sweeping over me, bringing the scent of thyme and the whistling of the train. It plays with my moist hair. Nature does love me! It comforts me and makes me promises."

Satirical drawings in a school exercise book of Paul Klee (German literature), 1897

During his school years, young Paul was interested in more than the official subject matter, and so he filled page after page of his exercise books with bizarre drawings...

"The future slumbers within man and needs only to awaken. It cannot become. Hence, even a child knows Eros." Paul Klee, 1901

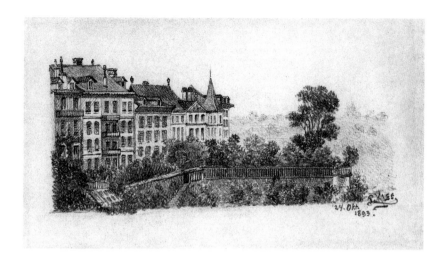

Klee eventually passed his graduation exam, just barely squeaking by. In a letter to his father a few months later, he wrote: "I laugh when I think of the education that those asses in Waisenhausstrasse wanted to drum into me. The next time I come to Berne, I'll knock them out, all of them!"

MRS. BRUSH-GODDESS AND THE PARAMOUR CALLED MUSIC

After graduating in September 1898, Klee was faced with the crucial question of which career path to follow. One thing he was sure about: he did not want to become a model burgher; he wanted to live for art. He had no intention of turning his passionate attempts at writing and poetry into a career, though he briefly found the idea quite attractive. In his childhood and youth, Klee had developed a deep love for music and music making. Barely a year before graduating, he wrote: "I am increasingly alarmed by my growing love for music. I do not understand myself. I play sonatas by Bach; what is Böcklin in com-

Blick auf die Junkerngasse (View of the Junkerngasse), 1893

Drawing with a sharpened pencil, thirteen-year-old Paul created a precise rendition of one of the most elegant residential streets in his hometown of Berne.

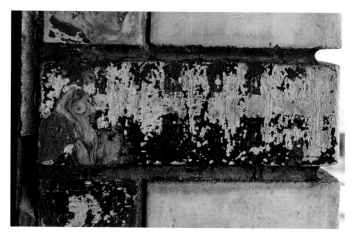

Painted wall of Klee's parents' house in Berne (selection), *c.* 1898

In the spring of 1897, the Klee family moved into a house in Berne's Obstbergweg. One day, young Paul opened the window to his room and let brush and paint run free. He painted the brick building's niches near the window with alternating depictions of human figures and landscapes. Presumably, the writing is also Klee's. He created small portraits, pictures of naked women, grotesque beings, and a diverse range of natural moods, which particularly astonish the viewer through their free use of color—something that Klee had to struggle with later until his fateful trip to Tunisia. Today, the house is privately owned. It is a small wonder that—despite a century of wind and weather—these works continue to exist!

"By chance, I glimpsed my reflection in the window and so examined the person looking out at me. A quite congenial fellow ... I had explored him often before. Not always successfully. But today I understood him." Paul Klee, 1897

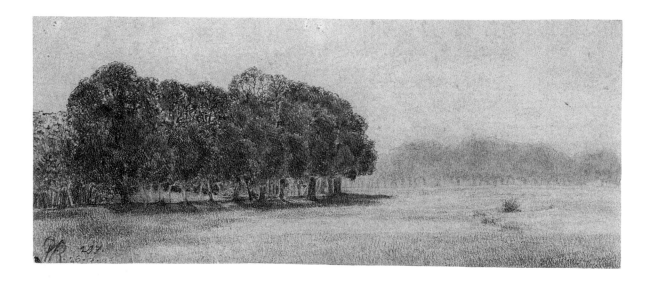

parison? It makes me smile." A short while later, however, the somewhat shy young man discovered that he did not feel virtuosic enough as a violinist—not a good precondition for a career as a musician. He even briefly toyed with the idea of becoming a composer, but in the end he felt that music was no longer capable of progression and was on a "downward path." Deciding more or less on intuition, Klee opted for painting, though not without doubts. In the end, the decision also represented a kind of emancipation from his musical parents, who would have liked him to become a musician. Some time later, Klee wrote a friend: "What a curse it is to marry when you madly love another! Yes, that is the way it is. My lover is and was music, and I embrace the oily-smelling Brush-Goddess only because she is my wife."

Untitled (Landschaft mit Baumgruppen) (Landscape with Groups of Trees), 1897

The young Klee created an extremely atmospheric reproduction of this group of trees, presumably drawn somewhere near Berne. We can still see the same attention to detail and precision of style found in his early childhood drawings. Klee's compositions would soon grow looser and more liberated, a development cautiously hinted at in this drawing.

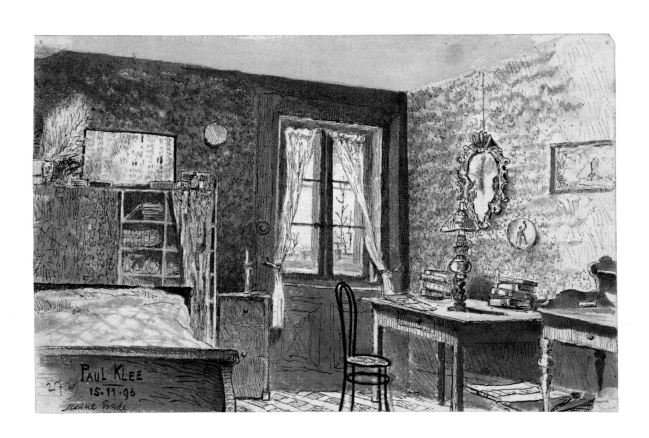

Meine Bude (My Room), 1896

A look into sixteen-year-old Paul's room. At his desk, young Paul not only did his home-
work, but also wrote novellas and poems, and worked on his drawings. The bookcase
behind the bed, which was covered with drapery, is where Paul kept his 'treasures', such
as a beetle collection, books, several models of Platonic solids, and a "bottle colony".

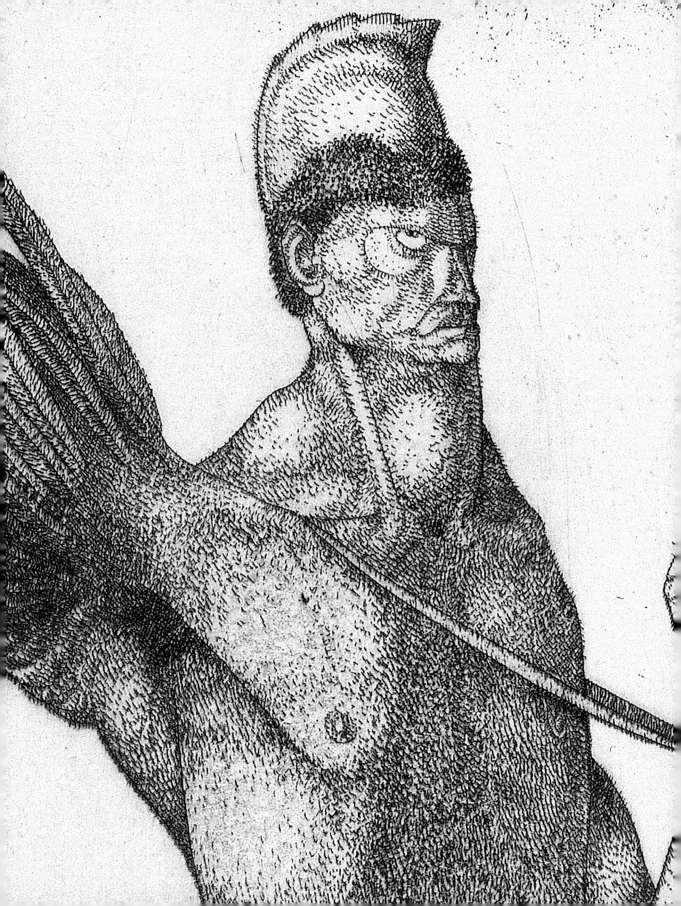

STUDENT AND SELF-APPRENTICE

1898–1906

"I drafted a last will. I asked that all existing artistic endeavors be destroyed. I knew quite well how paltry it all was, and how futile when compared to the intuited possibilities." Paul Klee, 1900

BIGGER, MORE INTERESTING, LIVELIER

Should he go to Paris or Munich? As a place for his studies, Klee was captivated by both cities; in the end he chose Munich, at the time Germany's artistic capital. In October 1898, one month after graduation, he traveled to the Bavarian capital, carrying in his luggage his violin and one of his recent sketchbooks. His destination: the Bavarian Royal Academy of Fine Art, where he planned to enroll as a student. But more important than studying for the eighteen-year-old was the chance to put some distance between himself and the place and people of his childhood and youth. Later, in recalling this time, he wrote that "...the fine arts offered something seductive, even if at first it was not art as much as the promise of getting away as soon as possible; out of the country, to somewhere where things were bigger, more interesting, livelier." Nevertheless, shortly after his arrival in Munich he showed some of his drawings to the Academy's director, professor Ludwig von Löfftz. After all, his father—at his mother's urging—had taken out two mortgages for their son's education. Although the professor praised Klee's landscape drawings, he found him lacking "practice in figuration" and recommended that, in preparation for the Academy, Klee first attend the private drawing school run by the painter Heinrich Knirr (1862–1944), whose focus was on nudes and portraits. Knirr quickly recognized Klee's abilities, and Paul later wrote his family: "As you know, Knirr always made great efforts to liberate me from the pettiness that has been inherent in me since birth. And now I am happily at the other extreme

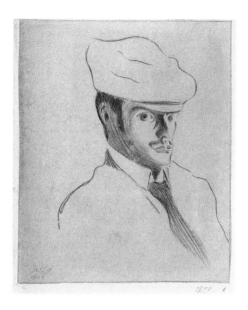

... As he was correcting the most recent nudes, he long remained quiet, but then it started. An unholy outburst. I was ruining myself. What a bunch of smearings ... When I recounted this incident to a young painter from Basel who had also studied under Knirr, he told me I should be happy that Knirr was worked up during corrections, that this was the best indication of the high regard he felt for my skills and abilities." And indeed, Knirr would soon describe Klee as his best student in many years.

BECOMING A PERSON

Klee had just scored his first successes at drawing school when instruction began to bore him, and so he skipped class every now and then. Consequently, he found himself more enticed by life outside painting school. This meant forming friendships, carousing all night long—and meeting women and learning how to love them. Klee also nurtured his passion for music more intensively than ever. He played chamber music and made sure not to miss any important concert in the Bavarian capital. Sometimes he visited the opera several evenings in a row. In a letter to his parents, he wrote: "But now I see that fortune falls upon me thick as hail. Today *Oberon*—a majestic production, with ballet; tomorrow *Don Giovanni*; the day after, *Meistersinger*, Wagner's 'most

Selbst (Myself), 1899

In the same year that Klee created this self-portrait, he wrote full of doubt: "For me, music is like a forfeited love. Fame as a painter? Writer, modern poet? A bad joke. And so I am without a calling and loaf about."

brilliant' work, as you can hear at every turn here ... My poor head. And my poor wallet." In addition to his favorite composers Mozart, Bach, and Beethoven—later to be joined by Verdi—Klee was also fascinated by the music of Richard Wagner. Deeply impressed after hearing *Götterdämmerung* in June 1899, he wrote his family: "Never before has opera touched my soul so deeply. Beauty upon beauty and climax followed by climax."

For Klee, this urge to experience life (and thus himself) newly and more intensely was not in contradiction to his desire to become an artist—quite the opposite. Looking back at this period, he later wrote: "Put simply, first and foremost I had to become a person; art would follow."

THE PAINTER-PRINCE

In October 1900, upon the advice of his teacher Knirr, Klee began attending a painting class at the Academy given by the then famous Franz Stuck (1863–1928). Stuck, who several years earlier had helped found the Munich Secession, painted primarily allegorical and mythological paintings and was later raised to the nobility.

Although Klee held the "painter-prince" in high esteem, his enthusiasm for Stuck's class was restrained. The primary reason was that Klee found Stuck incapable of imparting to his students the basic characteristics of color and, by extension, of painting—a criticism in which Klee was not alone. Even Wassily Kandinsky (1866–1944), who attended Stuck's painting course at the same time—though without getting to know Klee personally—later criticized this weakness of Stuck's. And so the Academy did not provide the searching young artist Klee with the tools necessary for resolving his difficulties. In fact, this situation soon caused Klee to doubt himself as a painter. After a short time of studying under Stuck, he wrote his family: "I ... have again realized that I cannot paint."

And so he again focused on drawing, in particular satirical drawings and illustrations. Stuck was so excited by these works that he encouraged his student to offer them to *Jugend* magazine, the publication that gave Art

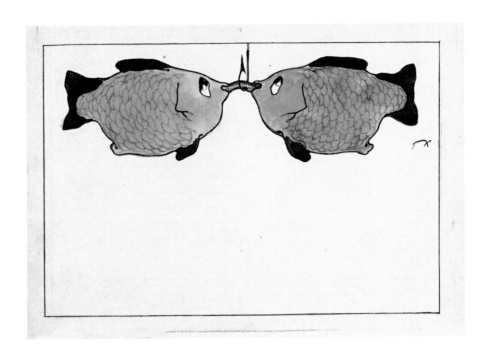

Nouveau its German name, Jugendstil. But Klee had no luck with the magazine, which rejected his submissions.

THE PERFECT ART

During his brief time with Stuck, Klee discovered the joy of making figures out of plasticine and clay. Soon, he remarked: "As far as sculpture is concerned, for now it remains the perfect art." This enthusiasm for three-dimensional figures led to Klee's decision, supported by Stuck, to study sculpture. In March 1901, after five months in Stuck's painting course, Klee enrolled in the Academy's sculpture course, which was taught by Wilhelm von Rümann (1850–1906). Professor von Rümann, however, was not immediately excited by Klee's drawings, and so he asked Klee to take an entrance examination at the Academy on the following Monday. Klee, who was convinced that his drawings showed sufficient mastery of form, found a test of his sculptural abilities superfluous. Defiant and proud, he wrote his parents of his decision not to appear for the professor's examination: "He will be looking for me in vain on Monday."

Untitled (Zwei Fische, ein Angelhaken, ein Wurm) (Two Fish, a Hook, a Worm), 1901
How humorous and how tragic! As if they were in love, these fish share a worm—and the fisherman has twice the catch. Klee hinself was passionate about fishing until the early 1920s, but after that, out of a love for animals, he no longer touched a fishing rod.

Upon seeing a tree / Oh, to be like the little birds: / they avert / their thoughts from trunk and roots, / and swing nimbly, complacently, all day long, / on branching tips, singing their song. Paul Klee, 1902

LILY, GOD, AND THE MONSTERS OF PERVERSION

At a home concert in the winter of 1899, Klee met the Munich pianist Lily Stumpf (1876–1946), who was three years his senior. Stimulated by their intimate music-making sessions, Klee soon felt more for Lily than he had for any woman before.

Nevertheless, he initially fulfilled his need for exploring "the sexual mysteries" with other women. For example, in January 1900 at the Kindl Keller brew house in Munich, he made the acquaintance of the shop keeper Tini, and not without consequences: in November, she gave birth to their son, though the boy died only a few weeks later. That Christmas Eve, just before Klee was to celebrate the holiday with Lily, he invited the nude models Cenzi and Bertha to his room. In his diary, he describes what followed: "They lie down and I have the proud feeling of having two women in my power. The final moments are spent in all kinds of adventurous banter, but we must part, and, in somewhat of a trance, I appear at Lily's." When, around this time, Klee once again thought of his lost child, he told his former schoolmate Hans Bloesch (1878–1945): "Nobody must know who the father was. He was a scoundrel and on top of it all he got lucky. Just imagine Christmas, with such a brat interrupting the holy silence with his beautiful song. I am sure our Lord Jesus did not cry. By the way, I don't believe in him and yet I am a Christian."

Klee was fascinated by Eros, and his search for and inquiry into his own sexuality is clearly expressed in his artistic efforts. In this regard, he wrote in his diary: "Sexual helplessness gives birth to monsters of perversion. Symposia of Amazons and other abominations."

Klee created several cycles of paintings depicting female archetypes, sexuality, and eroticism, with titles such as *Carmen, Gretchen, Isolde*; *Nana*; *Théâtre des femmes*; and *Disgust*, a painting depicting a women lying with the upper part of her body on a table and, like Pandora, pouring out a container filled with

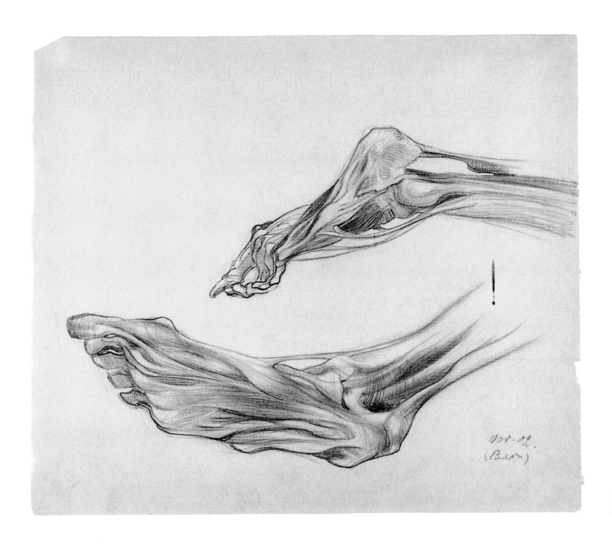

"disgusting things." However, it would appear that Klee preserved none of these paintings.

Despite further affairs, his warm feelings for Lily continued to grow. During this stage of love, Klee—who consistently denied having believed in God as a child—wrote: "This time I feel the strong God inside me ... My God works great things in me." A few weeks later he confessed, fulfilled: "What a sense of perfection one attains through love! What a heightening of all things. What a measure it is! What a key. Of these days, each is a lifetime. Were I to expire now, I could not imagine a more beautiful end." Klee wrote these sentences shortly after his secret engagement to Lily in the spring of 1901.

Untitled (Anatomische Zeichnung der Fussmuskulatur)
(Anatomical Drawing: Muscles of the Foot), 1902

Klee took a course in anatomy in order to improve his familiarity with the structure of the human body. This study—presumably of a medical cadaver—was made there.

"I want to be like a newborn, to know nothing of Europe, nothing at all. To know no poets, to be completely without momentum; close to the source." Paul Klee, 1902

A TRIP SOUTH

In October 1901, Klee and his friend Hermann Haller (1880–1950) departed on a trip to Italy lasting six months—an undertaking that, at the time, many art academy students still considered a mandatory part of their education. The two had known each other since their schooldays in Berne, when they had been brought together by their shared interest in painting. Like Klee, Haller had also studied with Knirr and Stuck in Munich. They traveled via Milan to Genoa, whose port Klee described with awe: "The iron bollards as seats. The unfamiliar clime. Steamers from Liverpool, Marseille, Bremen, Spain, Greece, America. Respect for the size of the Earth ... The most adventuresome figures with fezzes ... Piers lined with houses and storerooms. A world unto its own. This time, we are the idle wanderers amidst it all." Via Pisa, the two traveled on to Rome, where their arrival was celebrated with a liter of *barbera*, a red wine. After just a few days, Klee made the literary remark: "Rome is epic, Genoa dramatic." He visited churches and museums, and studied the works of the Renaissance and antiquity at length, with an increasing interest in architecture. His constant companion on these tours was Jacob Burckhardt's book *Cicerone: A Guide to Enjoying the Art of Italy*, whose opinions he often chafed at. In his Roman hostel—for which he had purchased an owl known as a *civetta* as a pet, and in which he would sometimes warm himself with vermouth—he read intensively classical works, such as Tacitus' *Annals* and *Histories* and Xenophon's *Banquet*, but also Émile Zola's *Rome*.

During this time, Klee remained faithful to Lily, worshipping only a few photographs of classical female statues. He confided to his diary that "...I never tire of spreading them out before me. It cleanses me of certain cravings. I enjoy female company (of muses) and am a better person for it."

Klee's attempts at painting during this period did not leave him very satisfied. Again and again, he felt that color was little more than decoration for his drawings. Regarding color, Klee wrote in his Italian journal: "I realize that a long struggle awaits me in this area." In the end, he remarked helplessly that, though he was now familiar with the art of antiquity and the Renaissance, he could not relate to the art of the present day. This realization made him less

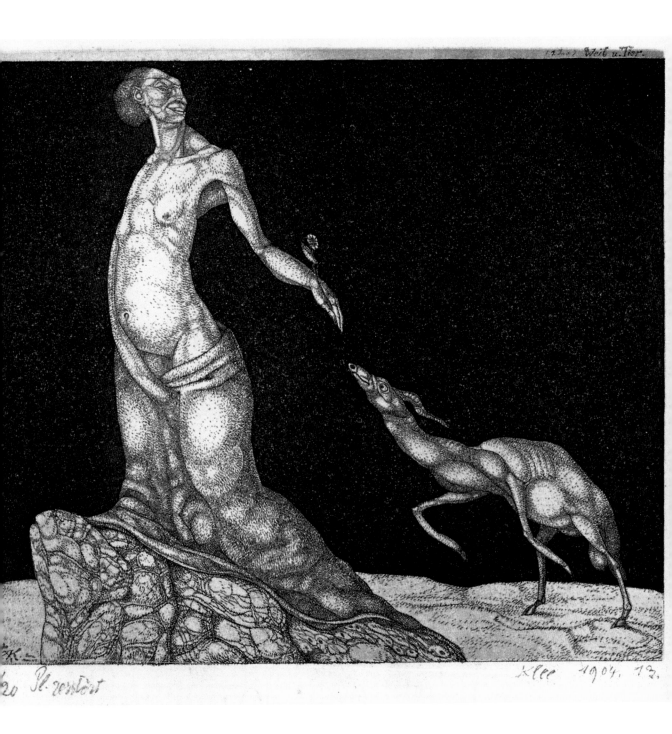

Weib u. Tier (Woman and Beast), 1904

Klee described this first image from the *Inventions* cycle in his diary: "An animal,
the animal in Man, follows a lady, who shows herself not completely unapproachable.
The female psyche is easily unveiled."

**Schwangeres Mädchen sitzend; weiblicher Akt mit Andeutung des Beinkleids
(Pregnant Girl Seated** together with **Female Nude with Suggestion of Leg Coverings**),
1905

Klee originally drew these female figures on two separate pages of his sketchbook.
Then he cut and tore them out and mounted the pieces together on one sheet.

sure about his choice to seek out new artistic paths, and so he continued to focus on drawings of a satirical nature. Since today we know of only a few works from Klee's Italian travels, we may assume that he destroyed many of his creations from this time out of a sense of dissatisfaction. To his beloved Lily, he described his situation as an artist as follows: "I find myself in the middle of an intense period of change." After a long sojourn in Rome and excursions to Naples, Pompeii, Sorrento, and Amalfi, he continued on to Florence. Here, he was fascinated in particular by Gothic art and by a small painting of a woman by Botticelli in the Palazzo Pitti (*Portrait of a Woman. c.*1475), which he considered "the simplest and most accomplished painting."

WAITING FOR HIS OWN WORLDVIEW

In May 1902, after six months in Italy, Klee returned not to Munich, but to his parents in Berne, where he spent the next few years working in reclusion. It was here that he took stock of his situation as an artist in general and a painter in particular. The real cause for his dissatisfying painting work, he believed, lay not in outside circumstances, but in his character and his insufficiently dynamic or positive worldview. In this regard, he wrote in his diary of his desire "to master not only life in practice, but to shape it tangibly within me and, in so doing, to adopt as mature an attitude as possible. It's clear that this will not happen by virtue of a few principles, but that it will grow naturally. Nor would I know where to find such principles. A worldview is built of its own; will alone cannot determine which direction offers the most clear-cut road, for this is in part determined by fate. Some of the seeds have been present since the womb." Klee, who now saw himself as a "self-apprentice," continued solemnly: "And may the sincerity of my intentions always be a greater inhibition than my lack of skill. With an awareness of existing laws, to expand until the mental horizon is defined, and difficulties, automatically falling into place, are again made simple."

A STRANGE FEAST OF THE DEAD

Klee soon began performing with the Berne Musical Society again, playing
first violin and touring with the orchestra throughout Switzerland. A tireless
musician, he also gave home concerts with a quartet of friends. In November,
he began attending lectures on "sculptural anatomy," as well as a daily anatomy
course at the University of Basel, which often had twelve or more corpses for
study purposes. "A strange feast of the dead," observed Klee, who at the outset
was haunted by the corpses in his dreams. Klee's teacher Stuck had advised him
to improve his knowledge of anatomy, and he had made his decision while in
Italy: "Am planning to study anatomy thoroughly in Berne—like a doctor.
Once I know that, I will 'know everything'." In addition, Klee regularly
attended an evening life-drawing course in order to improve his nude drawings.

Childhood drawing, 1884

In 1902, Klee discovered his figurative childhood drawings in his parents' attic.
In a letter to Lily, he wrote: "The latter are the most important to date, independent
of the Italians and Dutch, stylistically of a high class with a naive eye. In short, I am
very proud of them."

*"To be capable of reconciling the contradictions! To express
a multitude of meanings with one word!!"* Paul Klee, 1902

In one of his many letters to Lily, he expressed his conviction that, as a result, his own pictorial ideas would take a back seat, only to later "spring up all the more refreshed."

THE SELF-APPRENTICE'S SELF-DOUBTS

The following year (1903) did not start out well for Klee. He was still far from being an established artist and experienced repeated periods of deep self-doubt. He frequently encountered a lack of understanding for his work from friends and even from his father, who could not relate to his son's imagination. All the while, Klee felt a great responsibility towards his parents and his future wife Lily, and he worried about properly measuring up. This situation caused Klee, who now considered himself phlegmatic, to sink repeatedly into dark moods accompanied by thoughts of suicide. At the same time, he felt the need to continue to draw and, again and again, to work cautiously with paints. Still, every creative impulse was infused with a strong sense of pessimism regarding the end result. Writing in his diary, Klee observed: "It is as if I were pregnant with things awaiting form, and certain of miscarriage!"

During this difficult time Klee, who all his life read books intensely and frequently, was also studying Zola's novel *L'Œuvre*, about a passionate and brilliant young painter who, consumed by ambition, repeatedly destroys his paintings because he considers them imperfect. In addition, the novel's protagonist is highly unbalanced and has horrible fits of anger that make it impossible for him to create art. In the end, he neglects his friends and family and becomes isolated. After failing to paint a monumental picture of Paris, he hangs himself before the unfinished painting without having left behind any body of work. Klee was deeply moved by the novel, writing in the spring of 1903: "...what an eerie book! It relates to us! How terrible to experience this book while one is standing on the threshold of horrid possibilities." At the same time, however, the book stimulated him: "It has also become clear to me that I still lack Paris. This I realize. I must go there."

Der Held mit dem Flügel (Winged Hero), 1905

Regarding this work, which belongs to his *Inventions* cycle, Klee wrote: "The hero with wings, a tragicomic hero, perhaps a Don Quixote of antiquity … This man—who, unlike divine beings, was born with just one angel's wing—undertakes steadfast attempts at flight. In so doing, he breaks an arm and a leg, but continues to persevere. It was especially important to capture the contrast between his monumentally celebratory composure and his already desultory condition—an allegory of tragicomedy." When *Inventions* was shown at a Munich exhibition in 1906, a Swiss critic wrote: "One finds it difficult to find a reasonably clear meaning within this frenzied aberration of forms."

Drohendes Haupt (Menacing Head), 1905

Writing about the final image of the *Inventions* cycle, Klee confessed: "…a dismal conclusion to these etchings. A thought more destructive than deed. Pure negation as demon. Physiognomy primarily resigned."

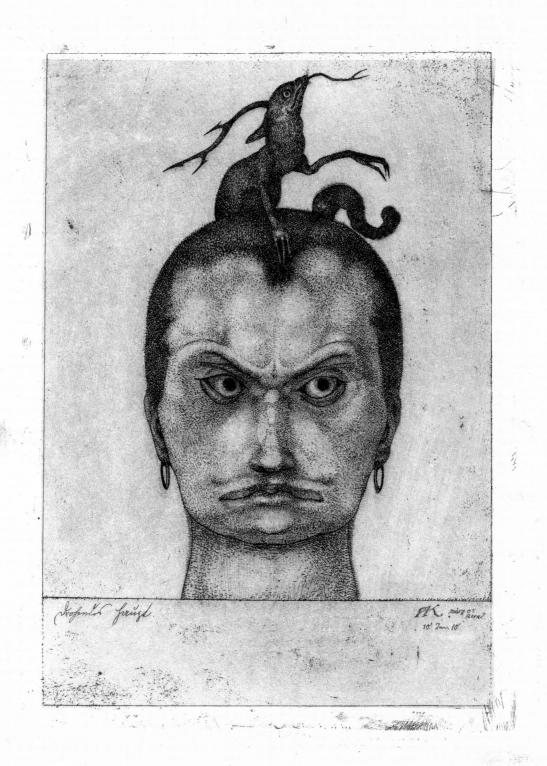

"Imagine that you have died. After many years of being away, you are allowed a single glance earthward. You see a lamppost and an old dog lifting its leg. You are so moved, you cannot help sobbing." Paul Klee, 1905

FIRST FRUITS

In July 1903, Klee began to create etchings of his illustrations, the results being a cycle of eleven etchings he called *Inventions* because they had sprung from his imagination. After all his disappointing attempts at painting with a brush, Klee found the process of etching to be revitalizing. At the same time, his etchings convinced him that he was a good illustrator. After all, when beginning his studies in Munich, he had told his mother: "If you want to etch, you must be able to draw." While still in Munich, he had privately learned the fundamentals of etching from Walter Ziegler (1859–1932), who had told Klee that his peculiar line technique practically begged for his drawings to be made into etchings. He was not always satisfied with an etching, in which case he would produce additional versions. With *Inventions*, he finally produced the "first fruits" of his labor. Klee regularly sent Lily, who remained in Munich, photographs of his works that he had taken and developed himself. In December 1903, he wrote to her of his joy over these etchings: "There was always too much in there ... My etchings have convinced me of this realization. To some extent, they have such a strong effect only because nothing distracts from the figure. Instead, the little that is present in addition to it [the figure] only serves to enhance and complement it, etc. Until this issue has been completely resolved, I plan to... for the most part limit myself to one single figure."

Klee now took a break from playing with the orchestra. It was a small form of protest, for the Berne Musical Society would no longer grant him free tickets. He had always provided his family and Lily with highly detailed reports of his visits to the opera and concerts, and now he began to write reviews of musical performances for the *Berner Fremdenblatt*.

Klee worked on the etchings for *Inventions* in addition to his drawings until the sprint of 1905.

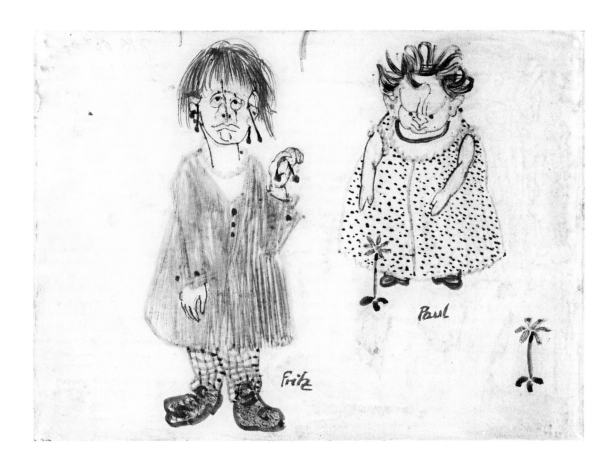

Paul u. Fritz (Paul and Fritz), 1905

In 1905, Klee painted a series of reverse-glass paintings of children. He soon hit upon the idea of turning this series into a children's book—not, however, in order to present happy and well-behaved role models of manners. In reference to another picture from this series, Klee wrote Lily: "I made the child with the pear twice and am now satisfied; it has character, even if somewhat maleficent. It should draw attention to the greed, the teeth, the animalistic, without ignoring the childlike grace … How many prints do you think … such a picture book should have?" The planned book was never published.

"Ever more parallels between music and visual art impress themselves upon me. But no analysis has been successful. Both arts are undoubtedly transitory; this could be easily proven." Paul Klee, 1905

KLEE'S DARK FAMILY OF TOOLS

Around this time, Klee gave names to the pencils and etching needles with which he worked every day, turning them into a very unusual "family." The opera fan called one of these tools "Rigoletto" in honor of the mocking cynic from Verdi's opera. Another was named "Robert the Devil," after the protagonist of Giacomo Meyerbeer's opera of the same name, in which Robert, the son of the Devil, is subjected to a struggle for his soul between the forces of the Devil and the forces of light. Other tools were called "Nero" after the cruel Roman emperor and "Judas" after the disciple who betrayed Christ. But that was not all. In reference to two old Swiss names for the devil that he had found in the *Journal of Swiss Folklore*, Klee baptized two other members of his dark family of tools "Füntzhart" and "Chrütli."

Klee wrote about these names in his diary: "Chrütli is the name of an old Swiss devil, the guardian devil of abortion. In practicing his trade, he argues that even God had allowed for his own son to be slaughtered—and he was a grown man."

GLAMOUR AND MISERY IN PARIS

In late May 1905, the twenty-five-year-old Klee departed on a two-week trip to Paris with his friends Bloesch and Louis-René Moilliet (1880–1962). Klee spent several days visiting the Louvre, attended opera performances, enjoyed the Folies Bergère and Taverne D'Olympia cabarets, saw other exciting sights of the city on the Seine, and traveled to Versailles. He was particularly captivated by Rococo art and the Impressionists, but above all he realized that he had now gained a true overview of the entire history of art.

At the same time, however, he was deeply troubled by social conditions in the French capital. Shocked, he wrote Lily: "The multitude gives one the im-

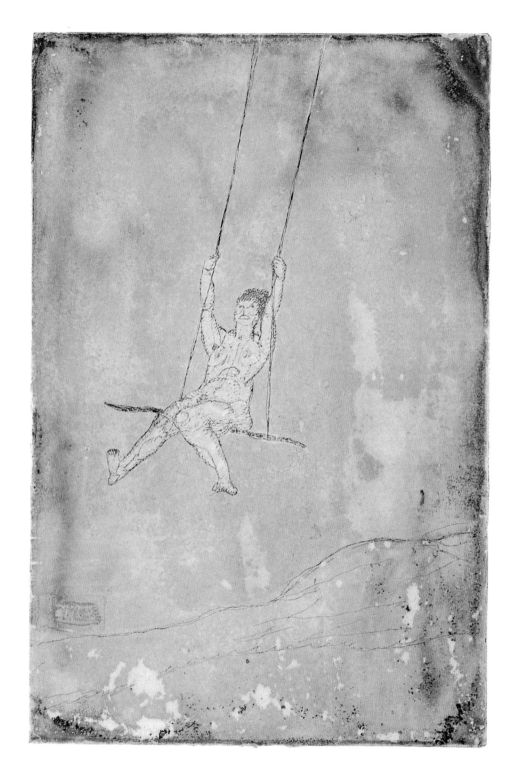

Akt auf der Schaukel (Nude on a Swing), 1906

The woman in this reverse-glass painting appears to float on the swing while at the same time demonstrating perfect balance—a subject that Klee repeatedly came back to.

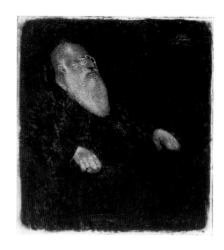

pression that it is absolutely indifferent to individual human life. In the long run, one becomes completely desensitized by such a place, for one cannot possibly help everyone as one should." In addition, Klee observed that Parisian society was exceedingly superficial and possessed no appreciation for art. Klee could not shake these impressions, and a short time later he again wrote Lily: "My feelings for mankind have suffered a terrible down turn." These sentiments led Klee to consider questions of social justice and to ask whether such conditions could somehow be resolved—perhaps even through socialism. But in his letter to Lily he wrote, resigned: "Just as, in our time, charity within capitalist institutions is no more than alms, socialist institutions within the 'divine world order' of man cannot be anything more. After all, the main enemy is the eternal Creator. And I despair for socialism, for mankind doesn't even want it."

EVERYTHING WILL BE KLEE

In the spring of 1905, Klee ventured an experiment: he blackened a sheet of glass with India ink and placed a white sheet underneath. Then he used a nail to scratch an image in the blackened glass, with white lines becoming visible on the black background. Klee realized: "The means is no longer the black line, but the white. The bright energy on the nocturnal background corresponds nicely to the words 'let there be light.' And so I slide gently into the new world of tonalities." In this approach, Klee saw a parallel not only to Creation (in which God had used light to make the world out of the dark chaos), but also to the everyday phenomenon of nature, which made everything visible through

m Vater (My Father), 1906
Klee etched this likeness of his father with a needle into a blackened sheet of glass.

"An important work of art is created after one has had to give up an even more important one." Paul Klee, 1905

whiteness, through its light. In etching, by comparison, Klee saw exactly the opposite phenomenon—with the artist starting "where nature has left off. Thus the terrible difficulties, but also the allure inherent in working with the black line." The new technique allowed Klee to experiment with and discover something new without having to deal directly with the vexing issue of painting.

In the autumn of 1905, he began to make reverse-glass paintings, more than fifty over the next few months. He first used a quill to draw an image on a sheet of glass, then applied paint, and finally covered the painted surface with white or gray paint. When the sheet of glass is turned around, the colored image appears on a white background. The process was the opposite of painting on a white sheet. This method inspired Klee to not only take old, previously rejected illustrations and to transfer them successfully on to glass with color, but also to look for entirely new motifs.

Klee continued to experiment with glass plates in the subsequent months. For instance, he used a nail to scratch an image onto a glass pane covered in black paint, then placed an unexposed photographic plate underneath and briefly exposed it, thus turning the engraved image into a photographic negative. Another time, he coated the glass plate with white, used a nail to scratch into the white layer, and then applied colored or black fields on top.

Klee's progress at this time was not limited to working with color. Where the works he had made in nature had previously been naturalistic, now he could allow his own abstract influences to enter his pictures. Overjoyed, he wrote in February 1906: "I have succeeded in directly including 'nature' in my style. Studies are a thing of the past. Everything will be Klee, no matter if it is days or mere moments between impression and reproduction." He continued: "Will I make as much progress in the area of color? In any case, a spell has been lifted in me—the most difficult, the hardest there is for an artist." This newly acquired maturity in art also allowed Klee to take a great step forward in his private life: marriage to Lily.

FROM HERMIT OF SCHWABING TO AVANT-GARDE STAR

1906–1920

THE WEDDING

For five years following their engagement, Paul and Lily saw each other rarely, but cultivated an active exchange of written correspondence. On September 15, 1906, they were finally married in Berne. Some two years earlier, Klee had written Lily his vision of married life and what he expected from it: "You have a hearty and competent outlook on life, but you need not believe that we can achieve full harmony. If we can manage to arrange our life decently, which means living together without petty worries, and to have decent intercourse,

kleines Erinnerungsbild Lily (A Small Memento of Lily), 1905

Lily became Mrs. Klee roughly one year after he immortalized her in this reverse-glass painting. But this cheerful pianist had been a self-assured, emancipated, and energetic woman for a long time.

and if in so doing we remain healthy so that we will not have to cut back on work—then this is our consummation. By decent intercourse, I mean dignified, simple people with a classical education or good books, which for me are nearly one and the same thing. For the purpose of this whole intellectual 'intercourse' (I do not want any other) is to expand one's experiences or to avoid one-sidedness. In the end, it all comes down to increasing one's working capacity; and the marital relationship should subordinate itself to this one and only true purpose." Lily was welcomed in the Klee household like a daughter, but the marriage was a thorn in the side for Lily's father, a practicing physician. In his opinion, a struggling artist was not a suitable spouse for the daughter of a well-to-do family.

THE KITCHEN STUDIO

Two weeks after their wedding, Lily and Paul moved to Munich, where they rented a small three-room apartment in a dark rear building at Ainmillerstrasse 32, in the middle of the turbulent artists' quarter of Schwabing.

Since Klee had almost no income, Lily gave piano lessons for up to ten hours a day (at the time, a truly daring division of gender roles). On top of this, the two frequently played music together. During this period in his life, Klee had almost no contact with other artists. Writing in his diary, he stated that "in this city of 5,000 painters, I now live all alone and for myself." The small apartment consisted of a bedroom, a living room with a piano, and a music room—where they kept the grand piano under which their son Felix had his bed when he got bigger. Klee had hung a lithograph of Edvard Munch's (1863–1944) *Kiss* in the bathroom. Since he did not have his own studio, he turned the kitchen into one. Here, he created not only his small-format illustrations, reverse-glass paintings, and watercolors, but also mixed the acid baths for his etchings. In December 1908, Klee finally rented a small attic studio in Munich's Feilitzschstrasse no. 3/IV.

"The pictures that my little Felix has drawn are better than mine, which have often percolated through my brain— something I unfortunately cannot prevent altogether, since I sometimes work too much." Paul Klee, c. 1922, quoted by Lothar Schreyer

Bildnisscizze n. Felix (Portrait Sketch of Felix), 1908

Using black India ink in a so-called "black watercolor," Klee sketched his son Felix in different shades of light and dark.

BUBI

On November 30, 1907, Lily gave birth to the couple's only child, Felix. Since Lily's days consisted of giving piano lessons, Klee not only looked after the household, he also devoted himself keenly to raising their son. Klee—who at home spoke the Bernese German dialect—took little Felix on walks through the English Garden in his baby carriage, and they later explored the city together, always on the lookout for new motifs. Since the only meal Lily knew how to cook was stew, Klee cooked for the family day after day, often creating splendid multi-course meals with a touch of the Mediterranean. If no wooden spoon was at hand in the kitchen studio, he simply turned a brush around and stirred the food with the wooden handle. The ardent cook had amassed his recipes in the kitchen of his aunts' hotel in Switzerland. Years earlier, when he had doubted his future even more intensely than now, Klee had written Lily about the hotel: "...if everything fails, I will take it over."

Man bricht gar leicht den Hals klimmt man hinauf die Leiter; Behaglich sitzt man auf der ersten Sprosse (S. 42) (It's all too easy to break one's neck when climbing up the ladder, it's more comfortable to sit on the first rung [p. 42]), 1908

One of Klee's illustrations for the satirical verse epic *Der Musterbürger*, written by his friend Hans Bloesch.

Looking back on his childhood, Klee's son Felix said many years later: "As a child, I had little contact with my mother ... You might say that I grew up on my father's apron strings. During all my development, until he was drafted into the army in March 1916, I essentially knew only my father." Klee followed his son's development closely, and in the first few years following his birth he kept a "Felix calendar," recording in detail the child's weight, language development, gestures, and moods. When Felix took seriously ill for several months, Klee recorded the course of the fever in minute detail. With great dedication, he built ships, trains, and a farm for his "Bubi," and accompanied Felix's early

Steinbruch Ostermundingen (Quarry of Ostermundingen), 1908

Klee was fascinated by the stone quarry near Ostermundingen not far from Berne, painting it some twenty times between 1909 and 1915—here in a black watercolor painting.

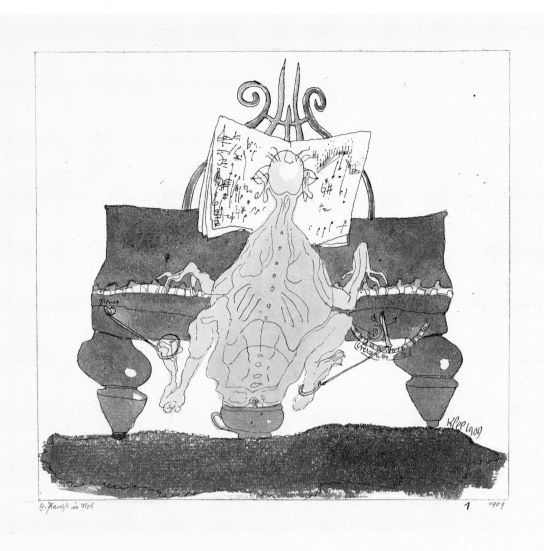

d. Pianist in Not (The Pianist in Need), 1909

Why does this musical instrument turn into an instrument of torture, malevolently shackling the person playing it? And what ails the pianist's stomach, so that he is forced to sit on a chamber pot instead of a piano stool? In this satirical work on paper, Klee is presumably skewering contemporary music, which he could never warm to as much as he did to classical music, despite his later acquaintance with the composer Paul Hindemith (1895–1963). Or perhaps it is a stab at the shallow popular music that a young neighbor of Klee's was constantly listening to. When, soon thereafter, this young man headed down the wrong path, Klee commented: "If one listens to such inferior music for hours on end, nothing else can come of it."

attempts at painting with constant interest and an intense exploration of children's art. In an essay written in 1912, Klee—surely inspired by Felix's childhood pictures, as well as by the pictures he himself had drawn during his own childhood, which he had rediscovered several years earlier—wrote: "There also exist the primal beginnings of art as found in the ethnographic museum or at home in the nursery (laugh not, dear reader), for children are equally capable, and this is by no means detrimental to the youngest efforts, but there is a positive wisdom in this circumstance. The more helpless these children, the more revealing their art ... Parallel phenomena are the drawings of madmen, meaning that insanity is not a fitting insult. In truth, if we are to reform art today, then all this must be taken much more seriously than all the museums of art."

blumensteg, Giesskanne u Eimer (Flower Stand, Watering Can and Bucket), 1910

In the summer of 1910, Klee created several color works, about which he wrote: "Wet on wet watercolors on water-sprinkled paper. Quick nervous work, spattered over it all in a certain tenor."

"In Schwabing, my neighbor was Paul Klee. At the time, he was still very 'small.' But I can claim with justified pride that, in his small drawings from that time (he had not yet begun to paint), I could sense the later, great Klee." Wassily Kandinsky, 1930

Strassen Kreuzung (Crossroad), 1911

Klee drew this Munich intersection with a quill. That same year, he wrote: "The line, permitted by progress! … The surfaces still look a little empty, but not for long!"

LIGHT AND SHADOW

Klee repeatedly proclaimed that he wished to follow his own artistic path, independent of other artists. At the same time, his visits to Munich's museums and galleries and his study of artists' magazines and art historical works were especially important for him during this socially isolated period. Much of what he read and saw inspired him and influenced his work. For instance, at a Munich gallery in 1907 he admired the works of Claude Monet (1840–1926) and marveled at *The Absinthe Drinker* by Édouard Manet (1832–1883), who had significantly influenced the Impressionists. Manet had intensively studied the Spanish painter and printmaker Francisco de Goya (1746–1828), whose paintings evoked the wicked nature of mankind and conjured up fantastic and

Il le perce d'outre en outre (illustration for **Candide**), 1911

Klee's illustration for the ninth chapter of Voltaire's *Candide*. In extreme motion, the murderer's entire body tautens for the delivering the final, precise deathblow.

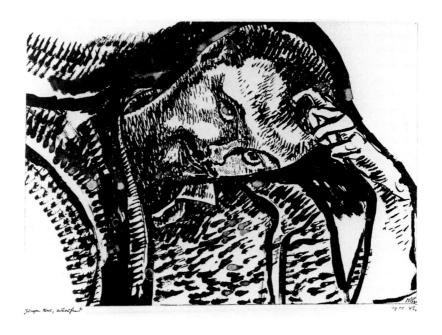

demonic images. Klee, too, had been inspired by Goya for some time, and so it is no surprise that, in a personal questionnaire in 1908, he listed both Manet and Goya as his favorite painters. A short time later, after having seen the paintings of Vincent van Gogh (1853–1890), and while reading the famous Dutchman's published letters, Klee observed: "Too bad that the early Van Gogh is such a beautiful human being and less good as a painter, while the later wonderful artist is such a marked man. One would have to find the median point for these four points of reference, then yes! best of all to be like that oneself." In spite of their pathos, Klee found Van Gogh's paintings to be a perfect combination of invention and nature. Thus inspired, he again began to work more intensively with nature as a model, still primarily in drawings. Now, however, Klee was no longer interested in a pure representation of nature; instead, he tried to allow his own subjective associations to become a part of these more abstract studies. For this, he experimented with a diverse range of methods. For instance, he observed the people on Munich's suburban meadows with a pair of opera glasses in order to draw them "in the simplest outlines," with the goal of "creating abstractions from a real point of view." Another time, he completed a picture after turning a nearly finished work upside down.

In these years, Klee entered a period during which he intensively experimented with a wide range of techniques involving light and shadow,

Junger Mann, ausruhend (Young Man, Resting), 1911

The same year that he created this self-portrait, Klee wrote in his diary: "In lucid moments, I sometimes review twelve years of the history of my own inner self. First the inhibited self, the one with large blinders on, then the disappearance of the blinders and of the self, and now, bit by bit, again a self without blinders. Good thing that one did not know all this beforehand."

"And one more revolutionary discovery: more important than nature and the study thereof is one's attitude towards the contents of the paint box. Some day, I must be capable of freely improvising on the paint–piano and its rows of watercolor cups." Paul Klee, 1910

Laternen (Street Lamps), 1912

Klee was still unsure in his use of color when he made this painting.

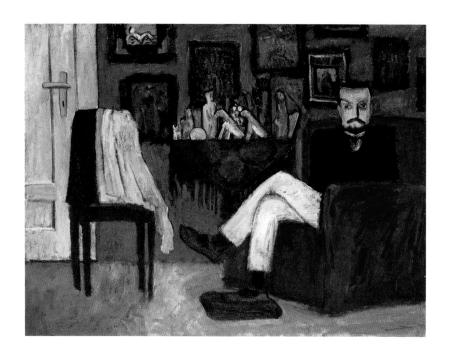

brightness and darkness. His so-called "black watercolors" in particular were important studies that helped him gather experience for working with light in his later colored works. In 1908, Klee described his approach to these black watercolors—how he transferred tonality, i.e., the contrast between black and white, onto glass or paper: "Besides the constructive arrangement of the image, I also studied the tonalities of nature by adding layer upon layer of diluted black watercolor. Each layer must dry well. In this way, I create a mathematical ratio between light and dark. Squinting assists in measuring the essence of nature."

LIBERATED FROM THE CUL-DE-SAC OF ORNAMENT

In 1907, Klee's friend, the illustrator and draftsman Jacques Ernst Sonderegger (1882–1956), introduced him to the demons, masks, and ghostly beings of Belgian painter and etcher James Ensor (1860–1949). At the same time, Klee again explored working with line—and, to his consternation, frequently ended up with ornamental designs. Here, Van Gogh and Ensor were his salvation.

Gabriele Münter: **Mann im Sessel (Paul Klee)** (**Man in Armchair [Paul Klee]**), 1913

Münter painted Klee in her studio on a hot Sunday. Later she wrote: "It will not be a portrait ... And yet this paradoxical depiction contains a true expression of the essence of Klee the man and Klee the artist: his physical existence in the world is remarkable, and the spirit leads its own life, immersed in the tintinnabulation of things and in itself."

Joyful, he wrote in his diary in 1908: "A work of art goes beyond naturalism if the line—as in Van Gogh's drawings and paintings and in Ensor's prints—appears as an independent pictorial element ... All in all, this would appear to be an outlet for my line. I am finding my way out of the cul-de-sac of ornament ... Newly invigorated by my naturalist studies, I can again venture to re-enter my original field of mental improvisation." Under this influence, Klee created drawings with bizarre little figures which strike the viewer as preparation for the illustrations that he would soon commence.

Around this time, Lily had given Klee a book by Honoré de Balzac with illustrations by Gustave Doré (1832–1883). Excited by these images, Klee felt ever more strongly his own desire to work with illustrations—a plan that he had been hatching for years. In 1908, his friend Bloesch asked him if he wanted to illustrate his satirical verse epic *Der Musterbürger* (The Model Citizen)—a stinging attack on the Swiss bourgeoisie. Klee, who frequently mocked the middle class himself, used India ink to make little strokes and scrawling lines for his first series of literary illustrations—which, however, were never published during his lifetime.

At a 1909 exhibition organized by the Munich Secession, Klee saw eight paintings by Paul Cézanne (1839–1906). The works so fascinated him that he now placed Cézanne above Van Gogh, immediately calling him a "master teacher par excellence" and admiring his works as the "greatest event of painting."

**Der Polizeihund wird in Wut versetzt – damit er die Spur verfolgt
(The Police Dog is Antagonized – So That He Will Follow the Trail), 1913**

One of the many illustrated greeting cards that Klee sent his friend Franz Marc between 1913 and 1914.

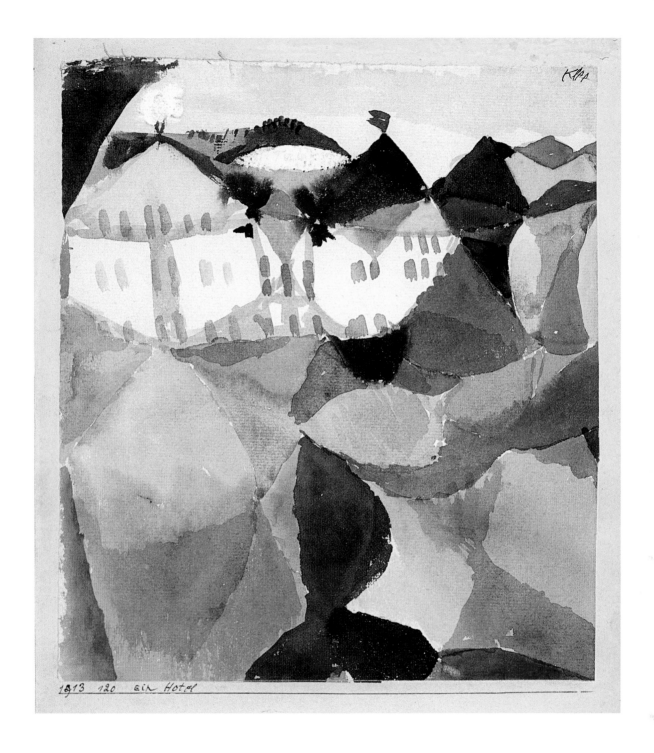

Ein Hotel (A Hotel), 1913

Shortly before departing on his trip to Tunisia, Klee quietly headed down the path towards abstract color fields, as in the lower part of this picture. He then consistently developed upon this approach on his famous journey.

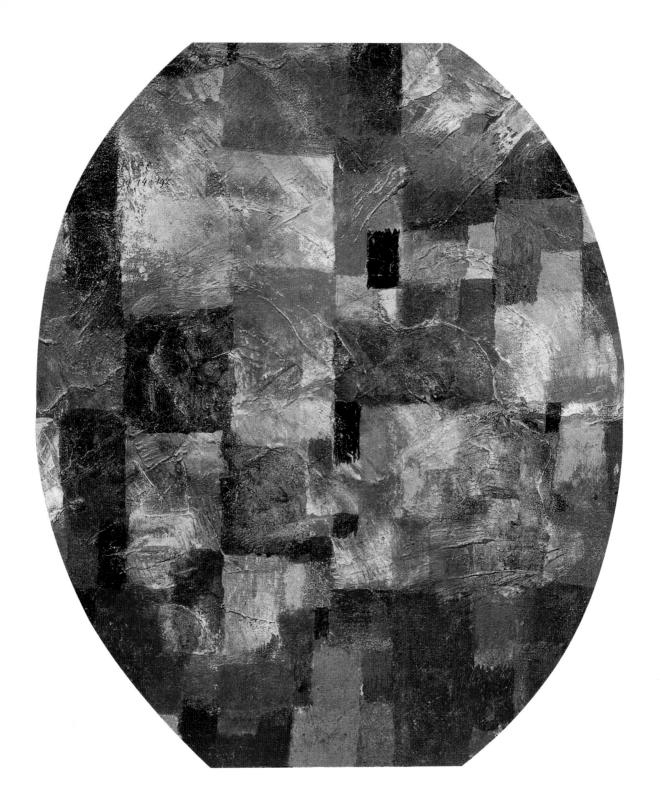

FROM HERMIT OF SCHWABING TO AVANT-GARDE STAR

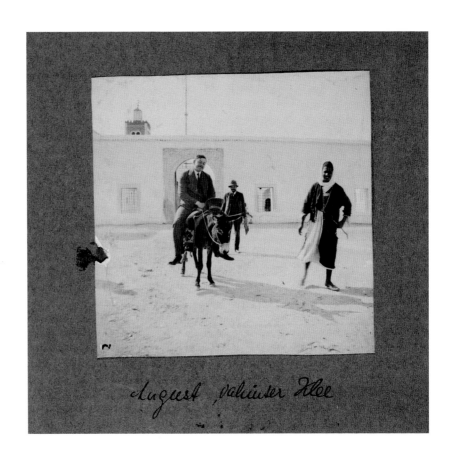

August, geliebter Klee

Hommage à Picasso (Homage to Picasso), 1914

Klee painted this picture after being inspired by Picasso's Cubist works; its main allusions to Cubism can be found in the oval format. It is the only work by Klee whose title contains a homage to another artist.

August Macke and Paul Klee with their guide in Kairouan, April 1914
(from August Macke's photo album)

Just a few hours after this photograph was taken, Klee wrote in his diary with a sense of fulfillment: "Color and I are one. I am a painter."

THE TENTATIVE ILLUSTRATOR

That same year, Klee made a somewhat cautious entry in his diary, saying that he wanted to "tentatively" try his hand at literary illustrations. An avid reader, Klee had already chosen a book to illustrate, one that had excited him unlike any other: the philosophical novel *Candide* by Voltaire (1694–1778), which presented the world as a most dubious creation. Nevertheless, he did not begin work on the project until 1911, and it would keep him occupied until the following year. The resulting drawings featured strangely thin and stylized figures of unusual proportions, drawn with a nervous but loose line (see p. 54). Writing in his diary, Klee describes what this work triggered within him: "...perhaps I have found my true self again—although I am still swinging back and forth between differing opinions." As professed at an earlier date, Klee aimed for more than merely illustrating a literary motif: "...I created images and rejoiced only when a poetic and a pictorial thought coincided seemingly 'by chance'." Despite extensive efforts at quickly bringing the book to print, it was not until after the war that Klee could find a publisher for the *Candide* illustrations. They finally appeared in 1920.

Robert Delaunay: **Fenetre sur la ville (Window on the City)**, 1914

This picture is one of the "window paintings" that Klee was able to admire in Delaunay's studio in 1912. The pictures from this series are composed of bright color, removed as far as possible from representation.

"A pill-dung-whirligig beetle does his work before me. This is how I will work as well: testing again and again whether it rolls; reducing, re-measuring. And at some point it will work. But will I also march backwards with my ball, I mean backwards to the goal?" Paul Klee, 1914

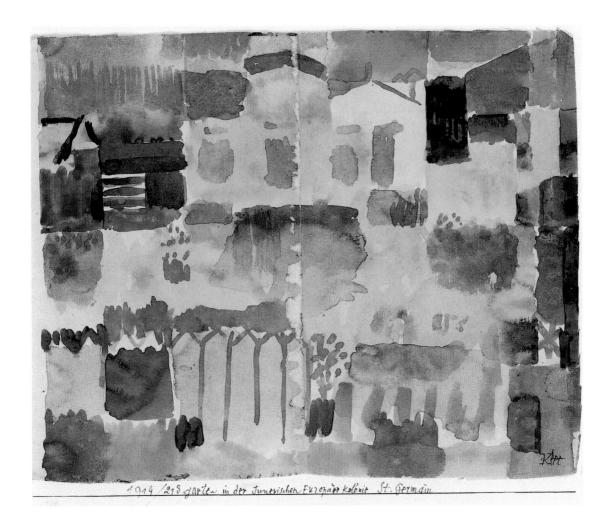

garten in der tunesischen Europäer Kolonie St. Germain (Garden in St. Germain, the European Quarter of Tunis), 1914

Klee liked this watercolor so much that he labeled it "special class" (which Klee marked as "S KI" until 1919; afterwards as "S CI"), an honor bestowed only on works that Klee reserved for his own posthumous estate and thus did not sell.

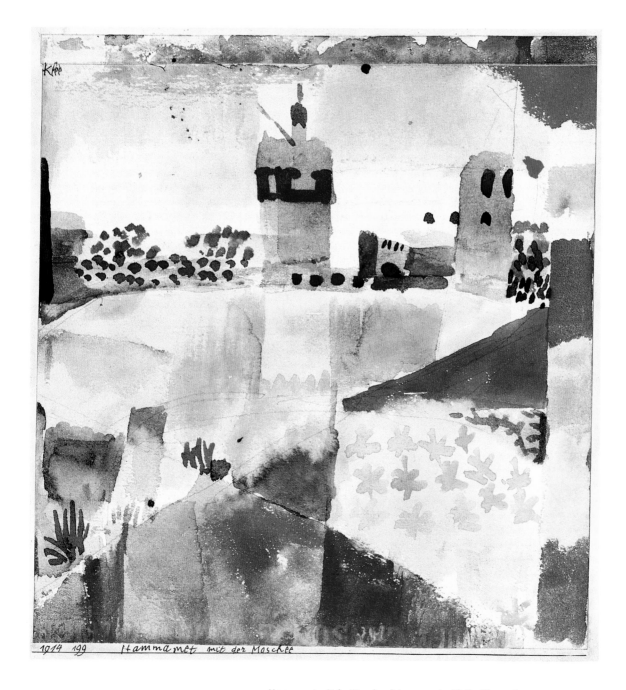

Klee

1914 199 Hammamet mit der Moschee

Hammamet mit der Moschee (Hammamet with the Mosque), 1914

Following their stay in St. Germain near Tunis, the painter friends traveled to Hammamet, where Klee painted this watercolor. In the upper half of the painting, we can still clearly identify the mosque, a tower, walls, and gardens, but the lower half is painted in overwhelmingly abstract color fields showing the influence of Delaunay. After completing the watercolor, Klee further emphasized the work's clear division into a more representational and more abstract half by cutting off a small strip from the lower red border, turning it by 180 degrees, and placing it on the picture's upper edge.

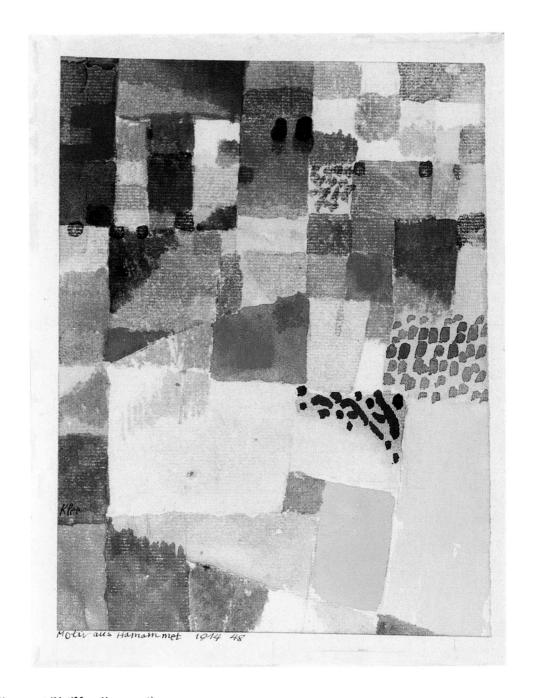

Motiv aus Hamammet (Motif from Hammamet), 1914

This watercolor was not painted directly from the urban landscape of Hammamet, but—as indicated by Klee's notes in his catalogue of works—is based on Klee's partially abstract picture *Hammamet with the Mosque* (opposite). Armed with this knowledge, we can identify the blue surface at the top left as part of the roof; the red area (top middle) with the adjacent smaller yellow area as the tower with the two windows; and the adjoining dots as plants. The first painting helped Klee take another step towards nearly complete abstraction—pure color and form.

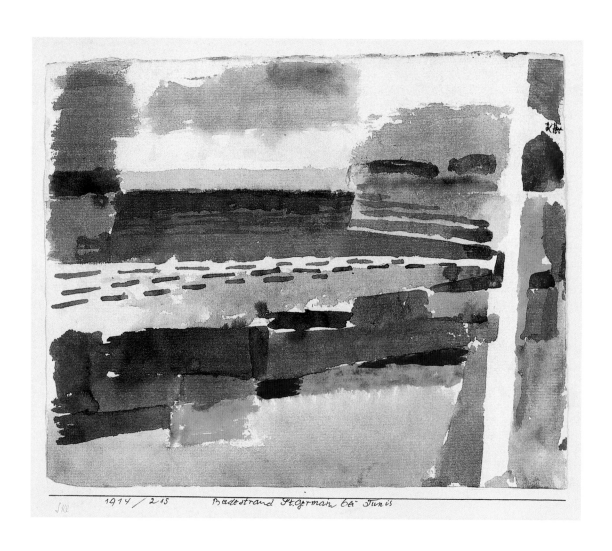

Badestrand St. Germain bei Tunis (Bathing Beach of St. Germain near Tunis), 1914

Here, Klee painted horizontal bands (making use of the white of the paper as well) on to wet paper, a process requiring rapid work. The vertical white stripe is where the rubber band was affixed that held the sheet of paper on to the backboard.

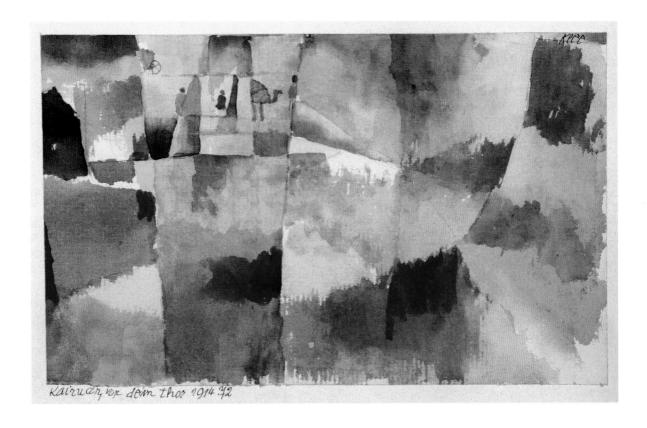

Kairuan vor dem thor 1914 72

THE ENTHUSIASTIC BENEFACTOR KUBIN

Klee's recognition and success as an artist developed slowly and steadily. In 1909, he sold two illustrations that he had sent to the Berlin Secession. After many years in anonymity, in 1910 Klee held his first solo exhibition, showing fifty-six of his works in Switzerland. This traveling exhibition first opened in his hometown of Berne, and then moved on to Zurich, Winterthur, and Basel. At the time, the Bernese building contractor Alfred Bürgi became the first to

Kairuan vor dem Thor (Kairouan, before the Gate), 1914

This predominantly abstract watercolor—whose loose color fields randomly overlap and blend into one another—was not painted until after Klee's return from Tunisia. It is not the only works created in Munich in which Klee dealt with the sights and impressions from this journey. The vertical lines and the curved line divide the picture into several parts. The only objects hinted at in this painting are several fragments of figures, a camel, and a cart—the frame containing these objects stands out almost as if Klee had cut it out of another watercolor.

purchase some of Klee's works. After Bürgi's death, his art-minded wife Hanni, who went on to become a good friend to Lily and Klee, invested a large share of her inheritance in paintings, which over the years grew into one of the largest and most important private collections containing Klee's works. Soon, well-known artists took note of Klee's work. In January 1911, for instance, Klee met the Austrian illustrator and author Alfred Kubin (1877–1959), who had recently purchased one of his works. Relishing the unaccustomed attention, Klee wrote of this encounter, which would grow into a life-long artists' friendship: "Kubin the benefactor has arrived. He made such an enthusiastic impression that he held me spellbound. We sat in front of my paintings, truly excited! Truly enormously excited! Utterly excited!"

KLEE'S CATALOGUE OF WORKS

Perhaps in response to his first exhibitions and sales, Klee now decided to compile a list of his works. As a young boy, Klee had used consecutive numbers in his sketchbooks, but he had quit this practice shortly before heading off to the academy. In February 1911, he wrote in his diary: "I am starting a catalogue of all my works still in my possession." Quickly, however, this project turned into an even larger undertaking, with Klee recording nearly all his previously created works in a catalogue. After all, this index represented Klee's own acknowledgment of his accomplishments and an account of all his previous artistic efforts.

mit d. mauve Dreieck (With the Mauve Triangle), 1914
After his return from Tunisia, Klee created a series of abstract watercolors in which he worked with contrast-rich, colorful, geometric shapes, delineated and subdivided by lines.

1915 102

Föhn im Marc'schen Garten (Föhn Wind, in Franz Marc's garden), 1915

Klee used colorful rectangles to paint the Marcs' house in the Bavarian town of Ried;
the landscape, on the other hand, consists of colorful triangles. Only the red rectangle
would appear to not truly belong to this landscape. Perhaps Klee saw this rectangle
as representing Marc's future studio, which he wanted to build on the meadow in front
his house, purchased only recently in 1914.

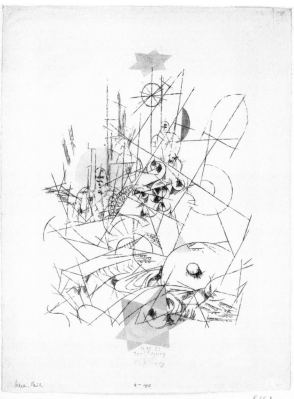

Klee was a highly meticulous person in private life and recorded even the smallest expense in his household accounting, but he apparently felt that such a painstakingly kept catalogue did not exactly fit the image of an artist. As a result, his diary entry from this time sounds like an attempt at justifying something he felt to be both necessary and embarrassing: "All the things an artist must be: poet, naturalist, philosopher. And now that I have written an extensive and precise index of all my artistic products ... I have also become a bureaucrat." Klee started with the works from his childhood, but included only those that he considered to be successful and complete works of art. The catalogue, which he maintained until his death, represents a handwritten record of around 9,000 of the almost 10,000 works that Klee produced in his

Trauerblumen (Mourning Flowers), 1917

For Klee, the human world and the plant world were closely connected; so much so that during the terrible war years, during which he created this piece, even the flowers were in mourning.

Zerstörung und Hoffnung (Destruction and Hope), 1916

Klee created this lithograph, whose test print he had called *Ruinen und Hoffnung* (*Ruins and Hope*) during his wartime military service.

lifetime, all carefully itemized in loose-leaf folders, notebooks, and lined school binders. In addition to the year of creation, he also assigned every piece a serial number, starting each year with the number 1. Later, his Munich art dealer Hans Goltz complained that it was highly disadvantageous for business that anyone could discover how many paintings Klee had created in one year—if people saw that he was making a large number of paintings, his works would not be worth as much. For this reason, starting in 1925 Klee no longer placed a serial number after the year, but used a sophisticated code consisting of letters and numbers and decipherable only by himself, with which he also marked the works themselves. In addition to the date, Klee's list—which over the years constantly changed in form and function—also included the title, the

Spiel der Kräfte einer Lechlandschaft (Interplay of Forces of a Lech-river Landscape), 1917

Klee painted this watercolor on the Lech River plain near Lengwied, not far from Gersthofen, where he was stationed during his military service. In early October 1917, he wrote Lily: "...a light veil hung over the day, the light just as I like it, and I ventured out into the river's floodplains ... By evening, I had five watercolors, three of them quite excellent, captivating even me. The last one, painted in the evening, resonated fully with the wonder all around me, and is wholly abstract while at the same time being wholly of this place."

painting or drawing technique, and sometimes also its genre. Occasionally, he also made a note as to which works had been sold to whom and at what price, which works he had given away, and which could be seen in exhibitions.

IN THE COMPANY OF THE BLUE RIDER

As in previous summers, in July 1911 Klee and Felix found themselves drawn "Swisswards" for several months. He visited his parents and friends in Berne, climbed mountains, and repeatedly and enthusiastically swam in lakes and streams. On this trip he also met with his longtime friend, the Swiss painter Louis-René Moilliet, who at the time had a visitor from Bonn, the young painter August Macke (1887–1914). At this meeting, the three painters could not foresee that, in a few years, they would together undertake a legendary journey to the Orient. Later, at an exhibition in Munich, Klee saw several paintings by Henri Matisse (1869–1954) that he found "strangely exciting." Some time later, Klee wrote that Matisse had to a certain extent found the way back to the "childlike stage of art"—a quality that Klee repeatedly conjured up

Kosmisch durchdrungene Landschaft (Cosmically Penetrated Landscape), 1917
Klee shows that there is a direct relationship between the cosmic and the earthly. In 1923, he offered a description of the modern artist: "He who is capable of capturing the universe within a straightforward painted spectacle."

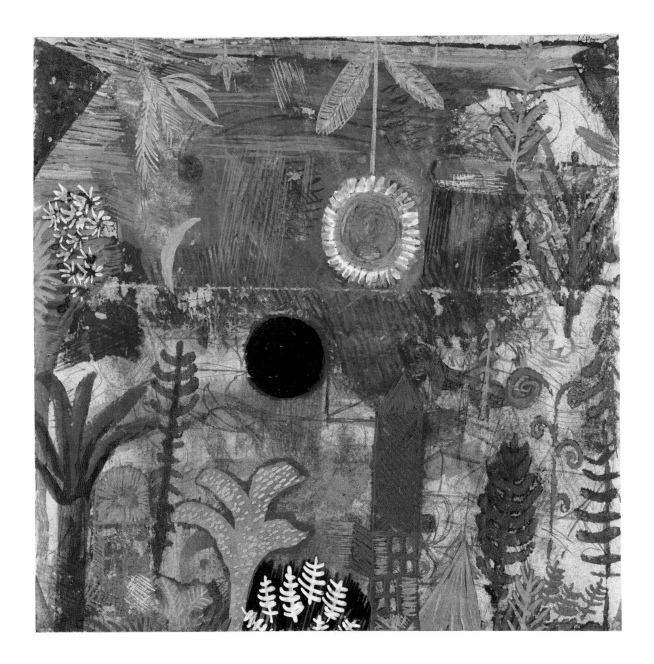

Versunkene Landschaft (**Sunken Landscape**), 1918

What laws apply here? Where is up and where is down? Plants that grow upwards and plants that grow down from the sky. A crescent moon and a heavenly flower that is also the sun. Perhaps many things in this painting appear other than we know them on Earth because Klee painted this work with a "more detached [eye], closer to Creation ... in which I sense a kind of formula for animal, plant, Man, Earth, fire, water, air, and all the coursing forces at once," as he wrote in 1916.

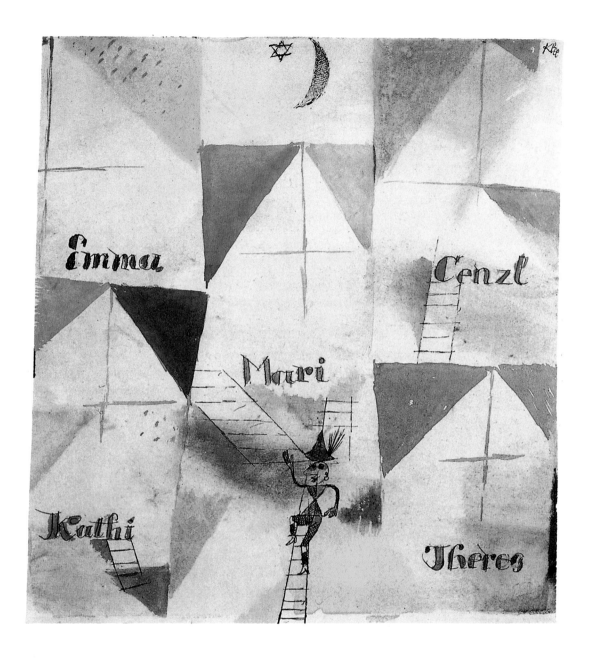

Der bayrische Don Giovanni (The Bavarian Don Giovanni), 1919

Towards the beginning of his studies in Munich, Klee started keeping a small "Leporello catalogue," with the names of lovers whom he had not "possessed." The figure with the Bavarian hat is none other than Klee, who here compares himself with Mozart's Don Giovanni, always on the lookout for new erotic adventures. The names of the coveted ladies are written directly over their windows, perhaps because, at night, his conquests are best reached through their windows. Klee apparently had liaisons with several of the women named here, but others he only dreamed of...

"Genesis as formal motion is the essence of a work.
In the beginning: the motif, activation of energy, spermata.
Works as the creation of form in the material sense: proto-female.
Works as form-determining spermata: proto-male.
My drawing belongs to the male realm." Paul Klee, 1914

in his works. But Matisse's main importance for Klee was that the Frenchman's paintings provided him with vital further inspiration for his own work with color. Soon (again in Munich and again thanks to "Uncle Luli," as Klee playfully called Moilliet), he was introduced to Kandinsky—who, it turned out, lived just one house down the street. Like Klee, Kandinsky had studied under Stuck, where the two had noticed each other but had not gotten to know each other any further. The trained attorney Kandinsky was thirteen years Klee's senior, had traveled widely, was well known, and had painted his first purely nonrepresentational work one year earlier. He had money, was involved with Rudolf Steiner (1861–1925) and theosophy, and his treatise *On the Spiritual in Art* was about to be published. Together with Alexej von Jawlensky (1864–1941), Marianne von Werefkin (1860–1938), Kubin, and several other artists, he was still a member of the New Artists' Association of Munich, which he had helped establish. The Klees met ever more frequently with their newly discovered neighbor and his then-partner Gabriele Münter (1877–1962). The foursome chatted, debated, shared their works, and came to value one another. Many years later, Klee described his relationship with Kandinsky with the words: "His stage of development was far beyond mine: I could have been his student, and in a sense I was, for certain of his words took the opportunity to shine a beneficial and affirmative light on my search."

At the time, the New Artists' Association of Munich was rocked by fierce disputes because the majority of its members refused to exhibit Kandinsky's *Composition V*, whereupon Kandinsky, Münter, and Franz Marc (1880–1916) left the group. Subsequently, Kandinsky and his friend Marc, who frequently included animals in his paintings, founded Der Blaue Reiter (The Blue Rider). Under this name, the two planned to publish an annual almanac with pictures, articles, and criticism, all written by artists. Initially, however, they organized an exhibition under the title *The Blue Rider*. The exhibition, held in December 1911 at Munich's Thannhauser Gallery, included their own works as well as works by Münter, Macke, the painting composer Arnold Schönberg

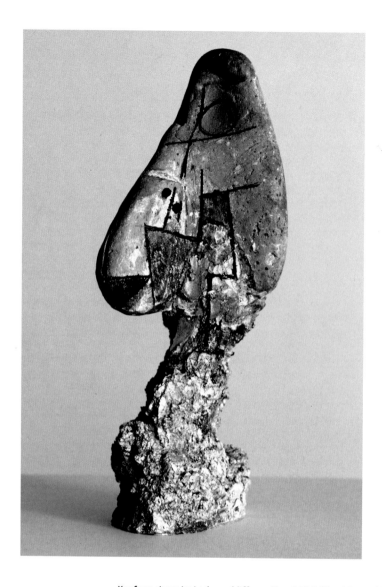

Kopf aus einem im Lech geschliffenen Ziegelstück (Head Formed from a Piece of Brick Smoothed by the River Lech), 1919

While he was studying in Munich, Klee had developed the desire to study sculpture. At the time, he wrote: "As far as sculpture is concerned, for now it remains the perfect art." Although he never studied sculpture, his love for this art form remained. Klee found the stone for this piece during his military service, writing to Lily in January 1918: "I climbed around in the riverbed … I found the most beautiful polished stones. I took some bricks with me. It is a small step towards a sculpture." Klee then created a plaster figurine and placed the painted brick on top, creating a fascinating combination.

Rotes Mädchen mit gelbem Topfhut (Red Girl with Yellow Bowl-shaped Hat), 1919

In the late 1920s, the progressive art educator Hans-Friedrich Geist (1901–1978) often analyzed paintings in his classes in the Thuringian town of Meuselwitz. Among other works, he also looked at this work by Klee. Some sample comments made by his seven- and eight-year-old pupils: "What a wonderful cap she's wearing." / "Look how it widens near the bottom." / "She's got her hands lying there on her heart." / "She's hurting." / "She's sick." / "No! No! Some people act like that…" / "She's thinking how swell she is." / "The sweet little mouth." / "The eyes can really slide back and forth." / Susan: "Y'know what? She's looking for a sweetheart." / "Susan!" / "Well, what's wrong with that?"

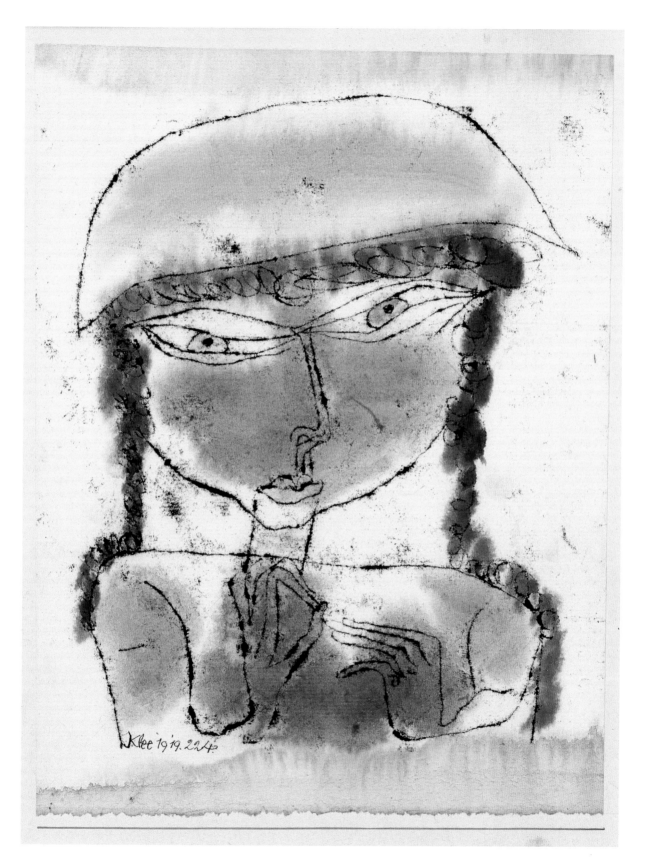

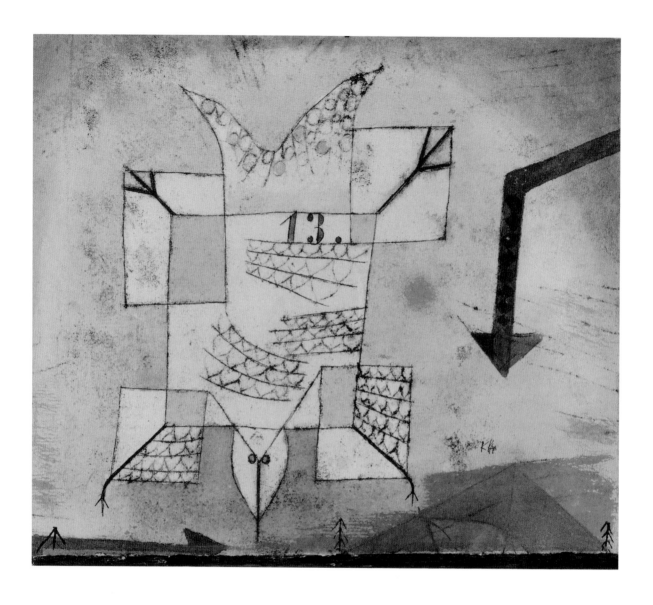

Abstürzender Vogel (Crashing Bird), 1919

During his wartime military service and on into the 1920s, Klee painted several crashing birds that look like heavenly doves of peace caught in a deadly nosedive. At the same time, these birds represent the airplane crashes that Klee saw during his time as book-keeper at the pilot school in Gersthofen. In February 1918, for instance, he wrote: "We had three dead here this week. One done in by a propeller, two bit the dust from the air. Yesterday, a fourth landed with a bang … on the roof … Running from all sides … A cinematic effect of the first rank." In this picture, the bent, earthward-pointing arrow symbolizes the power of the fateful downwards motion of the bird-plane.

(1874–1951), the Parisian painter Robert Delaunay (1885–1941), and the "customs officer" Henri Rousseau (1844–1910). Klee was not represented, but wrote a review for the Swiss magazine *Die Alpen*, for which he reported regularly on the latest news from Munich's world of art and culture. In his review, he commented carefully on the works on display, writing: "I am sure that there are perhaps three people among my readers who would have remained serious. It would thus be conceivable to participate in the mocking—it may even have been partially justified." At the same time, however, he emphasized that he believed in the Blue Rider. He mentioned only Kandinsky by name, whom he considered the "boldest" in the show. Soon thereafter, in February 1912, the Blue Rider's second and final exhibition, *Black & White*, was held at a gallery belonging to Munich bookseller and art dealer Hans Goltz. Exhibited paintings included works by members of the Dresden Expressionist group Die Brücke, Russian Constructivist Kazimir Malevich (1878–1935), Cubist draw-

nach der Zeichnung 19/75 (Versunkenheit) (After the Drawing 19/75 [Absorption]), 1919

This mask-like face gazes raptly into worlds that one does not need eyes to see. It is a self-portrait. As early as 1905, Klee had realized: "If I were to paint an entirely true self-portrait, one would see a strange shell. And sitting inside—this would have to be made clear to all—am I, like the kernel inside a nut. One might also call this work Allegory of Incrustation." When this work was published in 1919, Eckart von Sydow wrote: "The true psychograph, soul-scribe, soul-disenchanter, god-enchanter—here he is: Paul Klee."

ings and paintings by Georges Braque (1882–1963), works by André Derain (1880–1954) and the still little-known Pablo Picasso (1881–1973), and also seventeen pieces by Klee. Again, Klee wrote a short article for *Die Alpen*. With a view towards the announced publishing of the almanac, he briefly informed his readers of the Blue Rider's aims: "The novelty of that which is felt and created today shall be revealed in relation to earlier times and eras; folk art and children's art are promised, Gothic art here and art in the Orient, Africa." As before, Klee did not go into further detail regarding this unusual concentration of avant-garde contemporaries, and the only artists he listed by name were the participating Cubists. Just to be sure, he explained Cubism, for he felt that people in Munich "often still considered Cubists to be typical of Schwabing." Klee did not write of his fascination with the Cubists and Delaunay—though they were probably the reason why, accompanied by Lily, he spent several weeks in April 1912 sating his curiosity in Paris, where he visited museums and galleries in order to marvel at the paintings of Derain, Picasso, and Braque. He also visited Delaunay in his studio, saw his famous "window paintings," and learned about Delaunay's theory of color and light. Klee returned to Munich

Sumpflegende (Swamp Legend), 1919

Klee painted this picture in his studio in Schloss Suresnes. After the painting was confiscated by the Nazis, it was shown in the 1937 exhibition *Degenerate Art*—hung crookedly on a Dada-wall. Then it was sold just like that.

cheerful and full of new impressions. Although some of his works soon showed elements of Cubism, Klee—ever the individualist—proclaimed that he would continue to follow his own path. After his return from Paris, he wrote Kubin: "As much as I have, especially there, learned to appreciate the latest efforts, I do admit that I should explore less and spend more time working on the personal." Shortly after Klee's return, the first and only Blue Rider almanac was published. True to the Blue Rider's call for the equality of all art forms and eras and all areas of culture, the 230-page book contained essays on art and music, images of Bavarian and Russian folk art, Egyptian shadow-play figures, Chinese painting, French avant-garde artists, children's art—and an ink drawing by Klee.

Klee's encounter with Cubism would not leave him alone. His initial fascination now became clearer and more differentiated. Writing in *Die Alpen*, he mused that Cubism was not suited for the depiction of people and animals, since this would cause them to lose their "viability." He also condemned the "destruction" and "mistreatment" practiced by artists such as Picasso, for whom the painting's subject was completely unimportant. By contrast, Klee predicted big things for Delaunay, who was "creating the model for an independent painting that, without any motifs from nature, led a wholly abstract existence of form." No wonder, then, that Delaunay soon asked Klee if he might translate his essay "Light" into German.

In Klee's somewhat idiosyncratic translation, published in 1913 in the journal *Der Sturm*, Delaunay explained: "So long as art does not free itself of the

Der Blick des Ahriman (The Gaze of Ahriman), 1920

Cosmic worlds, a Star of David—and the "good-evil" gaze of Ahriman, the Devil.
In 1917 Klee remarked: "...the devilish will coalesce into concomitance with the heavenly, dualism will not be treated as such but in its complementary oneness."

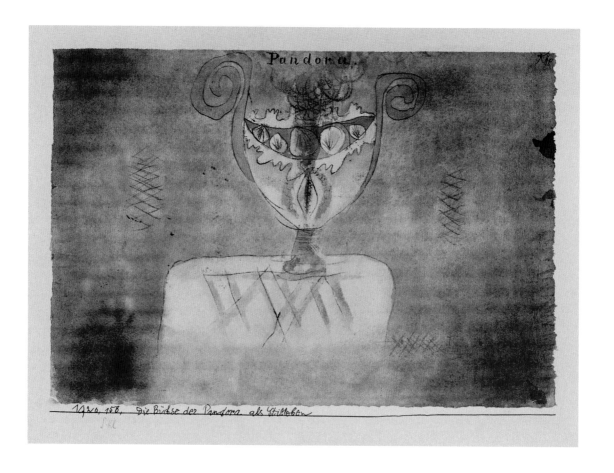

object, it remains descriptive ... And this applies even when it ... accentuates ... an object's light-appearance ... without raising light to an autonomous representational element. Nature is suffused by a rhythm that is impossible to constrain in its diversity. Art emulates it in order to attain clarity in this same loftiness, to elevate itself to visions of manifold harmony, a harmony of colors that separate and recombine in one stroke."

In Munich, Klee now regularly attended the fashionable salon held by Marianne von Werefkin, met her partner Alexej von Jawlensky, and became friends with Franz Marc, whose wife Maria soon started taking piano lessons from Lily.

Die Büchse der Pandora als Stilleben (Pandora's Box as Still Life), 1920

Does the dark misfortune flow from the Greek-looking container or from Pandora's mouth, reminiscent of an intimate part of the female body? Even as an adolescent, Klee saw "face and genitals ... as corresponding poles of the female sex." This work is an oil-transfer drawing, produced using a technique developed by Klee in order to create multiple reproductions of an image. The process involved placing a drawing on a blank sheet, then placing a piece of paper with black oil paint on the underside between the two. Using a sharp object, Klee then traced his drawing, thus transferring it onto the blank sheet. The transfer was then colored with watercolors.

Much had changed for Klee: he was a liberated hermit, enjoyed contact with and the friendship of other important avant-garde artists, and had been exhibited together with an international cohort of up-and-coming artists. And on top of it all, he was on the verge of making his breakthrough—his "discovery" of color.

In the autumn of 1912, some of Klee's works were shown at the important International Sonderbund Exhibition in Cologne, and several weeks later, also in Cologne, he presented fifty-nine works at the private exhibition hall of the Gereons Club. In the spring of 1913, the Thannhauser Gallery held the largest solo exhibition of Klee's works to date. This was followed in December by an

Biografische Skizze (Biographical Sketch) from the catalogue of the
Goltz Gallery, 1920

This confession became part of Klee's philosophy, had a significant influence on his image as an artist, and some of the lines were later engraved on his gravestone: "I cannot be grasped in the here and now, for I live just as much with the dead as with the unborn. Somewhat closer to the heart of Creation than usual. But not nearly close enough. Do I radiate warmth? Coldness? This is impossible to discuss beyond the blazing heat. I am far from being pious. I sometimes take a little delight in the misfortune of others, in the here and now. These are the nuances in this matter. Men of God are just not pious enough to see it. And men of letters take just a little offense."

"Is Paul Klee an Oriental? Certainly yes, for some of his paintings appear to have been woven in honor of the freshest visions from A Thousand and One Nights.*"* René Crevel, 1930

exhibition at the First German Autumn Salon organized by Herwarth Walden's Der Sturm gallery in Berlin, featuring an important selection of Expressionist artists. The influential gallery was soon exhibiting Klee regularly, and so became an important springboard in Klee's career.

THE FAIRY-TALE MADE FLESH

On April 5, 1914, Klee and his friend Moilliet boarded a train for Marseille, where Macke was waiting for them. From here, the three painters traveled by boat to Tunis—a journey on which Klee's long struggle with color would take a fundamental turn. The year before, Klee had suggested to Moilliet, who had visited Tunisia several times before, that they travel there together. Perhaps Moillet's tales of the country—as well as those of Kandinsky and Münter, who had explored Tunis several years earlier—had nurtured Klee's wanderlust. Perhaps Klee's desire to travel was also fueled by the old rumor that his grandfather had been from North Africa. At the outset, Moilliet showed little enthusiasm for the idea, instead advising Klee to travel alone. But Klee had a specific idea of the undertaking, which he envisioned as a kind of study trip, "where one inspires the other." Finally, Moilliet declared his willingness to come along, even promising to help sell some of Klee's works in order to finance their journey. In December, Klee asked Macke—whose paintings repeatedly depicted oriental motifs and who worked much more loosely with color than Klee—if he wanted to join their merry band. Macke agreed.

The boat carrying the three artists reached Tunis on April 7, 1914. Deeply moved after spying the first contours of the Arab town from the ship, he wrote in his diary: "A fairy-tale made flesh, yet still not within grasp—far away, quite far, and yet so clear … The sun has a dark power. The colorful clarity on shore is filled with promise. Macke senses it also. We both know that we will work well here."

That same evening, the three toured nighttime Tunis, guided by the Swiss doctor Ernst Jäggi, at whose house there were staying. Klee was deeply moved

by what he saw, describing the atmosphere as "matter and dream all at once, with my self a third participant." Dr. Jäggi owned another house by the sea, and the threesome soon moved in. From there, they went on excursions to Sidi Bou Said and the Bay of Carthage, armed with pencil, brush, sketch pad, and watercolors. Impressed by the town's Arabic architecture, Klee attempted to create a pictorial "synthesis of urban and pictorial architecture." Filled with excitement, he painted the local landscape suffused by the soft and clear light of the North African sky. As Klee broke free from representation and worked more naturally with color, his works began to exhibit an ever-stronger tendency towards abstraction.

On April 14, the little group traveled by train from Tunis to Kairouan, with a short study stop in Hammamet before continuing a day later. Kairouan, which lies at the edge of the desert, made an intense and moving impression on Klee as nothing ever had before. Writing in his diary on the first day in town, he noted: "At first a great delirium, which culminates at night with a

Kamel (in rhythm. Baumlandschaft) (Camel [in a Rhythmic Landscape of Trees]), 1920

This landscape with camel can be understood as a musical composition by Klee, who after all was also a musician. In it, the horizontal paths become musical staff lines and the trees are transformed into notes.

mariage Arabe. Nothing is singular, all is whole. And what a whole!! *A Thousand and One Nights*, an extract containing 99% reality. What an aroma, how permeating, how intoxicating all at once … Edification and intoxication. Fine-scented wood is burning." Klee concluded this description with the question "Home?" left unanswered.

The following day, April 16, 1914, was clear and quite warm. Klee painted first thing in the morning, took a short donkey-ride, saw an excited mob chasing a mouse, and bought something in the souks (markets), eventually ending up in a sidewalk café. On this day, Klee realized that he had found what he had long been looking for: in the peculiar atmosphere of the oriental landscape and amidst this culture that he and his friends were exploring, he had finally overcome his years of difficulty with color. It was not an overnight breakthrough, but the result of ceaseless searching, of Klee's constant engagement with color, inspired by his encounter with the paintings and theories of artists such as Cézanne, Matisse, Delaunay, and the members of the Blue Rider. Writing in his diary on this felicitous day in Kairouan, the thirty- two-year-old Klee wrote the later oft-quoted words: "It penetrates so deeply and so gently into me. I feel it and it gives me confidence in myself without effort. Color has got me. I don't have to pursue it. It will possess me always, I know it. That is the meaning of this happy hour: color and I are one. I am a painter." Deeply moved by this sensation, Klee returned to Tunis alone the next day. A few days later, he returned to Munich via Palermo and Berne, without his travel companions. Back in Munich, he immediately showed some of his Tunisian watercolors at the first exhibition of the New Munich Secession, of which he was a founding member.

IN A HORROR–FILLED WORLD

World War One erupted just three months after Klee's return from Tunisia. Macke fell in battle only a few weeks after the outbreak of war. In December 1914, Klee—who had initially defended the war—wrote the Bernese art collector Hermann Rupf: "What a misfortune this war is for us all, and especially for

me, who has so much to thank Paris for and who has nurtured intellectual friendships with artists there. How will we face one another afterwards! What shame for the destruction on both sides!" Like the art historian Wilhelm Worringer in his 1907 study *Abstraction and Empathy*, Klee established a connection between the events of war and abstract art. Writing in his diary, he observes: "The more horror-filled this world (as it is today), the more abstract is art, whereas a happy world brings forth art that is of this world."

Marc had gone to the Front right after the outbreak of war, but he and Klee continued to nurture the deep friendship that had developed between them, now in the form of written correspondence. Unlike Klee, Marc supported the war, seeing in it a necessary process that would purify Europe of nineteenth-century materialism and pave the way for a new, spiritually oriented era. When Marc's wife gave Klee several of Marc's essays promoting these ideas, Klee was

Rosa, 1920

Klee had painted primarily with watercolors before discovering oil paints in 1919.
Almost all his oil paintings from this period are small-format works, including *Rosa*,
which measures only 20.3 x 14.6 cm.

"I have long had this war inside me. And so it does not concern me at heart. I have had to fly in order to work my way out of my ruins. And I flew. I linger in that devastated world only in memories, as one occasionally does when reminiscing. I am thus 'abstract with memories'." Paul Klee, 1915

appalled. Bewildered, he carefully set out his opinions on the matter to his friend. The two met several more times when Marc was on leave from the Front. One time, Klee cooked; another time he played music for Marc. Nevertheless the two friends' different attitudes to the war had created an unspoken distance between the two. On March 4, 1916, Marc was struck by shrapnel; he died the same day.

The very next day, Klee—who was a German citizen because his father had never applied for Swiss citizenship—received his draft notice. As a conscript, he was first sent to the Bavarian town of Landshut. When Klee's family learned that he was about to be transferred to the Front, they did all they could in order to prevent the transfer. In August 1916—thanks to family connections and on the basis of a decree ordering that renowned artists no longer be sent to the Front—Klee was transferred to Schleissheim near Munich. Being a painter, he was given the task of painting airplane parts, improving camouflage, and using stencils to apply the Iron Cross and numbers and letters used for identification. In January 1917, Klee was transferred to Gersthofen near Augsburg, where he spent the rest of the war as a clerk for the pilot school's financial department. Here, he finally found more time to paint.

THE STAR OF THE AVANT-GARDE

In 1916, Klee managed to sell many more paintings than ever before. Partially responsible for this success was Herwarth Walden of the Sturm gallery in Berlin, who had constantly and consistently promoted Klee. Walden even sold postcards of Klee's works, including one with a portrait photo of Klee. Germany was now home to a new generation of middle-class collectors looking to overturn old concepts of values; in their view, the young avant-garde art reflected their modern, liberal worldview. In 1917, Klee sold more works than

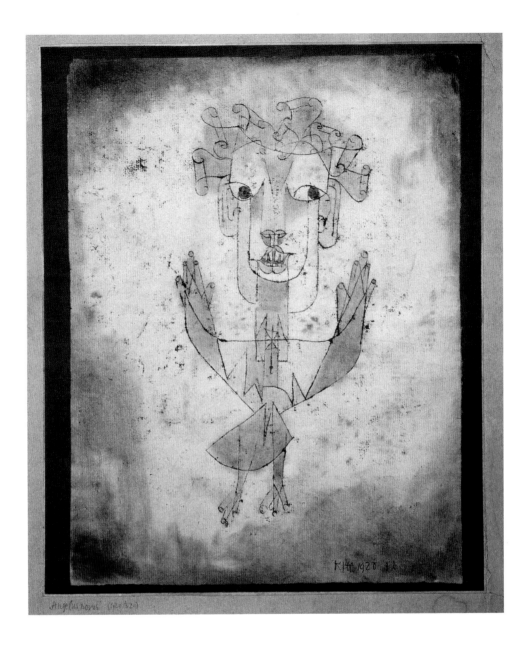

Angelus novus, 1920

The writer and philosopher of history Walter Benjamin (1892–1940) purchased this watercolor from Klee in 1921. Following Benjamin's suicide, the work passed into the possession of philosopher and sociologist Theodor W. Adorno (1903–1969), who left it to the philosopher of religion Gershom Scholem (1897–1982)—both men had been close friends of Benjamin's. Benjamin's interpretation of this work made it famous, an icon. In 1940, while fleeing the Nazis, he wrote: "This is how the angel of history must look. His face is turned towards the past ... he sees one single catastrophe, which keeps piling up wreckage upon wreckage ... He would like to ... make whole what has been smashed. But a storm is blowing from Paradise, which has got caught in his wings ... What we call progress—that is this storm."

ever before, partially because so many well-to-do individuals had earned good profits from their involvement in the wartime economy—profits that, in these uncertain times, they hoped to invest as quickly as possible.

Thanks to these successes, for the first time in his life Klee could fully provide for his family. Art critics, too, wrote ever more frequently in praise of Klee, turning him into a new star. The poet and art critic Theodor Däubler, for instance, wrote: "Ever since Marc's death, Paul Klee has been the most important painter of the Expressionist school"; and art historian and architect Adolf Behne identified Klee as the herald of "a forthcoming glorious century."

During this successful period, Klee stopped writing in his diary, which he had entrusted with his innermost thoughts and feeling, his experiences, his artistic development, and, on more than one occasion, transcriptions of letters. With the idea of publishing his diaries, he now reworked these personal notes, which no doubt had also been a form of support and justification during his less successful years.

UPHILL AGAINST THE WIND

After his Christmas leave in 1918, Klee did not return to his military service in Gersthofen. He was officially discharged in February 1919. Finally, he could devote himself fully to his art. He now rented a studio in the immediate vicinity of the English Garden—in enchanted little Schloss Suresnes, in which several other artists lived as well. Here, he returned to painting with oils for the first time since experimenting with them during his student days. In April, during the Munich Council Republic, Klee was asked (as secretary of the New Munich Secession) whether he would cooperate with the communist Action Committee of Revolutionary Artists. Despite the fact that, in 1906, he had taken a critical stance towards revolution and socialism, Klee said yes. In the event, no cooperation ever materialized—the Council Republic was overthrown a short time later.

Concerned that he may be persecuted for this partisan stance, Klee briefly fled to Switzerland, where he met the anti-bourgeois members of the Dada

"In an era of colossuses, he falls in love with a green leaf, a little star, the wing of a butterfly; and since the heavens and all eternity are reflected therein, he paints them as well." Hugo Ball on Paul Klee, 1917

movement, who had already shown his paintings two years earlier at Zurich's Dada gallery.

That summer, Klee was suddenly being mentioned as a possible successor to Adolf Hölzel (1853–1934), the director of the Stuttgart Academy. Although Hölzel's assistant and student representative Oskar Schlemmer (1888–1943), who would later work with Klee at the Bauhaus, wrote a glowing recommendation, the opinion of Klee held by the academy's veteran professors was highly critical. They declared that Klee possessed no teaching abilities, calling him "starry-eyed and insubstantial," "feminine," and "frivolous." In the end, some voices in the local press criticized Klee's early etchings as "perverse" and claimed that he was of Jewish descent, in the hopes of further defaming him through shrill anti-Semitic squawking. It was like battling uphill against the wind—Klee did not get the position.

In October 1919, Klee concluded a general agency contract with the Munich gallery owner Goltz, ensuring him a fixed regular income for a period of three years. In the spring of 1920, Goltz organized the first large-scale exhibition of Klee's works, featuring a total of 371 recent items. A short time later, the first monograph on Klee was published. It was written by Leopold Zahn, who depicted Klee as a painting philosopher and an artist detached from the world, and who compared him to an oriental wise man, a Taoist. Two more books about Klee followed soon thereafter, further increasing his popularity.

SEEING AND MAKING VISIBLE

Klee had repeatedly emphasized the importance of having one's own world-view, which he described as an indispensable quality for an artist. He had attained his own distinct view of the world step by step, and had formed it into a unified whole during the war years. Klee was convinced that the real world was merely an analogy for the spiritual world behind it—a world into which he had at least partial insight. This is the context in which we must understand Klee's famous words, written in 1920 for Kasimir Edschmid's anthology *Creative Confession*: "Art does not reproduce the visible; rather, it makes visible."

"The holiday has the good effect that I am full of art, a realization that is enhanced by the repeated playing of Bach. Never before have I experienced Bach with such intensity, never before have I felt so much at one with him. Such concentration, such solitary final enrichment!" Paul Klee, 1918

Klee later emphasized that this "making visible" had nothing to do with the artist's fantasy. Fantasy, he said, was an artist's dead end, and should not be confused with the exploration of spiritual worlds.

Lily, too—who was intensively involved in Rudolf Steiner's anthroposophy—may have considered spiritual worlds to be reality. She had sent some of Steiner's works to her husband in the field, and although Klee criticized these writings almost without exception, he still wrote Lily: "I admit that there are things written in there that reinforce what one has discovered on one's own."

In 1920, Klee described how he saw himself as an artist, and how he wanted to be seen: "I cannot be grasped in the here and now, for I live just as much with the dead as with the unborn. Somewhat closer to the heart of Creation than usual."

At the time, Klee was not alone in his metaphysical worldview, which would leave a fundamental mark on his postwar works. Especially as a result of the chaos and horror of the wartime and postwar years, many Expressionist artists saw a metaphysical view of the world as a viable alternative.

Some years later, Klee described the place or position in which he saw himself as an artist to his Bauhaus colleague Lothar Schreyer (1886–1966): "I say it often, but sometimes it is not taken seriously enough: worlds have opened to us and are opening to us that are also a part of nature, but not everyone peers into them ... I mean, for instance, the realm of the unborn and the dead, the realm of that what may come, would like to come, but need not come—an intermediate world. I call it an intermediate world, for I sense that it exists between the worlds that are externally perceivable by our senses, and I can absorb it internally in such a manner that I can project it outwards in the form of analogies. It is a place that children, madmen, and primitives are still or again capable of peering into. And what they see and shape is the most precious

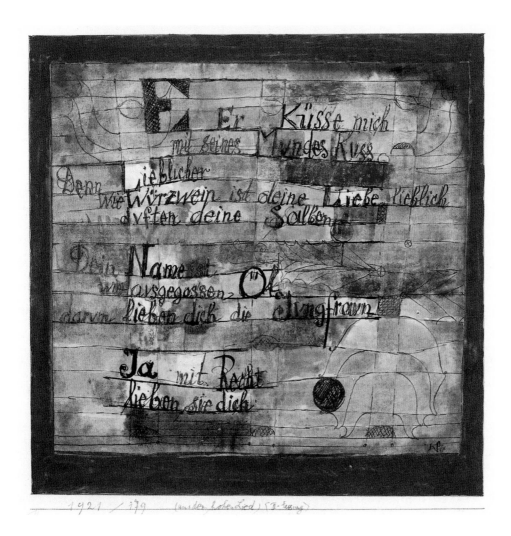

1921 / 179 (aus dem hohen Lied) (II. Fassung)

affirmation for me. For we all see the same thing, though from different sides. It is the same in whole and in detail, across the entire planet; not fantasy, but fact upon fact."

Nevertheless, Klee had no desire to be associated with esoteric science—and repeatedly made fun of Lily's enthusiasm for astrology.

(aus dem hohen Lied) ‹II. Fassung› ([From the Song of Songs], Version II), 1921

In 1916, Lily gave Klee a volume of Chinese poetry, in which the publisher claimed that Chinese characters were pure pictograms. Fascinated by the book, Klee began to produce paintings in which writing—in the form of poems and text—blended with pictorial elements. For this "script image," he made use of the first lines from Solomon's *Song of Songs* as translated by his father, Hans Klee.

BAUHAUS MASTER, DÜSSELDORF PROFESSOR

1921–1933

*"The work of art contains pathways for the viewer's eye, scanning about like a grazing animal ...
The visual work was created from motion, is itself movement fixed in place, and is received by motion (the eye muscles)."* Paul Klee, 1920

A TELEGRAM FROM THE LABORATORY OF MODERNISM

In the autumn of 1920, Klee and Lily visited their friends Jawlensky and Werefkin in Ascona in the Swiss canton of Ticino. The couple had settled here a short time earlier, having left Germany at the outbreak of World War One. In October, while on this visit, the forty-one-year-old Klee received the following telegram from the recently founded Bauhaus in Weimar: "Dear Honorable Paul Klee: We hereby unanimously ask you to join us as master in Weimar." This felicitous message was signed by, among others, the founder of the Bauhaus, architect Walter Gropius (1883–1969), and the following Bauhaus masters: painters Lyonel Feininger (1871–1956) and Georg Muche (1895–1987), sculptor and printmaker Gerhard Marcks (1889–1981), and painter and educator Johannes Itten (1888–1967).

Klee, who had been dreaming of a teaching position for some time already, traveled to Weimar and gladly accepted the offer. After their meeting, Klee gave Gropius the enigmatic name "Silver Prince." For the time being, it remained unclear what Klee—whose teaching experience was limited to giving classes at Munich's Debschitz School—would be teaching at the Bauhaus. Perhaps Itten, who like Klee hailed from Switzerland and had studied music with Klee's father in Berne several years before, had suggested inviting Klee to the Bauhaus. Klee's recent popularity was surely a deciding factor for Bauhaus director Gropius. When still planning the new school, he had stated: "We must not start out with mediocrity, but are duty-bound to ... attract strong, world-renowned individuals ... even if we do not know them intimately."

Gropius, who had fought in the war, wanted the Bauhaus to be a modern, anti-academic artistic training facility for the difficult, directionless postwar era.

Paula Stockmar: Paul Klee on a portrait postcard from the Sturm gallery, 1916

Klee's postwar popularity was partially thanks to Walden and his Berlin Der Sturm gallery, which began selling this postcard depicting the thirty-seven-year-old Klee in 1916.

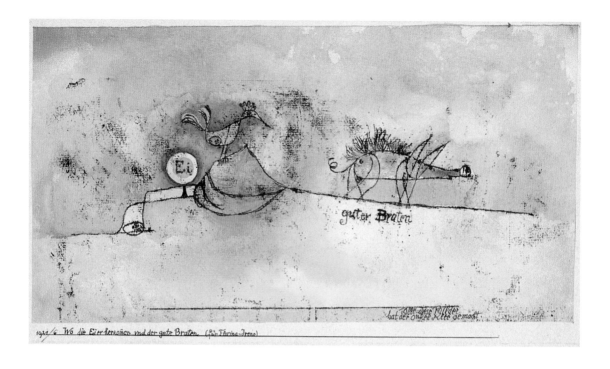

Since he believed that art could not be taught, his unconventional approach was based primarily on providing technical training in the Bauhaus's various workshops, which would be characterized by a "freedom of individuality," "priority of creativity," and "avoidance of rigidity." Another distinctive characteristic was the fact that each workshop was led by two masters: a "work master" and a "form master." The "work master" was a trained artisan who taught technical skills; the "form master" was an artist who guided the students by working artistically with form.

In his Bauhaus manifesto, issued on the occasion of the school's opening in April 1919, Gropius wrote: "There is no fundamental difference between the artist and the artisan. The artist is a magnification of the artisan ... but a technical foundation is indispensable for every artist. This is the fount of artistic creation." With this manifesto, Gropius invoked a new architecture that would involve cooperation between artisans and artists in the spirit of medieval craft lodges: "The final aim of all artistic activity is the building!" At the same time, Gropius wanted the Bauhaus to be a living as well as working community of masters and students. For this reason, seasonal and costume parties, collective visits to concerts and lectures, and group outings were a fixed part of the

Wo die Eier herkommen und der gute Braten (für Florina-Irene)
(Where the Eggs and the Good Roast Come from [for Florina-Irene]), 1921

Klee gave this work to his goddaughter Florina-Irene Galston at her baptism.
In the bottom right corner, he wrote: "All the pictures were made by your Uncle Klee."

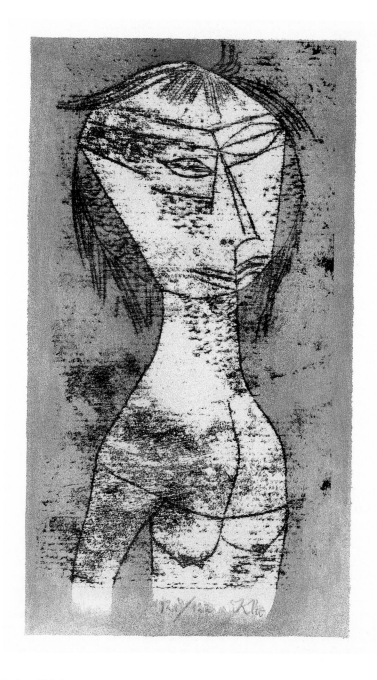

Die Heilige vom innern Licht (The Saint of the Inner Light), 1921

The *Exhibition Guide* to the National Socialists' propaganda exhibition *Degenerate Art* in 1937 included this work by Klee, right next to a work by a schizophrenic. The page carried the title *Two 'Saints'!!* and informed the reader: "It is highly revealing that this *St. Magdalen with Child* looks more human than the concoction by Paul Klee, which actually wanted to be taken seriously." Even earlier, while Klee was at the Bauhaus, several psychiatrists had described Klee and his art as sick. In 1922, for instance, a doctoral candidate in medicine who had visited Klee diagnosed him—on the basis of his art and the "psychic dysfunctions in his social behavior," combined with egocentrism and autism—as having a "schizophrenic disposition."

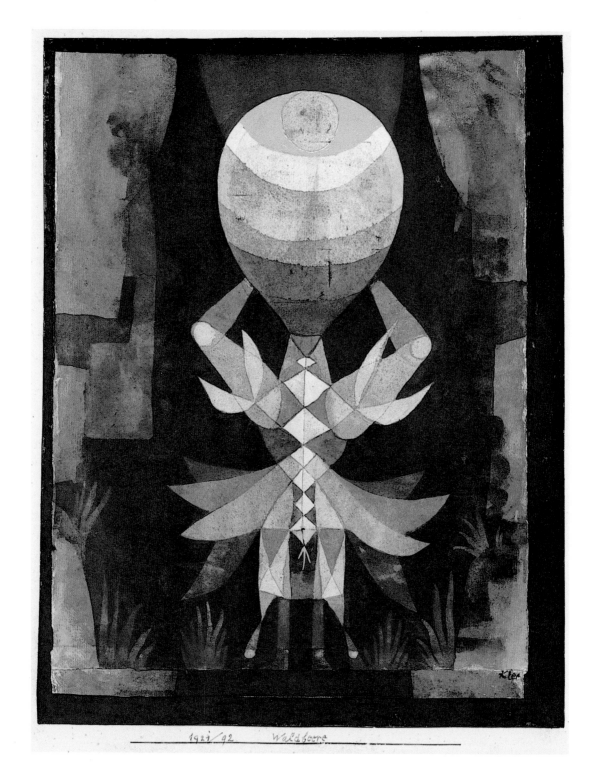

1921/92 Waldbeere

Waldbeere (Woodland Berry), 1921

What a mysterious, glowing creature with a body and a berry–head,
composed of various shades of brightness!

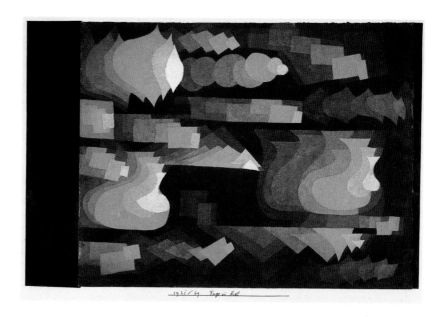

Bauhaus program. This concept took the ideas that Gropius had discussed with the social-revolutionary Expressionist artists of the Workers' Council for Art and combined them with the esoteric "life reform" and progressive education movements of the time.

Klee was no doubt already familiar with Gropius's ideas. Shortly after the collapse of the short-lived Munich Council Republic, he had dreamed of a new and modern form of artistic education. Perhaps Klee had the recently published Bauhaus manifesto fresh in his mind when he wrote his friend Kubin in May 1919: "As the ideal laboratory, we would not be cultivating new inventors, who in the end would not be inventors but only inventor-masks … we would be able to channel the outcomes of our inventive activities towards the people. This new art could then make its way into the trades and bring forth a great flowering. For there would be no more academies, but only art schools for artisans."

Fuge in Rot (Fugue in Red), 1921

Klee's art is rich in musical references. And so his motifs include opera singers, musicians, or even mechanical twittering birds. Landscapes with trees are suddenly transformed into musical notes, and in his theoretical writings Klee compared composing a picture to composing music. The title of this picture tells us that we are dealing with a musical composition rendered with the tools of paintings. The simultaneous superimposition and permeation of various colored fields is reminiscent of polyphonic music, and the colorful gradations of brightness lend the picture an additional sense of motion.

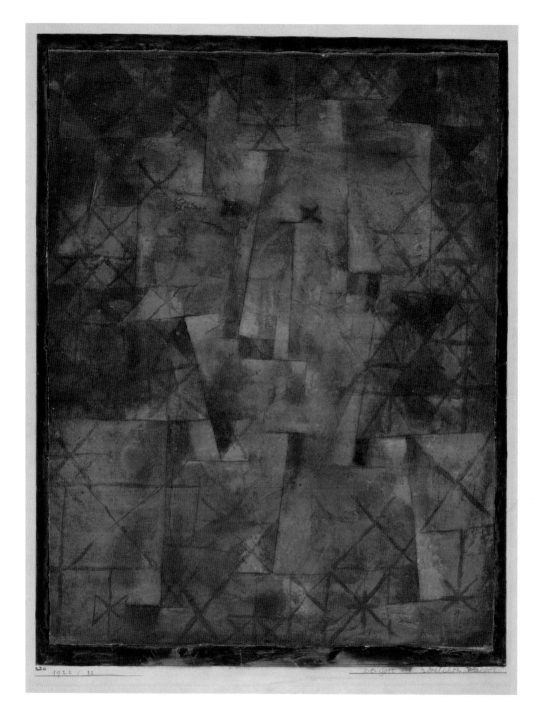

Der Gott des nördlichen Waldes (God of the Northern Forest), 1922

On more than one occasion, Klee altered or painted over works that he had begun years before, and this one is no exception. Klee began this painting in 1920. Later, he apparently turned it upside-down and inserted an X-shaped symbol. Then he painted over the edges (but not the middle) and used just a few strokes to hint at a face through which we can discern the painting's older layers. With this form of 1922, Klee considered the painting to be complete.

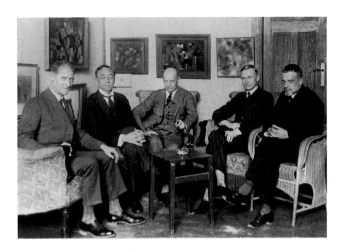

KLEE THE BAUHAUS MASTER

In January 1921, Klee traveled to Weimar in order to begin teaching at the Bauhaus. At Weimar's train station he was met by Schlemmer, who immediately discovered that Klee—although he had often been described as detached from the world—was thoroughly interested in everyday issues: one of Klee's first questions for Schlemmer regarded the local price of meat. Klee began working as form master in the bookbinding workshop and, until the autumn, commuted between Munich and Weimar every two weeks. At the outset, Klee had hoped to introduce some "get-up-and-go" to the artisan workshop, for (as he wrote Lily) he had "sensed nothing ... of the new spirit." In fact, Otto Dorfner (1885–1955), the bookbinding shop's work master, had a clear and resolute idea of how the workshop should be taught, meaning that no real cooperation with the artist Klee ever materialized.

These early days at the Bauhaus were overshadowed by a death in the family: it was March, and Klee had briefly fallen asleep in his wicker chair during a short break in his new Weimar studio. As he recalled later, during this nap he suddenly saw his mother coming towards him, only for her to seemingly pass through him and then wave. Several hours later, he received a telegram with the news that his mother—who had been seriously ill for many years and had been fully paralyzed from age of forty-three onwards—had passed away.

In October, Lily and Felix joined Klee in Weimar. The family, including their cat, moved into an apartment high above the park on the Ilm River. Nearby, the Bauhaus students soon planted a vegetable garden for their vegetarian school cafeteria, began planning a Bauhaus housing development, and eventually built the first—hotly debated—flat-roofed "experimental house." Right

Bauhaus masters in Klee's Weimar studio, 1925

From left to right: Feininger, Kandinsky, Schlemmer, Muche, Klee.

after the Klees moved into their apartment at Am Horn 53, fourteen-year-old Felix became one of the youngest Bauhaus students. After attending Itten's preliminary course, he worked as an apprentice in the school's carpentry workshop, graduating in 1925 with a journeyman's certificate.

The Bauhaus soon abandoned the bookbinding shop, and Klee was initially made the form master in the metal workshop. It was not unusual during the early Bauhaus years for a form master to change workshops, and so from 1922 to 1925 Klee took over the task of form master in the glass-painting workshop, which had only a few students. In addition, he gave several drawing courses and also led the evening life-drawing session. Klee developed a special relationship with the female-dominated weaving workshop, for which he gave theoretical courses both in Weimar and later in Dessau. His influence is clearly visible in many a Bauhaus carpet, but otherwise we know almost nothing about Klee's actual activities within the workshops. On the other

Postcard for the lantern festival at the Bauhaus, 1922

Every year on the occasion of Walter Gropius's birthday on May 18, the members of the Bauhaus organized a large lantern festival. In 1922, Klee designed the festival's invitation. In fact, celebrations were a frequent occurrence at the Bauhaus. At the weekly Bauhaus dance parties with music by the Bauhaus's in-house band, Klee—who did not like to dance—usually remained an observer. But if required, even Klee would dress up for the wild and colorful festivities. During his time in Weimar, he dressed up as "Song of the Blue Tree," and for the party held by Kandinsky and his wife in Dessau to celebrate their acquisition of German citizenship, Klee appeared as an oriental sheikh.

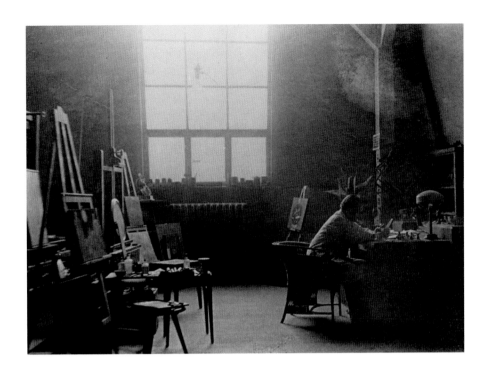

hand, we know quite a bit about his work as a theoretician and teacher at the Bauhaus.

KLEE THE EDUCATOR

During his early Bauhaus days, Klee had sat in on Itten's preliminary course. This course, introduced by Itten himself, was mandatory for every new Bauhaus student before he or she was allowed to attend instruction in one of the work-shops.

The preliminary course trained the students' senses, introduced them to the characteristics of various materials, and freed their minds from the old style-based way of thinking. A short time after attending the preliminary course, Klee organized a supplementary course in "composition practice," which was

Paul Klee in his Bauhaus studio in Weimar, 1925

Klee did more than draw and paint in his "Magic Kitchen"—it was also where he passionately mixed his colors, built color pots and painting utensils, or cut out picture mats and frequently built the frames himself. In addition to sculpture, masks, and objects by Klee, the studio also housed numerous mysterious objects, as described by Lyonel Feininger: "Butterfly wings, seashells, colorful stones, strangely shaped roots, leaves, moss, or whatever else he found on his solitary walks and brought home with him."

Group portrait of hand puppets, 1916–1925

All his life, Klee was a great fan of puppet theater. In 1916, he began creating a series of distinctive hand puppets for his son Felix, which by 1925 had grown into a large family of around fifty members. Felix naturally gave each puppet its own name. The puppets included, among others, a "Ghost of the Power Outlet" (1st row, 1st from right), a "Buddhist Monk" (1st row, 2nd from right), and an "Electric Spook" (2nd row, 4th from left). One figure (2nd row, 2nd from left) was a self-portrait. In addition, Klee built a puppet stage for these figures, complete with a backdrop he painted himself.

Felix regularly enchanted the Bauhaus community with his puppet performance. Once, as he was holding one of his many performances at the Dessau Bauhaus—which often satirized life at the Bauhaus—one of the audience members was little Livia Meyer, the daughter of the Bauhaus's second, communist, director. Many years later, after the death of his first wife (the singer Efrossina Greschowa), Livia would become Felix's second wife. After his time at the Bauhaus, Felix went on to become a stage director, switching from puppet theater to the metropolitan theater.

Senecio (Baldgreis), 1922

Klee created this picture at a time when discussion at the Bauhaus revolved around the relationship of the circle, triangle, and square to the primary colors. One eyebrow like a mountain, the other like a crescent moon, and eyes like a lemniscate (similar to a horizontal figure 8), a symbol of infinity. The head glows like yellow groundsel (senecio), combining the natural, cosmic, and mathematic.

"I am doing well; that means: I am working." Paul Klee, 1921

soon so popular that several students had to be turned away. In this course, Klee examined and analyzed works by students as well as his own works and those by other artists. He also included these analyses in his later courses, always with the aim of identifying the complex stages and paths of the creative process that an artist passed through while working: "This manner of viewing [the work] shall keep us from seeing it as something rigid and unchangeably fixed." The course was a huge success with the colorful folk at the Bauhaus, and in the 1921–1922 school year Klee subsequently offered the course "Elemental Design Theory," in which he expounded on his extensive theories. Klee recorded all his lectures and exercises from this course in a small volume that he gave the title *Essays on Visual Form*. These notes first appeared in distilled form in 1925 as the *Pedagogical Sketchbook*, published as part of the school's "Bauhaus Books" series. Klee wrote down other lectures, exercises, and thoughts on teaching at the Bauhaus on more than 3,800 loose sheets of paper—today known as his Pedagogical Estate.

Klee had been improvising during his first course, but everything for "Elemental Design Theory" was thoroughly planned, thought out, and constantly revised and redefined. For Klee, this included not only analyzing his artistic activities, but also developing a theoretical framework. In a letter to Lily, he described his approach to this task: "Here in the studio, I paint half a dozen paintings and draw and think about my course—all together. For it must work together, or it will not work at all." Klee's teaching activities also had a lasting effect on his own artistic endeavors. As a result, many of the works he created while at the Bauhaus specifically dealt with the topics he addressed in class—for instance, issues of space, movement, and color.

In his important Bauhaus course "Visual Form," Klee's lectures and practical exercises introduced students to the basic elements of form involved in visual design and composition. Klee opened his course with the phenomenon of the point, then moved on to the line. In his class from November 14, 1921, he explained: "From point to line. A point is not dimensionless, but is an infinitely small element of area that is an agent of zero movement; it is at rest. Movement is a precondition for change. There exist unmoved things. As a primal element, the point is cosmic. Things on Earth are in inhibited in their

Der Seiltänzer (The Tightrope Walker), 1923

Here, the viewer looks up at a tightrope walker walking in a world between heaven and earth. The acrobat manages his feat only thanks to the horizontal pole with which he maintains his balance. His birdlike head shows that such heights are the realm of forces that are essentially reserved for birds. In one of his first lectures at the Weimar Bauhaus, Klee explained that the tightrope walker was the "ultimate … realization of the symbolic balance of forces." All his life, Klee was fascinated by the world of the circus, which again and again made its way into his work.

Die Zwitscher-Maschine (The Twittering Machine), 1922

If there is no human hand to turn the crank, these eerie, wiry creatures remain inanimate. In action, they apparently give off quite different twittering noises—or so at least the different "tongues" would seem to indicate. This machine hopes to simulate nature through technology. But can it succeed? What will really happen once the large crank is turned? Will the artificial beings be even capable of maintaining their balance, or will they quickly collapse as they become bent and tangled?

Zwei Kräfte (Two Forces), 1922

The arrow is an ambiguous symbol that Klee discussed in detail in his Bauhaus courses. Among other things, it can illustrate motion, act as a signpost, or symbolize the waxing and waning of forces.

movement; they require impetus. The primal movement, the agent, is a point that is set into motion (genesis of form). A line is created. The true, active line, filled with tension, is the most real for it is the most active." He then moved on to area and space. Over the rest of the course, Klee explored questions of movement in a picture, the visual depiction of music, and balance. The course also focused on tonality; Klee concentrated exclusively on this topic in the 1922–1923 winter semester. In his lecture on color, he discussed not only the views of Johann Wolfgang von Goethe, Philipp Otto Runge, and Eugène Delacroix, but also the latest theories, those of Kandinsky. Klee's former neighbor from Schwabing, now separated from Münter, had joined the Bauhaus as a master in the summer of 1922, and now lived in Weimar with his wife, Nina. Although in daily Bauhaus life Klee was always open to jokes, in his lectures he was serious and introverted, illustrating the topics at hand by making drawings on the board. Still, his courses were never limited to dull theory, and Klee knew how to liven them up through experiential practical exercises. For instance, he and his students built equilibrium models from building blocks in order to demonstrate our sense of balance. However, Klee

Nord See Insel (North Sea Island), 1923

In 1923, Klee spent his summer vacation on the North Sea island of Baltrum,
where he made this painting.

did not want his demonstrations to be interpreted as an absolute recipe for artistic production—this would have gone against both the principles of the Bauhaus and his own way of thinking. His primary goal was to convey the fundamentals of form and structure in order to provide the students with the rudimentary "foundations" for their own visual work, "so that it may flourish in them."

In the end, Klee came to the realization that "a work is not the law; it is above the law." He now enumerated those elements that were indispensable for the living creation of art, but which could not be taught. Among other things, this included intuition. In this regard, he wrote for the Bauhaus magazine in 1928 (in lowercase, which the members of the Bauhaus consistently used at that time): "one can do considerable things without it, but not everything. one can do many things, all kinds of things, substantial things, and for a long time, but not everything."

Another important factor was what he called worldview. Right at the beginning of *Visual Form* in the early 1920s, he had written: "We are creators,

Wandbild aus dem Tempel der Sehnsucht ↖dorthin↗ (Mural from the temple of desire ↖thither↗), 1922

Paul Klee, entry in Otto Ralfs's guest book, 1923

When Klee saw his 1922 watercolor (above) at the house of the collector Otto Ralfs a year later, he wrote a short text (opposite) in his guest book, explaining the picture's compositional elements and the meaning he associated with them:
"We stand upright and rooted in the earth / currents move us lightly back and forth / free is only our yearning towards: / moons and suns"

working practitioners, and will thus naturally find ourselves primarily in the realm of form. Without forgetting that the formal beginning or, put more simply, the first stroke is preceded by an entire prehistory—not only the yearning and desire of man to express himself, not only the outer imperative to do so, but also a general condition within mankind, whose direction we call worldview and which pushes this way and that with an inner imperative to manifest itself."

THE PLAY OF FORCES

From the very beginning, the Bauhaus had been criticized by nationalist circles and conservative artists and artisans. But even at the Bauhaus, the artists were constantly arguing about and debating the school's direction and focus. While Gropius had originally attached great importance to artisanship, he soon saw prospects for the future in cooperating with industry. In 1923, this philosophy would be expressed by the new motto of "art and technology: a new unity," and would leave a defining imprint on the Bauhaus. From now on, the aim would be to develop prototypes and designs that could be mass-produced by industry. This approach was hotly debated by the members of the Bauhaus and was one of the reasons for Itten's departure in the spring of 1923. In December 1921,

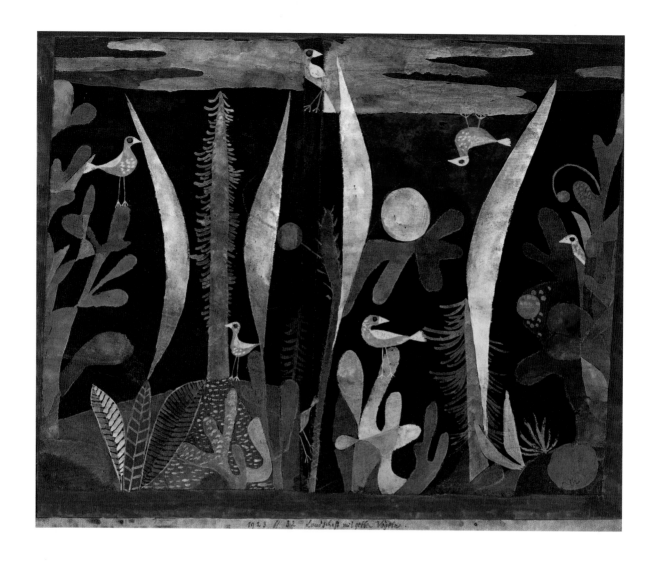

Landschaft mit gelben Vögeln (Landscape with Yellow Birds), 1923

Klee painted not only with brush, quill, and paints, but occasionally also with knife and scissors, true to the credo of "what doesn't suit me, I cut away with scissors," as he wrote in his diary in 1911. In this way, he cut many of his paintings into multiple pieces, turning each into an independent work of art. Sometimes, he cut up a painting and reassembled the pieces (as in this case) into an entirely new work. The reddish-brown tree was originally at the painting's center—until Klee cut it in half and assembled the two pieces with the two halves of the tree at the edges. He then mounted the pieces on a board, leaving a narrow strip between the two halves onto which he painted two additional yellow birds.

Eros, 1923

While at the Bauhaus, Klee noted: "The triangle came into being when a point entered into a relation of tension with a line and, following the bidding of its Eros, consummated this relationship." This process of creation is here depicted through arrows and the red triangle.

while the debates raged regarding the future direction of the "laboratory of modernity," Klee wrote: "I welcome the interaction of such diverse forces at our Bauhaus. I also approve of the mutual conflict of these forces if its impact is manifested in achievements ... There is no right or wrong for the whole thing, but it lives and grows through the play of forces; after all, in the grand view, good and evil interact productively."

Klee's quiet and levelheaded demeanor helped calm many a heated debate among the school's masters, and so he soon became a moral authority at the Bauhaus. Sometimes he managed to cool excited emotions with his unique brand of humor. Once, when things again got hot and heavy at the council of masters, Klee read the advertising on his cigarette package out loud—giving everyone a hearty laugh.

Die Stachel-Schlinge mit den Maeusen (The Barbed Snare with the Mice), 1923

An empathetic cat lover such as Klee naturally thought not only of his favorite animal, but also of mice!

After Itten's departure, the Bauhaus was joined by the Hungarian Constructivist László Moholy-Nagy (1895–1946), who took over Itten's preliminary course and taught the metal workshop. Moholy-Nagy was enthusiastic about the new media of photography and film and was critical of traditional painting. This was too much for Feininger, who distanced himself from this tendency within the Bauhaus, even labeling it a "symptom of our times." For the time being, Klee said nothing about these developments; at a lecture given in Jena in 1924, which included a brief and comprehensible description of the foundations of his work and teachings, he spoke in favor of a Bauhaus focused on collective work. He concluded by saying: "Sometimes I dream of a work of great breadth, spanning the entire realm of element, object, meaning, and style ... This will surely remain a dream, but it is good, now and then, to imagine this

Sternverbundene (Connected to the Stars), 1923

Klee painted this work after a lantern festival at the Bauhaus.

today still vague possibility ... We still have to search. We have found parts, but not the whole. We are still lacking this final force, for we are not borne by a people. But we are looking for a people, we have begun with this, over there at the Bauhaus. We have begun with a community to which we have sacrificed all that we had. We cannot do any more."

THE BLUE FOUR AND THEIR NURSEMAID

In 1923, Berlin's National Gallery presented a large exhibition of Klee's works in the Crown Prince's Palace, and the beginning of the next year saw his first solo exhibition in the United States. This exhibition was shown at the New York gallery of the Société Anonyme, which was headed by, among others, the French artist Marcel Duchamp (1887–1968). Klee had taken his first step to America. At the same time, an energetic woman with raven-black hair felt that Germany's avant-garde artists could be made even better known in America. The woman obsessed by this idea was the painter Emmy Scheyer (1889–1945), whom her good friend Jawlensky called by the Russian word for a jackdaw— "galka."

Reverse side of **Botanisches Theater (Botanical Theater)**, *c.* 1923

Sometimes Klee was not happy with what he had created, in which case he painted over the existing picture or simply turned the canvas around and painted a new picture. The reverse of *Botanical Theater* (opposite) shows such a discarded work.

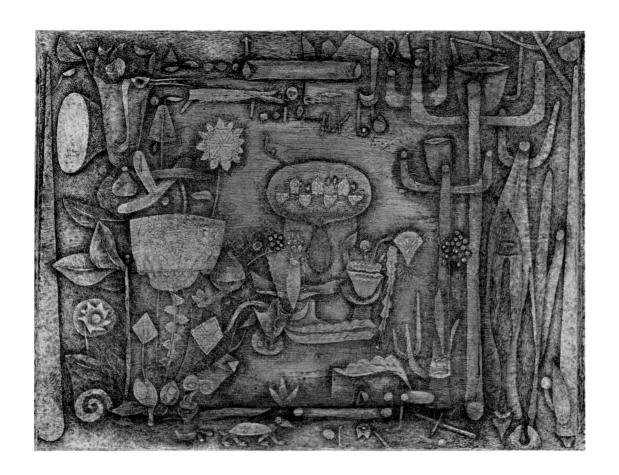

Botanisches Theater (Botanical Theater), 1924/1934

Roots, blossoms, seeds and plants, animals and strange metamorphosing creatures populate this stage, on which Klee uses hatched lines to highlight the constant process of creation and death in nature. For Klee, Creation was not a completed process, but remained open, unfinished. In 1914, he wrote: "Genesis as formal motion is the essence of a work." As with many of his other works, this picture was subjected to a multi-layered process of creation and transformation: various periods of work were covered over or recombined by scratching away the top layers. After painting this picture, Klee was not totally satisfied with the result and set it aside. In 1934, he reworked several areas. Then it was complete.

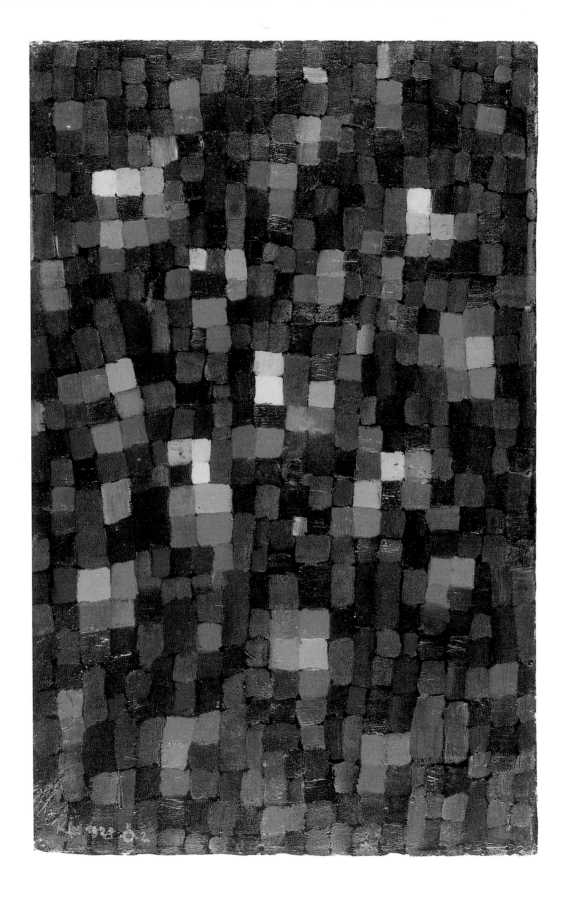

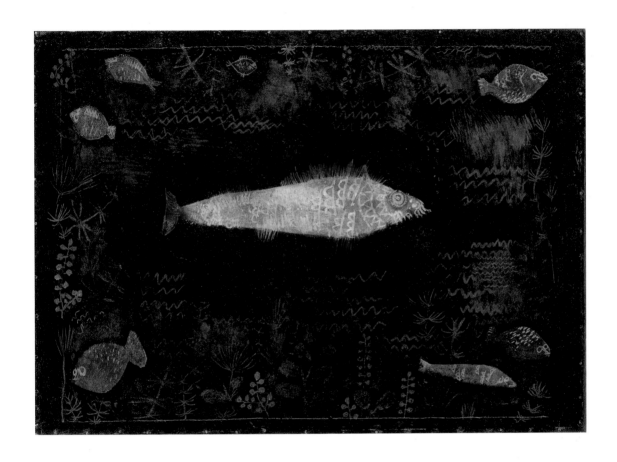

wie ein Glasfenster (Like a Window Pane), 1924

The colored geometric surfaces of Klee's Tunisian pictures were a kind of precursor to his "square paintings," in which he organized various shades of color, including black, white, and shades of brightness, in a rhythmic–musical checkerboard pattern.

der Goldfisch (The Goldfish), 1925

This dark underwater world contains aquatic plants and a few jolly fish—and, in the midst of it all, a motionless goldfish with a mysterious and fascinating radiance that lends it a mystical aura.

Scheyer talked with Jawlensky, forged her plans, and eventually approached Jawlensky, Feininger, Kandinsky, and Klee with her idea of presenting them in the New World as "The Blue Four," in reference to the Blue Rider. The four painters fluctuated between anxiety and excitement. Although the possibility of success was enticing, they were concerned that people should not get the impression that their art aspired towards a common style. Klee viewed this new undertaking with a sense of humor, describing Scheyer as a "nursemaid" carefully attending to her charges.

Indeed, Scheyer managed an exceptional advertising campaign for the four painters, showing slides, giving lectures, and organizing exhibitions in many cities throughout the USA. She inspired Marlene Dietrich—who wanted to borrow some of Klee's works in Hollywood—as well as the young musician and composer John Cage and the film director Josef von Sternberg, who even sponsored an exhibition of the "Blue Kings," as Scheyer jokingly called her four painters. In 1931, she convinced the Mexican artist Diego Rivera (who had purchased several of Klee's paintings for his wife, the painter Frida Kahlo) to contribute a catalogue text for one of the many exhibitions she organized. Although sales of paintings remained limited, until her death in 1945 Scheyer never tired of promoting her "Blue Four."

Pages from a catalogue for a Klee exhibition in Paris (Galerie Vavin-Raspail), 1925

Many Surrealist artists were fascinated by Klee; in 1928, the French critic René Crevel even saw him as the "true creator of Surrealism"—an assertion Klee rejected.

Clipping from the **San Francisco Examiner**, November 1, 1925

The Blue Four and their "nursemaid" Scheyer (left), with her "Blue Kings" Feininger, Kandinsky, Klee, and Jawlensky.

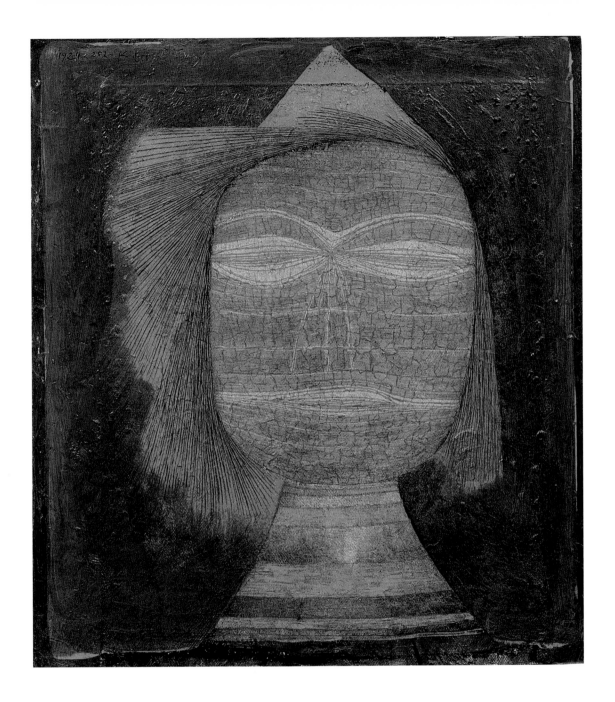

Schauspieler=Maske (Actor=Mask), 1924

Klee painted this mask-like face using the complementary colors of red and green, thus lending it an extreme sense of tension. Klee associated the color green with coolness, and red (as well as yellow) with heat. It is in the nature of actors to slip into contrasting characters—as embodied by the mask with its opposing traits.

Schema Ich–Du–Erde–Welt (I–You–Earth–World Diagram), *c.* 1924

This diagram resembling a face was used to illustrate Klee's 1923 treatise *Ways of Studying Nature*. Here, Klee illustrates that the modern artist "I" (left eye) can capture the object "you" (right eye) not only in a purely "optical–physical" manner (arrow in the middle), but also through the artist and the object existing in a mutual "resonance relationship." In addition, this makes it possible to capture the object as "...a synthesis of external seeing and internal looking" by applying two metaphysical approaches attainable only through "intense study." One way leads from below, via a "shared earthly rootedness" that mediates static forms; the second way, the path of "cosmic commonality," leads from above and mediates the dynamic.

"For the artist, dialogue with nature remains a conditio sine qua non. *The artist is Man, himself nature, and a piece of nature within nature's realm."* Paul Klee, 1923

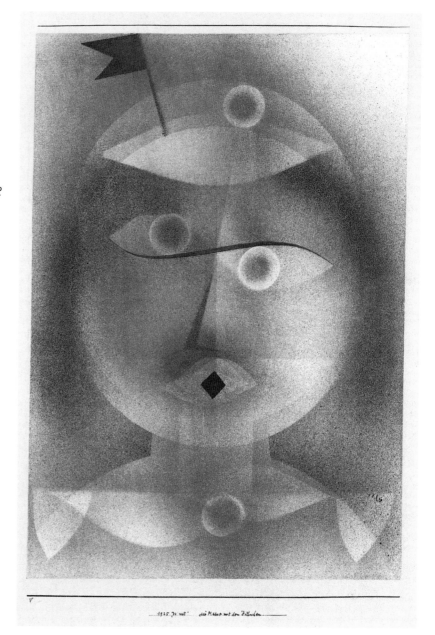

die Maske mit den Fähnchen (The Mask with the Little Flag), 1925

In 1924, Klee began creating pictures using a spray technique in which he placed paper cutouts on a sheet and then sprayed the sheet with a spray gun, thus leaving a negative imprint of the shapes. No sooner had Klee tried out this technique than many other Bauhaus artists began to experiment with it as well.

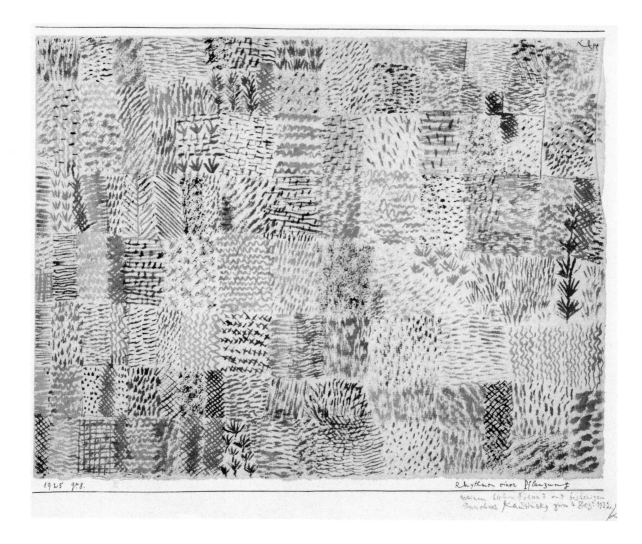

Rhythmen einer Pflanzung (Rhythms of a Plantation), 1925

The Dessau Bauhaus had already been shut down and Klee was teaching in Düsseldorf when he presented this picture to Kandinsky on his sixty-sixth birthday, with the dedication "To my dear friend and current neighbor Kandinsky, on December 4, 1932."

die Pflanze und ihr Feind (The Plant and its Enemy), 1926

Klee's picture titles can be many things: they might explain abstract works with quite objective concepts; they can be peculiar, cryptic, or humorous and inventive neologisms; they can be poetic developments of the picture's subject, be seemingly unrelated or even contradictory to it. But they may also offer hints as to the work's essential meaning. This work's title tells us that the giant aphid on the plant does not represent the diversity of flora and fauna; it merely points out that the aphid is the plant's enemy. Nevertheless, Klee—who always came up with a work's title only after it was complete—did allow the viewer the possibility of finding meanings and connotations other than those prescribed by the title.

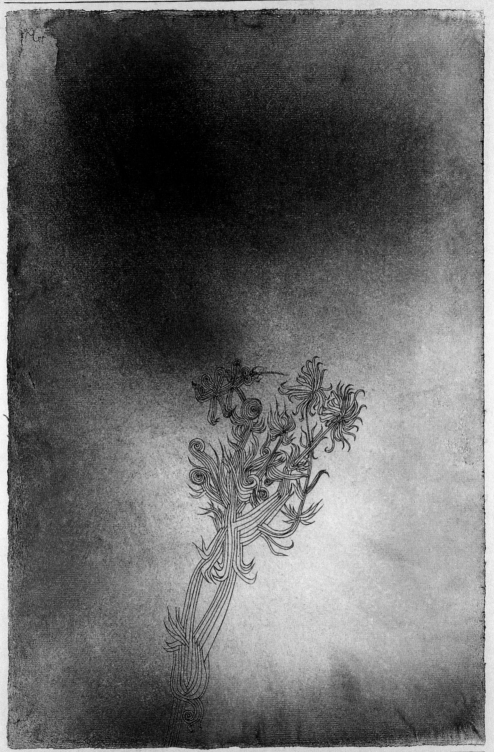

1926 9 4 der Pflanze und ihr Feind

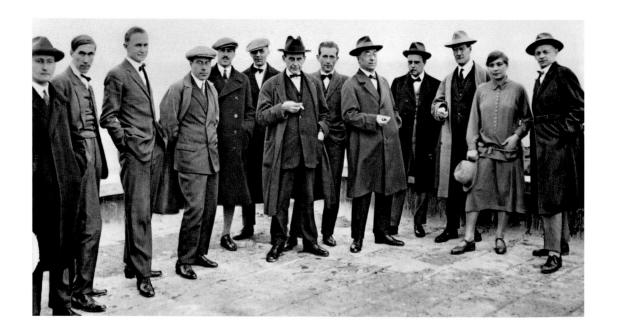

AT THE BAUHAUS IN DESSAU

Lily and Klee were on a long trip to Sicily when the long-standing anti-Bauhaus propaganda in Weimar came to a head. In September 1924, the Thuringian regional government made it known that they might not be extending their contract with Gropius and the masters. In this uncertain situation, Gropius announced that he would be canceling the contracts himself, effective April 1925. The Bauhaus had offers for a new home from many Germany cities. In the end, the decision was made to move to the central German town of Dessau, which had offered the Bauhaus the most open embrace. Here, in a small pinewood, Gropius built a house for himself and, next door, three semi-detached homes for the masters. In the summer of 1926, the Klee and Kandinsky families moved into one of these white, cubical, flat-roofed houses at Allee 6–7. From now on, they would be sharing a common wall. The Klee household also featured a technological novelty: despite her husband's fervid protests, Lily had pushed through their acquisition of a telephone. Klee, who did not own a radio (though he did have a gramophone), originally wanted to banish this "devil's box" to the basement, but in the end the couple agree to place it in the first-floor fuse box.

In the winter, the Kandinskys and the Klees celebrated Christmas together, and in the summer they traveled by carriage to Klee's beloved Wörlitzer Park

Group photograph of the Bauhaus masters, 1926

The Bauhaus masters on the roof of the recently inaugurated Bauhaus building in Dessau. Klee (fourth from right) is framed by Kandinsky (left) and Feininger (right).

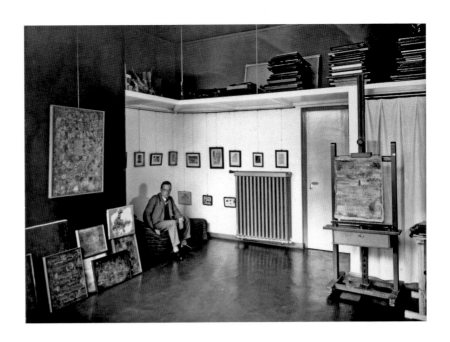

outside the gates of Dessau, one of Europe's most famous country parks. They also shared a box at Dessau's Friedrichstheater, where they often attended the opera. At this theater in 1928, Kandinsky staged Modest Mussorgsky's suite *Pictures at an Exhibition*, with Felix Klee as assistant director. Felix dreamed of becoming a director or theater manager, and this was his first engagement in this field. As in Weimar, Paul Klee was regularly playing music in private circles, this time with three members of the theater's orchestra. He also performed occasionally for the Bauhaus community: just before the grand opening of the new Bauhaus building—designed by Gropius—Klee, joined by Lily and a female singer, performed Mozart at a benefit concert for the school's cafeteria.

With the move from Weimar to Dessau, those at the Bauhaus who had little understanding of the presence of painting at the school became louder in their criticism. The critics' spokesperson, again, was Moholy-Nagy. In 1925, Feininger wrote: "Is this the atmosphere in which painters such as Klee and some others among us can continue to grow? Yesterday, Klee was all apprehen-

Lucia Moholy: Paul Klee in the studio of his master's house in Dessau, 1926

Klee loved his Dessau studio so much that he regularly returned to paint here even after becoming a professor in Düsseldorf. Based on a design by a Bauhaus student, he had the studio's main wall painted black, one of the side walls blue, and the other yellow. In this studio—which few visitors except cats were allowed to enter—Klee would frequently convert his easel into a music stand and play the violin for hours at a time. His neighbor, Nina Kandinsky could see directly into Klee's studio from her room, where she would often see his cat, of which she was extremely afraid. One day Klee revealed to her that the cat was watching her—and never kept a secret!

*"Lead your students... towards nature, into nature!
Let them experience how a bud is formed, how a tree grows, how a
butterfly unfolds, so that they may become as rich, as agile, with as
much self-will as nature in all its grandeur."* Paul Klee, quoted by Hans-Friedrich Geist, c. 1930

Arrangement with moss animals on Irish moss, false Irish moss, hornwrack,
mid- to late 1920s

Klee collected plants and animals that fascinated him, installing them on a piece of
paper with a prime coat of paint and making a plaster frame, which he then painted.

Herbarium page, 1930

While on his walks, Klee often collected plants for his herbarium. He described the
pressed plants as "treasures of form."

"If we do not pronounce judgment from the nearest earthly proximity, but take the big picture into account, then, truth be told, motion is the norm … The usual state of things in the universe is thus: the state of motion." Paul Klee, c. 1924

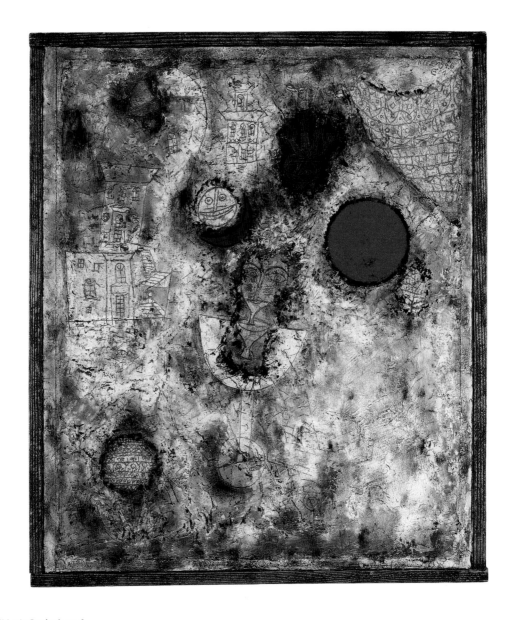

Zaubergarten (Magic Garden), 1926

Klee painted this mysterious garden on a piece of plasterboard,
into which he also etched houses and enigmatic symbols.

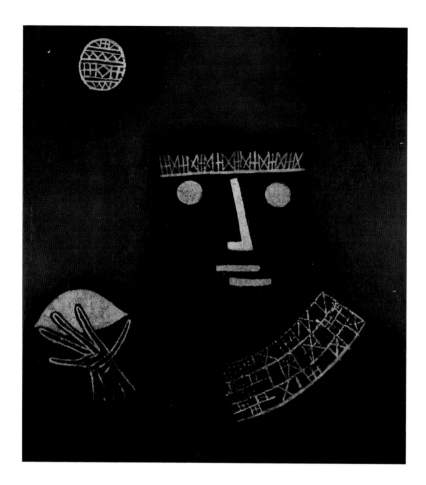

sion when speaking of Moholy ... assembly-line intellectuality ..." But the painters responded and protested—and so, starting in late 1926, the Bauhaus began offering courses in "free painting." Beyond this, Klee still led the evening life-drawing course, continued diligently to give his introductory courses for new students, and still taught in the weaving workshop. Nevertheless, it had long been clear that Klee was overburdened by, and unhappy with, his workload. As early as March 1925, Ise Gropius—the director's wife and an astute observer and chronicler of the Bauhaus—had noted in her diary that Klee "felt the need to take a break from teaching."

From now on, Klee's travels during the holidays became an important source of renewed strength and new artistic impulses. In 1926 he and his family

schwarzer Fürst (Black Prince), 1927

Is this picture a homage to the people of black Africa, who are closer to nature than we are? The secret symbols in the crown and the attire of the prince, who holds an exotic fruit, resemble the patterns found in traditional African fabrics.

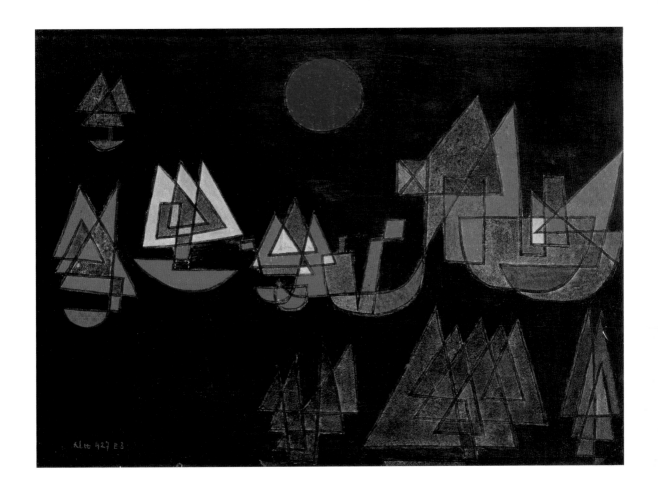

traveled to Italy, and 1927 saw him traveling via Berne to the island of Por-
querolles in southern France and then on to Corsica. This time, however, Klee
did not return to Dessau in time for the start of the new semester. When the
council of masters demanded his immediate presence, Klee—who felt ex-
hausted from teaching—wrote a letter explaining that he considered himself
first and foremost a working artist and that he required "relaxation in the form
of a commensurate (relatively long) family vacation."

During the semester, Klee the silent observer found relaxation on his daily
walks, which often lasted several hours and on which he explored the
surrounding countryside in his typical, somewhat hesitant manner. In an
earlier letter to Lily, Klee had once described the local landscape along the Elbe

Schiffe im Dunklen (Ships in the Dark), 1927

Working on a black background, Klee painted a blue moon and ships constructed from
semi-circles and overlapping triangles. At the Bauhaus, he once explained that it was
especially difficult to balance the color values of the picture's subject on a black "primal
ground." In 1932, Jawlensky gave Klee one of his *Abstract Heads*. In return, Klee later gave
him this picture.

133

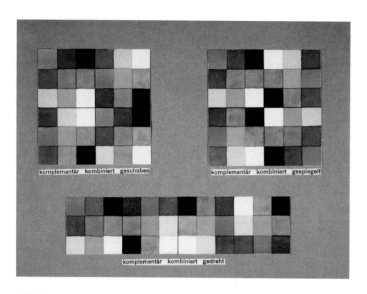

komplementär kombiniert geschoben

komplementär kombiniert gespiegelt

komplementär kombiniert gedreht

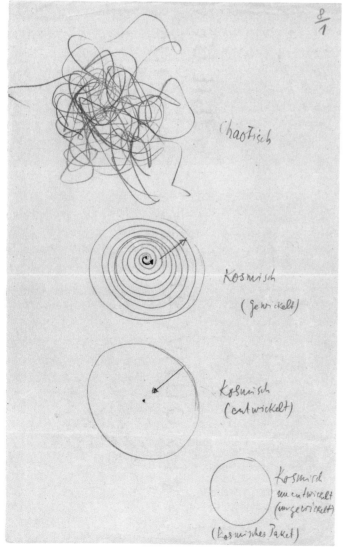

$\frac{8}{1}$

chaotisch

Kosmisch
(gewickelt)

Kosmisch
(entwickelt)

Kosmisch
unentwickelt
(ungewickelt)

(Kosmisches Paket)

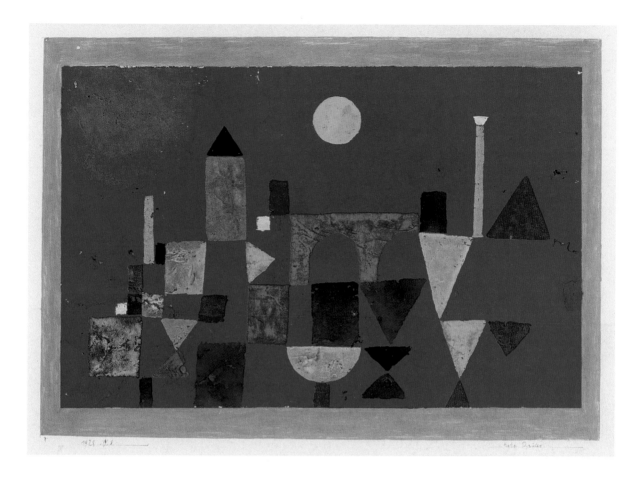

Reingart Voigt: Color study from Klee's class, *c.* 1929

As with musical themes, complementary color pairs are moved about: shifted (left), mirrored (right), rotated (bottom)—Klee's view of the economical use of color.

Page from **Bildnerischen Gestaltungslehre**, *c.* 1928

While Klee collected the teaching notes and lecture materials from his 1921 and 1922 Bauhaus courses in a small book that he called *Essays on Visual Form Theory*, his numerous notes for *Visual Design Theory*—made on loose sheets of paper between 1925 and 1931—remained unedited. Today, they are known as his Pedagogical Estate. In his introduction to *Visual Design Theory*, Klee wrote: "Theory of design addresses the paths leading towards shape (form). It may perhaps be called theory of form, though with an emphasis on the paths leading towards it." Klee placed this page before the first chapter. It shows two opposing traits: chaotic (top) and cosmic (bottom), as well as two intermediate phases of the cosmic.

rote Brücke (Red Bridge), 1928

Variable building blocks like those from a children's play set—someone must be building something! In 1920, Klee wrote: "Is a visual work created all at once? No, it is built up piece by piece, no different than a house."

and Mulde rivers: "Each time I marvel more at this region; such unique water parks! Though all the water makes one soft. But it is beautiful."

In December 1928, Klee set out on a long-desired trip to Egypt. The journey was financed by the Klee Society, which had been founded in 1925 by the enthusiastic art collector Otto Ralfs. The association's members paid a monthly membership fee that provided Klee with an additional source of regular income; in return, they could purchase his paintings at preferential prices. Klee did not work in Egypt, instead absorbing the local culture, and the region's flora and fauna, and visiting Alexandria, Cairo, Luxor, Thebes, Giza, and Aswan.

In December 1929, Klee celebrated his fiftieth birthday. Several museums organized exhibitions on this occasion, including the Museum of Modern Art in New York, whose director, Alfred H. Barr, Jr., had met Klee on a visit to the Bauhaus two years earlier. A few months later, in the spring of 1930, Klee informed Bauhaus director Hannes Meyer (1889–1954)—a Swiss architect who had replaced Gropius in 1928—of his decision to leave the Bauhaus the following year. At the time, probably neither of the two imagined that Meyer would be the first to go—summarily fired by the city of Dessau that same summer for his communist aspirations. Meyer's successor, the architect Ludwig Mies van der Rohe (1886–1969), was no more successful in changing Klee's mind. In fact, Klee had already accepted an offer from the Düsseldorf Academy of Art, a decision he explained in a letter to Lily: "After all, an academic position is four times easier."

Wolfgang Kleber: The stairway in the Klee master's house today

A view of the stairway at Paul Klee's Dessau master's house, which has been open to the public since being renovated in 1999.

Three portraits of Paul Klee, 1928

The photographs show very different but typical characteristics of the multifaceted artistic personality Klee: the contemplative, withdrawn but focused, pipe-smoking artist with a professorial charisma (top); the mischievous and jovial Klee spreading a mist of salty humor (middle); and finally the smiling lover of mankind, surrounded by an aura of gentleness and poetry (bottom). These photographs were made in the small pinewood surrounding the Dessau masters' houses built by Gropius.

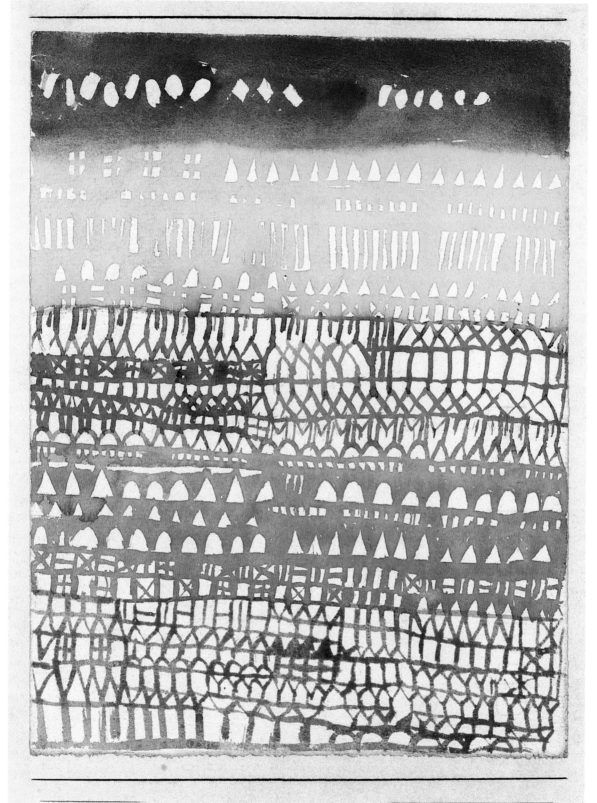

"We were a completely un-athletic family. For my father, sport was always an occasion for satire. He always said that [in sports] you didn't use your head." Felix Klee, 1989

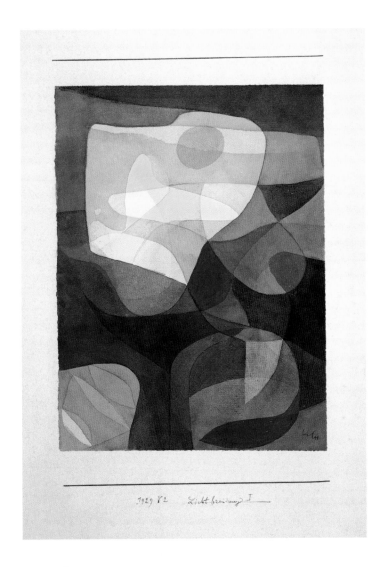

alte Stadt (Überblick) (Old Town [overall view]), 1928

A basic concept is repeated, with slight variations, row for row, almost like the score for serialist music. The different colors used for the individual thematic blocks bring to light various "musical" timbres.

Lichtbreitung I (Light-broadening I), 1929

Swaying, overlapping, transparent color forms, as if several independent musical themes were sounding all at once.

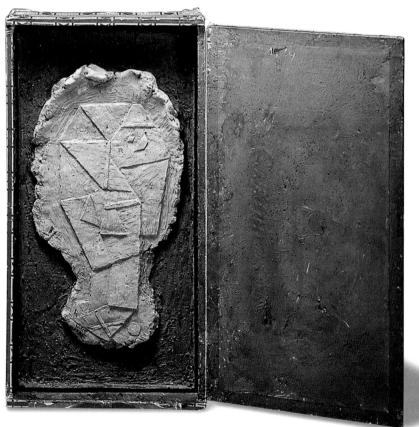

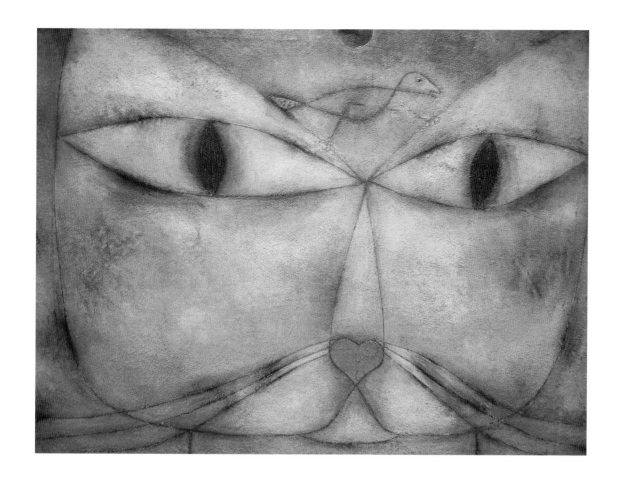

Ernst Kallai: **Der Bauhausbuddha (The Bauhaus Buddha)**, 1928/1929

Because everyone at the Bauhaus respected Klee as a moral authority, the members of the Bauhaus called him "the good Lord" and the "Bauhaus Buddha."

Untitled (Relief in Zigarrenschachte) (Relief in Cigar Box), 1929

Like an altarpiece: Klee mounted this plaster head in a cigar box with a movable lid. Just as most of Klee's paintings were small-format works, so his sculptures were not very large either.

Katze und Vogel (Cat and Bird), 1928

This cat constantly has only one thing on its mind—birds! Klee loved cats more than anything else, even though he felt that cats were "a creature that can be understood only indirectly." Nevertheless, he painted and drew cats all his life. During his time at the Dessau Bauhaus, when this picture was painted, Klee noted in his pocket calendar: "There are cats whose gazes are like armed flowers."

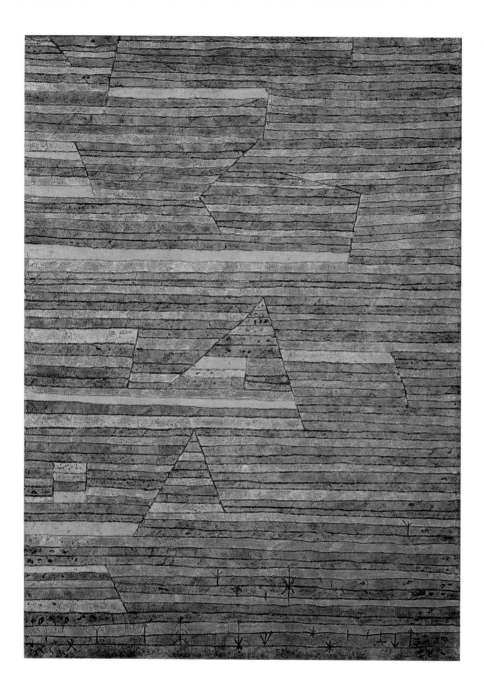

Denkmäler bei G. (Monuments near G.), 1929

Klee created this picture in his Dessau studio shortly after his return from Egypt. Perhaps this is where the third Bauhaus director, Mies van der Rohe, first saw this work, which later spent a long time in his collection. The picture is composed of narrow horizontal bands that are interrupted by forms resembling territorial markings, fields, and pyramids with burial chambers. The title refers to the pyramids of Giza, to which Klee traveled from Cairo by streetcar. His pocket calendar from December 26, 1928, contains the following entry: "In the morning Giza pyramids. Then ate a pigeon. In the afternoon bazaar odyssey."

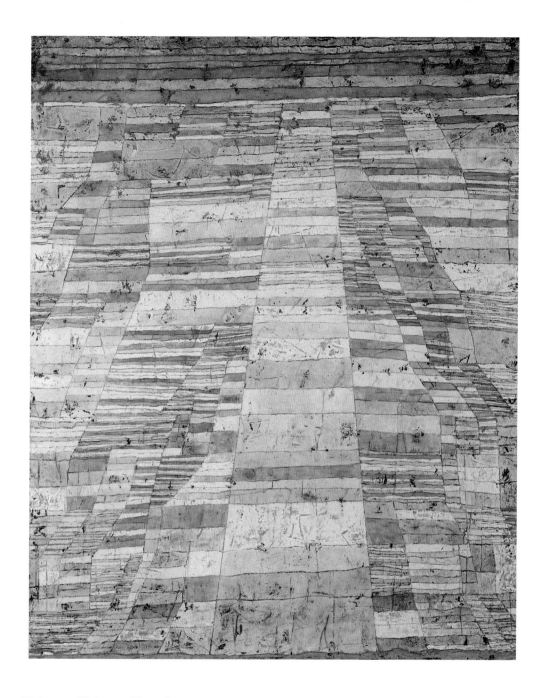

Hauptweg und Nebenwege (Highway and Byways), 1929

The vertical highway would seem to begin directly at the Nile before leading to the horizon. The equally vertical byways are occasionally curved and appear to occasionally become lost in the sand. Klee wrote Lily from Egypt: "...the landscape and agriculture in all of Egypt are quite uniquely arranged. The river is the artery of it all. Where it is ... there is magical green—fodder, vegetables ... scoop wheels as during the time of the pharaohs bring water from larger canals into the smaller and smallest. All by the grace of the Nile..." The picture's line structure is also reminiscent of the squared grids that acted as guidelines on ancient Egyptian reliefs.

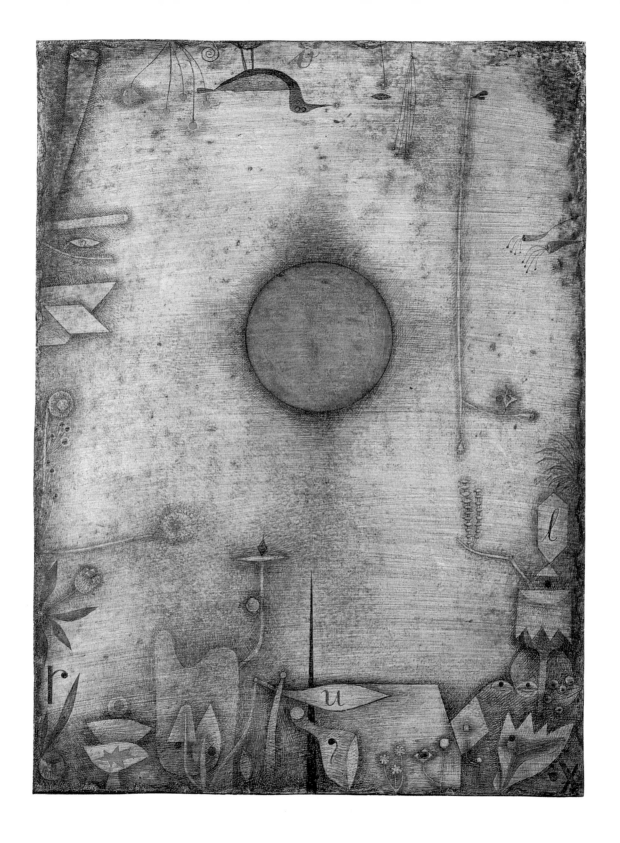

ad marginem, 1930

Something has been written in the painting's margins, which is why Klee gave this work the title *ad marginem*. With these marginal letters, however, Klee is deliberately misleading the viewer. Although "u" stands for down ("unter") and "o" for up ("oben"), he has placed an "r" on the left and an "l" on the right. Here one would do best to double-check these strange laws of nature. In fact, the painting's composition invites us to turn it around and around, allowing us each time to redefine its orientation. During his time at the Bauhaus, Klee wrote something that can be applied to this painting as well: "Opposed locations are not fixed; they allow for a sliding motion. Only one point is fixed, the midpoint in which meanings slumber."

andante, 1931

While at the Bauhaus, Klee wrote: "And what, above all else, is the line! A stream into the distance. Thought. Path. Assault. Dagger, stab, arrow, ray. The sharpness of the knife. Scaffold. Carpenter of all form: plumb-line."

versiegelte Dame (Sealed Lady), 1930

Only a few branching lines reveal anything about the inner life of the lady with the tightly sealed mouth. A few years earlier, Klee had written: "If I wanted to depict Man 'as he is,' I would require such a disorderly confusion of lines that ... it would cloud the result beyond recognition."

Bildnis in der Laube (Portrait in the Arbor), 1930

Klee's work sometimes reflects his fascination with other artists only very subtly, while at other times it is more clearly visible. Nevertheless, Klee was always looking for and following his "own" path, so that his art—always hovering somewhere between abstraction and representation—cannot be categorized within any particular style. Towards the end of his time at the Bauhaus, Klee created many geometric drawings and Constructivist works, but also this almost Romantic looking picture. The sometimes point-like application of paint is reminiscent of the "pointillist" pictures that he would go on to paint in Düsseldorf a short time later.

PROFESSOR IN DÜSSELDORF

Klee began teaching his painting course as a professor at the Düsseldorf Academy of Art in July 1931. The city of Düsseldorf had welcomed him by organizing an exhibition in his honor. Student interest in his course, however, remained limited; at the beginning, there were only four students on Klee's course, three of whom had come with him from Dessau.

Klee found it intolerable that his course was not attended by more students from the Düsseldorf academy, and he complained—after all, by now he was known far beyond the borders of Germany. However, not all teachers and

Klippen am Meer (Cliffs by the Sea), 1931

No sooner had Klee start his job as professor in Düsseldorf than he created his series of so-called pointillist pictures. Like the pointillists Georges Seurat (1859–1891) and Paul Signac (1863–1935), Klee applied tiny dots of color next to one another. He did so not only with a brush, but also a rubber stamp. Klee himself labeled these works "divisionist." Upon closer inspection, we can see that the "dots" are actually many tiny squares of pure color applied on a colored background, thus resembling mosaic tiles. These result in a shimmering effect that erases the boundaries between sky, sea, and cliffs, causing them to flow into one another in constant motion.

"How abominably most people paint, and one is not at all satisfied with oneself; who actually paints well? Can be counted on the fingers." Paul Klee, 1931

students were as open-minded to avant-garde art as the academy's director, the art historian Walter Kaesbach (1879–1961). Despite these circumstances, Klee felt at ease in Düsseldorf, remarking: "Even conservative spirits have grappled intensively with progress, and are sometimes more honest and thus more interesting than the modernists."

His only teaching activities consisted of analyzing and correcting the paintings made by his small group of students. After each class, Klee distributed cigarettes "as a reward," and smoked and chatted with his students. In his free time, he painted in the academy's studio—which was off-limits to anyone who did not know the secret knock.

Klee used this studio not only for painting, but also for playing music and cooking. He prepared his daily meals on a small spirit stove, frequently sending Lily detailed descriptions of these meals, as in a letter from February 1932: "In the morning, I had two English mutton chops with field lettuce and buttered bread. In the evening, sour kidneys with wild rice, which comported itself quite well in the spicy wine sauce. Today at noon, there was cold roasted chicken with butterhead lettuce, buttered bread with Gorgonzola and the usual Turkish [coffee]. In the evening, I used the remaining excellent kidney sauce to create minestrone with cauliflower-leaf, rice and onions, topped with Parmesan. Then the vegetable platter: brilliantly white cauliflower, boiled, drained and covered with butter and ground Swiss cheese—a very fine and agreeable meal. Then chicory salad, and tea. Instead of afternoon tea, there were two nice apples. In between, the painting came together..." In another letter, Klee described his homemade menus: "Such food always has an intellectually stimulating effect on me. I feel especially good afterwards..."

According to Klee's contract in Düsseldorf, he had to be present for only fourteen consecutive days each month. As a result, he finally had more free time for painting again. Since he had not given up his Dessau master's house, he traveled back to Dessau every two weeks in order paint, even after the National Socialists who controlled Dessau's town council shut down his former place of employment, the Bauhaus, in October 1932. The different layouts and ambiances in his studios in Düsseldorf and Dessau had an immediate effect on his work, something he apparently sought out consciously:

Drüber und drunter (Above and Below), 1932

Incredible, how much that is sweet, sunny, and lovely appears when you have
a look "below" the person with the cold blue face.

Ad Parnassum, 1932

The Latin title of this work, which Klee created during his time in Düsseldorf, means "at/to Parnassus." In Greek mythology, Mount Parnassus was the seat of the god Apollo, who was not only the god of oracles, but also a warrior, bringer of disaster, and god of healing and the arts, particularly music. Klee may have liked the combination of such seemingly antithetical qualities in one god, since he saw good and evil not as insurmountable opposites, but as different parts of one whole.

Umfangen (Encircled), 1932

Is it a woman or a plant bearing a seed? Whatever the case, the seed is surrounded
by moving shapes, forces of life. In this work, which belonged to the third Bauhaus
director, Mies van der Rohe, Klee addressed a recurring theme in his work: the
phenomena of becoming—transformation, decay, and the constant renewal of nature
and creation and its underlying qualities. In 1920, Klee compared these qualities
with the artistic process: "Art is a parable of Creation."

"A meal like on a laundry day, and I don't even wash. That is the only domestic chore I have not attempted. If I could do that, I would be more universal than Goethe." Paul Klee, 1932

while the Düsseldorf studio produced large-format paintings and a (for Klee entirely new) "pointillist" approach, his beloved and more intimate Dessau studio gave birth to a plethora of small-format works.

DARKNESS FALLS

Klee's life changed abruptly when the National Socialists seized power in Germany in early 1933. On January 30—the day on which Hitler was made Reich Chancellor—Klee wrote Lily about the current political situation: "I no longer believe that anything can be done about it. The people are too unsuited for real things, too stupid in this regard." The following day, Klee added in another letter to Lily: "I have an unpleasant sensation in my stomach, as if the New Year of the purified national Germany had been rung in with a torchlight orgy of sparkling wine."

Some years earlier, Klee had once asked his host to turn on the light as darkness fell. He could not concentrate otherwise, because too many inner pictures would appear to him. In the same way, this period of darkness unleashed a great number of inner pictures in Klee, including a large collection of drawings exposing the Nazi worldview with a profound sense of humor, subtle criticism, and an acute eye—although today's viewer will not always immediately identify their connection to that era's political events. A short time later, a German newspaper published a defamatory and aggressively anti-Semitic article on the Düsseldorf Academy and its director, Kaesbach. It had the following to say about Klee: "He tells everyone that he is a full-blooded Arab, but he is a typical Galician Jew." Responding to such voices, Klee wrote Lily later that year: "...even if it were true that I am a Jew and come from Galicia, this would not change one iota of my person and my achievements. I must not abandon this personal standpoint of mine—that a Jew who is a foreigner is not inherently inferior to a German who is a native. Otherwise, I would leave a strange legacy behind. I would rather face adversity than personify the tragicomic figure of someone vying for the favors of those in power."

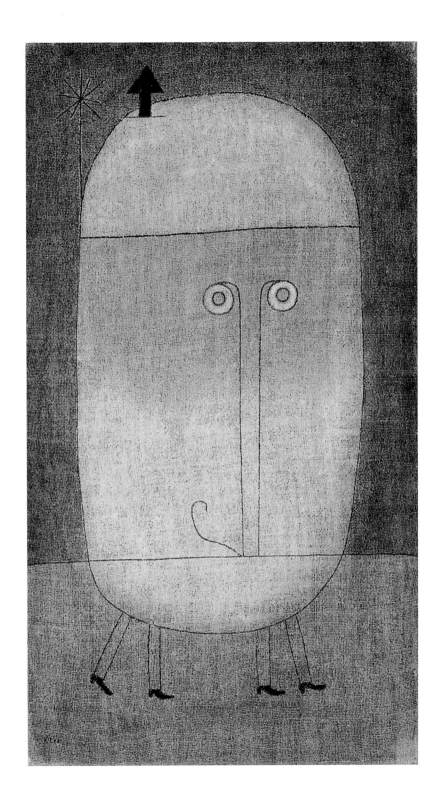

Maske Furcht (Mask Fear), 1932

Frightened, this creature's little legs move rapidly, while at the same time it seeks
to hide its true state of mind behind an impish and seemingly carefree mask.

"In all likelihood, I shall leave this place tomorrow evening. Then there will be the pleasant Christmastide, with bells ringing in every child's head. I have grown a little older in the past weeks. But I do not want to allow any bile to emerge, or only humorous doses of bile." Paul Klee, 1933

Klee was not in Dessau when, in March, the police and SA (Nazi storm troopers) broke into his house and confiscated laundry baskets full of letters, account statements, and notes—as a member of the Bauhaus, he was under general suspicion. Desperate, he asked for help from his friend and financial advisor Rolf Bürgi, the son of the collector Hanni Bürgi. Rolf immediately traveled to Dessau where, thanks to his protest, the documents were returned to Klee untouched. After the Dessau incident, Klee traveled to Lugano for a few days. When he returned from Switzerland in April and went to the Düsseldorf academy, director Kaesbach was no longer there and Klee was informed that he was being put on leave, "effective immediately." A short time earlier, the academy's acting director, Julius Paul Junghanns, had written to the district president about Klee: "Is seen as a Jew and intolerable as a teacher." Soon thereafter, the first of the "exhibitions of shame" (Schandausstellungen) featuring "cultural-Bolshevik paintings" was held in Mannheim. The organizers had included works by Klee.

Although Klee was critical of developments in Germany, in early May 1933 he and Lily moved into a newly rented house in Düsseldorf's Heinrichstrasse 36, where he devoted himself entirely to painting and drawing. In September, Lily wrote one of Klee's former painting students that "he has had an especially good creative period in the past few months, and countless drawings, watercolors, and even oil paintings have been produced. He is currently occupied by entirely new things, even large paintings. He is completely absorbed in his work and pays little attention to the outside world. In my opinion, there is no hope of my husband returning to teaching at the academy. I do not believe in miracles."

In October, Klee found himself drawn south. He traveled via Milan to Monaco, Nice, and Saint-Raphaël, and from there on to the Mediterranean island of Port-Cros. In France, he was impressed by more than nature, and he wrote Lily: "Perhaps this will soon be the only country where people are not

so aggressively obtrusive ... what this means for oppositional souls." On his way back to Germany, he met Kandinsky and his wife Nina in Paris, where the two had found a new home. He used this opportunity to ask the owner of the Galerie Simon, Daniel-Henry Kahnweiler, to take over as his general agent, since he could not extend his contract with the gallery owner Flechtheim in Berlin. Kahnweiler already had a contract with Picasso, whom Klee finally met for several hours in Paris. In late October, Klee received official notice that his position at the art academy was being terminated effective from January 1, 1934. Although Klee had wanted to remain in Düsseldorf, Lily had been pushing him for some time to leave Germany. Now she again talked to him, and in November he finally agreed to leave with her for Switzerland.

Menschenjagd (Manhunt), 1933

After the Nazis seized power in 1933, Klee created a group of more than 200 drawings in which, with a rapid and feverish line, he addressed the "National Socialist revolution," as he called it. Klee did not depict the radical cataclysms of that time, but parodied them while exposing (as with this example) the true, inhumane objectives of the Nazi ideology. Other works from this group were called: *Erneuerung der Mannszucht* (*Renewal of Military Discipline*), *wenn die Soldaten degenerieren* (*When Soldiers Degenerate*), *auswandern* (*Emigrating*), *Kriechender* (*Crawling Man*), and *närrisches Fest* (*Fools' Party*). When Klee left Düsseldorf in 1933, he bade farewell to his former students with the words: "Gentlemen, Europe stinks alarmingly of corpses."

155

HIS FINAL YEARS IN SWITZERLAND

1933–1940

"The great silence between Germany and me is just too eerie to accept at face value. Our life here is quiet and simple, and I have again painted some things with a very small orchestra." Paul Klee, 1934

EXILE

Klee left Germany on Christmas Eve 1933. Lily was already waiting for him at his family's home in Berne, where they initially lived with his father and sister. Looking back, Lily later described 1933 as an "evil" year that she remembered "with dread." The year's tribulations had led her to develop a nervous heart disorder. In January 1934, the couple moved into a small furnished apartment. At the same time, Klee had his first solo exhibition in England, at London's Mayor Gallery. In the summer, the Klees moved into an unpretentious three-room apartment at Kistlerweg 6 in the quiet Berne suburb of Elfenau, where Klee lived and worked until his death. His studio was no larger than around 4 by 5 meters (13 by 16 feet), facing west and with a balcony that offered a sweeping view of the Bernese uplands and the Alps. The studio walls gleamed in warm shades of ochre—they were hung with Bauhaus wallpaper.

Klee's life now became quieter. He sometimes met with old friends or collectors for whom he felt an affinity, where discussions would revolve around music, everyday events, and art. Klee again gave home concerts and spent three to four hours each day practicing the violin. Since Lily still could not cook and Klee was still a great enthusiast in the kitchen, he continued to prepare their daily meals. Klee created 219 paintings in 1934, whereas the figure for the turbulent previous year had been 482—more than in any other year before.

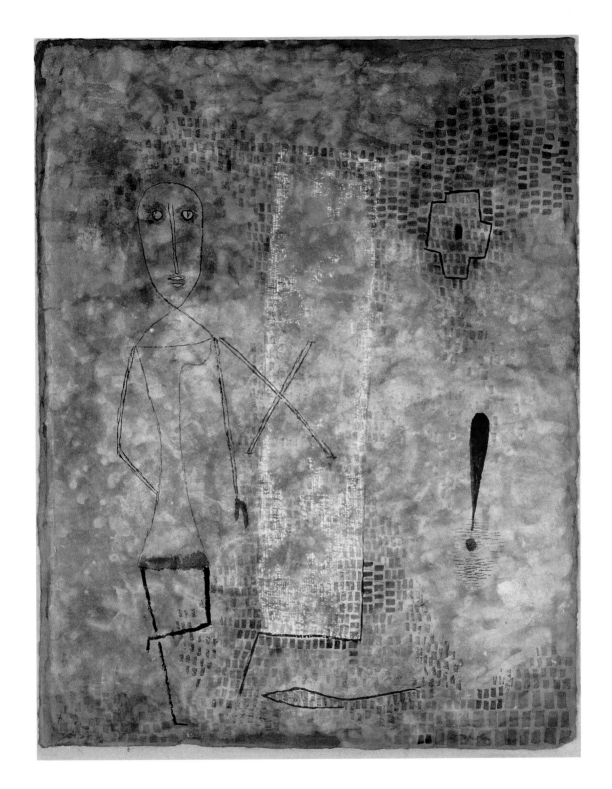

Europa, 1933

Lady Europe bends her leg at an odd angle, reminding us of a swastika. Or is she merely limping? One year after creating this picture, Klee asked, "Is Europe limping or am I?"

PRECIOUS BIMBO, HINDE, WISE MAO...

Another inhabitant of the Klees' three-room apartment was the Angora tomcat Bimbo, whom Klee sometimes called "Hinde," "Kätzer," "Wise Mao," or "Great Mao." The tomcat had once belonged to the dancer and Bauhaus gymnastics teacher Karla Grosch (1904–1933), a friend of the Klee family. Following her premature death, the cat was adopted by the Klees. Klee was a great lover of cats and had once said that, had he not been Klee, he would have become a cat. And so Bimbo had the run of the house: he had no scruples about helping himself from the table during lunch or teatime, and could go where he pleased in

Blühendes (Flowering), 1934

While in Weimar, Klee began creating his "square paintings," some of his few purely abstract works. Like music, Klee hoped to use the primary colors and the color palette derived from them in order to create a harmonic chord progression.

Vogelscheuche (Scarecrow), 1935

The figure looks as if it were made using fabric appliqué, but it's painted. Scarecrows are no different: they represent something that they actually are not.

the studio. Sometimes Klee would be working late in the kitchen, cooking Bimbo a warm meal. In many of his letters from these years, he writes in detail and with great devotion about his feline companion, to whom he felt at least as close as his human friends. Klee would have immediately traded one of his paintings for a successful portrait of Bimbo, but he felt that only Monet could have done him justice. Nevertheless, Bimbo was eventually captured in a portrait: in 1935, Ernst Ludwig Kirchner (1880–1938)—the co-founder of

Löwenmensch (Lion Man), 1934

Perhaps this work was meant as a homage to Lionel the Lion-Faced Man, who traveled around the world as a circus sideshow attraction in the early 20th century. But in 1930, Klee also described Mies van der Rohe as "something of a lion man."

Dresden's Die Brücke group and also a cat lover—visited Klee and subsequently painted *Hommage à Klee*, with Bimbo taking pride of place at the center.

WELCOME?

In 1935, the Berne Kunsthalle held a large Klee exhibition consisting of 272 works created since 1919. The exhibition, which included works by his classmate Hermann Haller, had wanted to provide Klee with a warm welcome to Switzerland, but few people took any notice of it.

Soon thereafter, a reduced form of this retrospective was shown in Basel, where the *National-Zeitung* newspaper grumbled: "Much of it strikes us as having no substance ... To the uninitiated, more than a few works must appear hieroglyphic, even incomprehensible. And we are especially skeptical of the conspicuous references to children's drawings and the like. We do not find it at all positive for a man of more than fifty years to allow himself to be inspired by such works."

Just the year before, the German art historian and critic Will Grohmann (1887–1968) had published a book containing Klee's sketches from his time at the Bauhaus, and another volume with earlier drawings was being planned. Now, however, the Gestapo confiscated the first volume, for the time being putting an end to all of Grohmann's plans.

Schweizer Landschaft (Swiss Landscape), 1919
"Does not this picture ... refer to what certain people call 'Swiss cow-lovers'?" asked a Swiss police officer in a report on Klee's citizenship request. What is more, he wrote, these cows looked "dim."

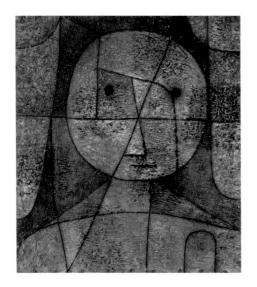

"Times are truly very difficult. After twenty-five years, we are again experiencing war ... It is the Devil who rules the world, and we all know who is the Devil incarnate." Lily Klee, 1939

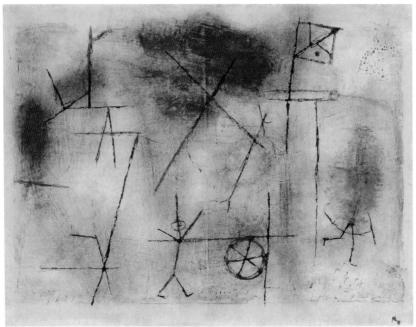

Gezeichneter (Marked Man), 1935

Klee painted this picture in the same year that his illness—later diagnosed as scleroderma—first made itself known. In it, we find echoes of his stigmatization by the Nazis and references to his illness.

Formel eines Krieges (Formula of a War), 1936

When the Spanish Civil War erupted in 1936, Klee increasingly addressed the subject of war in his works. The only identifiable objects in this work are two stick figures, a wheel, and a flag; all other characteristics and nature of war are represented cryptically, fully reflecting his diary entry from 1915: "The more horror-filled this world ... the more abstract is art."

*"I painted again today, but instead of finishing,
I painted it over with a new base coat.
This happens sometimes—so that we do not
become smug."* Paul Klee, 1939

THE MYSTERIOUS ILLNESS

Towards the end of August 1935, Klee came down with influenza, which developed into bronchitis and a fever. A doctor diagnosed that his heart had suffered as well. The fever was stubborn; Klee soon developed double pneumonia and felt weaker with every day. His life was in danger. At this time, he was visited by his old friend Jawlensky, who was seriously ill as well. In November, Klee suffered a sudden rash over his entire body, after which his skin started to flake. His doctor forbade him from smoking and playing the violin, saying it was too strenuous for him. For months, Klee could not paint. The diagnosis: measles. After his death, scientists studying Klee's illness reached the conclusion that his symptoms must have been the first stages of diffuse systemic scleroderma, a progressive illness that would plague Klee for the rest of his life. This rare auto-immune disorder is a chronic inflammatory disease of the connective tissue that leads to the gradual thickening and hardening of the skin, which among other things can result in a rigid "mask face." More importantly, this hardening can also affect the internal organs and impair their functioning. As a result, Klee developed a constriction of the esophagus, meaning that he could increasingly consume only mashed or liquid foods.

In April 1936, Klee cautiously returned to work. In order to regain strength, in July he took a vacation to the Engadin Valley in Switzerland, followed by a stay at a mountain resort in the canton of Valais. During this difficult year, Klee found enough strength to produce twenty-five works.

In January 1937, Klee was visited by Kandinsky and his wife Nina. It would be the last time they saw each other. At the time, Klee was too weak to work, and he did not resume painting until late February 1937. In a letter to

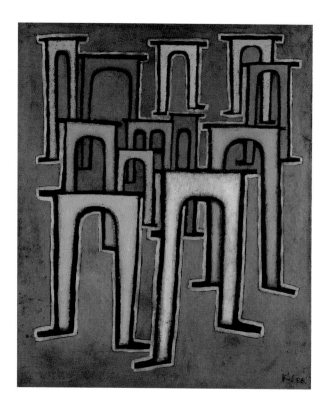

Grohmann, Lily reported in amazement: "He sits in his studio and one sheet after another falls to the floor, as before—curious."

Now Klee entered a new period in his career, creating what is generally known as his late work. He produced extremely large paintings, larger than any he had made before. Many of his works now contained strange archaic symbols reminiscent of hieroglyphs, which Klee himself called "secret symbols." He produced paintings with thick, black strokes, and ever more frequently created spontaneous, impulsive drawings—sometimes series of drawings based on a particular topic.

For several months in late summer, the Klees rented a house in Ascona, where Klee visibly recovered his lost strength, worked intensively, and met with painter friends such as Werefkin.

Revolution des Viaductes (Revolution of the Viaducts), 1937

Here, the unimaginable happens: heavy bridge arches appear to have set themselves in motion. Klee painted this picture in the same year that the Nazis opened their *Degenerate Art* propaganda exhibit, in which they defamed modern art and in which they included works by Klee. His viaducts are like people who have stepped out of the gray mass of the Third Reich, vigorously showed their colors, and ceased to function. They are like a community that has rediscovered its humanity in order to rise against oppression, uniformity, and manipulation by a totalitarian regime.

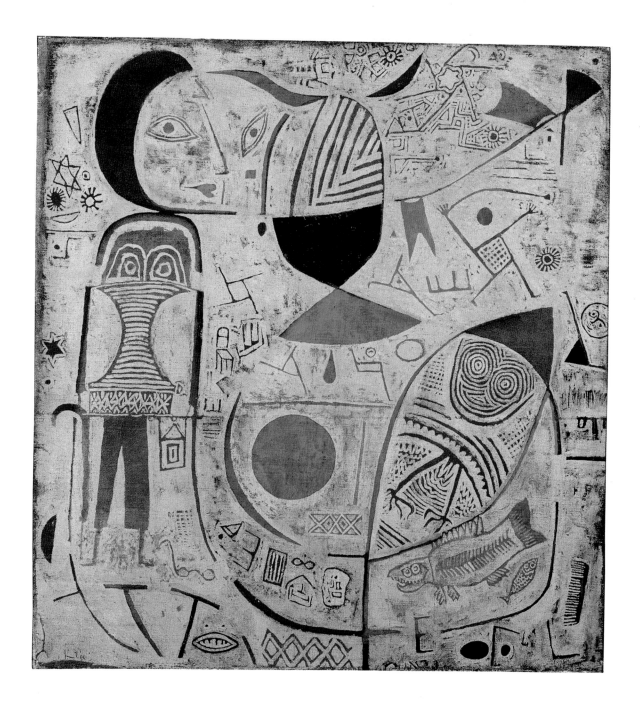

Bilderbogen (Printed sheet with pictures), 1937

With cryptic symbols, strange creatures, everyday objects, solitary letters, fish, and stars, Klee tells a peculiar and mysterious story that reminds us of a primitive carved image from a faraway time.

In late autumn, Pablo Picasso accompanied his ill son Paulo to a doctor in Berne, and planned to visit Klee while in town. On the appointed day, however, Picasso arrived several hours late. When he finally rang the doorbell at the house in Kistlerweg, Klee opened the door in a sweater and felt slippers—he had apparently decided that Picasso would not show up. Klee showed his visitor his latest works, which Picasso examined in almost complete silence. At one point, Picasso turned a piece of paper upside down. Smiling, Klee responded: "You can turn everything upside down. So much is upside down already." After this conversation, Klee told a friend that he had to be careful not to allow his art to be influenced by Picasso, "...for he is a great and very forceful personality, and one can easily adopt things, but each must go his own way."

Blüten der Nacht (Flowers of the Night), 1938

What do flowers that do not require sunlight look like? They have black buds, eggplant-colored and milk-blue blossoms, and seem kindred to the moon. Only the green is related to the sun, which is just disappearing at the top.

"Death is nothing bad; this I came to terms with long ago. Do we even know what is more important: life now or what will come after? Perhaps that other life is more important, but that is something we know nothing about. I will die happy if I have created a few more good works." Paul Klee, *c.* 1932, quoted by Petra Petitpierre

ein Weib für Götter (A Woman for Gods), 1938

This is no typical female being. It is a union of sun and moon; its powerful body almost seems to burst the picture frame—a woman for the gods!

Insula dulcamara, 1938

Klee originally called this work—one of his largest panel paintings—*Insel der Kalypso* (*The Island of Calypso*), but shortly thereafter decided on its current title, which proclaims that the picture contains both something sweet (dulcis) as well as bitter (amarus). Klee used a piece of burlap as painting support, pasted newspaper over it, and then painted a base color on that. Perhaps he had the plant *Solanum dulcamara*

(bittersweet nightshade) in mind when he painted this work, a highly poisonous plant that is nevertheless used in homeopathy for its healing properties. The delicate pastel colors of the stylized island portend spring, growth, and activity. In sharp contrast are the thick, dark lines and symbols—like constraining cliffs, evocative of impermanence, danger, and death.

"One day I shall be lying in the nowhere,
in the clouds
near an angel somewhere abouts." Paul Klee, no date

HOW KLEE EXPLAINED MODERN ART TO HITLER

In Germany in July 1937, the National Socialists opened *Entartete Kunst* (*Degenerate Art*), a propagandistic exhibition that started in Munich and then traveled in a slightly altered configuration to many others towns in Germany, and to Vienna and Salzburg in Austria as well as. In preparation for this exhibition, a committee working for Reich Minister of Propaganda Joseph Goebbels had visited various German museums in order to "procure" works of modern art, including 102 works by Klee. The sole aim of this show, the accompanying texts, and the exhibition flyers was to defame the artists and their work. The show's organizers saw the exhibited art as "having sprung" from the activities of "Jewish and, politically, clearly Bolshevik leaders." Modern art was presented as the "gruesome final chapter of cultural decay" and an "assault on the essence and continued existence of art in general." Besides works by the Expressionists and Dadaists, late works by Lovis Corinth, and examples of the Neue Sachlichkeit (New Objectivity), the show also presented seventeen of Klee's works that had been removed from museums. At the end of the show, all the art was auctioned off to dealers and museums throughout the world. Works that were not sold were burned by the Nazis as part of a propaganda rally.

During this time, Klee's works sold poorly in Europe. In the United States, however, Klee's status as a "degenerate" artist living in exile made him better known than ever before. One exhibition followed another, and the number of paintings sold in the country continued to grow steadily.

One night, Klee had a strange dream in which he gave Hitler an extensive lecture on modern art, after which Hitler sheepishly asked Klee to paint a 60-meter-long painting (just under 200 feet). Klee thought this over and decided he preferred to simply present 60 meters of his existing paintings. Still dreaming, he then planned to ask Hitler to view these paintings in the hopes that Hitler might begin to understand.

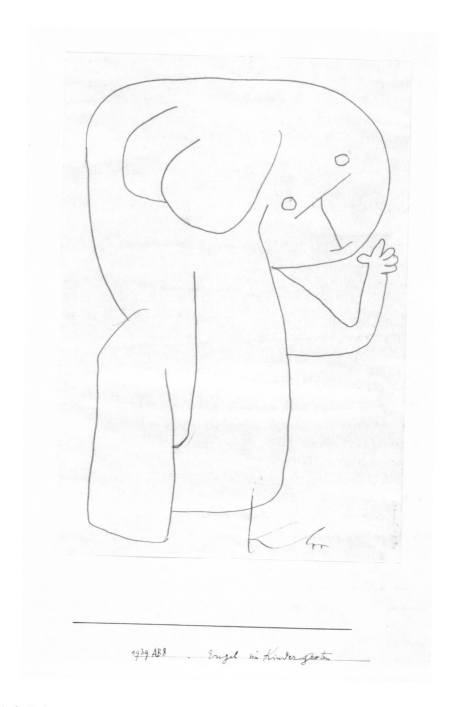

1939 AB8 . Engel im Kindergarten

Engel im Kindergarten (Angel in the Kindergarten), 1939

During his entire career as an artist, Klee repeatedly painted and drew winged
beings and angels. In his final years, he created more angel pictures than ever before,
for the most part using a thin chalk or drawing pencil. Many of his angels are still
in the process of creation, with extremely human attributes and characteristics,
such as: *Engel-Anwärter* (*Angel Applicant*), *Unfertiger Engel* (*Unfinished Angel*), *Engel,
noch hässlich* (*Angel, Still Ugly*), *vergesslicher Engel* (*Forgetful Angel*), *altkluger Engel*
(*Precocious Angel*), and (above) the thumb-sucking *Angel in the Kindergarten*.

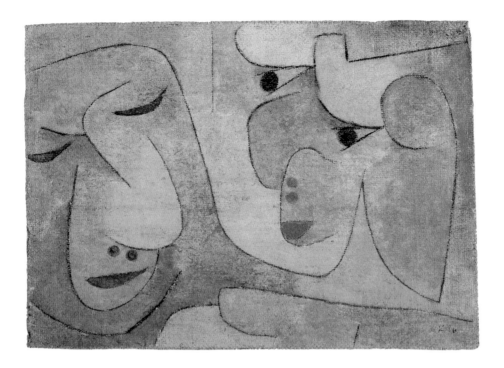

A STRANGELY DIGNIFIED INTELLECT

In the spring of 1938, Klee was visited by the artist Emil Nolde (1867–1956), who subsequently wrote: "He was suffering. The illness had given his features a strangely dignified intellect. I sat there, observing his round, dark eyes and the beautiful, silent melancholy that played around his mouth." Although the sensitive Klee almost never mentioned his illness or the events in Germany, many of his works from this time attest to his inner struggle with and artistic treatment of these fateful issues—sometimes with humor, sometimes defiantly, sometimes with hope, doubt, and suffering.

The following year, Klee wrote Grohmann: "Today, when the joy of living encounters many obstacles, perhaps it can be indirectly reconstructed through one's work? That is how it seems to me, and I believe that it works to some degree."

This year was more productive than all his previous years, with Klee producing 489 works. But his working pace would grow even further.

alte Ehe (Old Married Couple), 1939

The couple's heads seem to have almost grown together; the similarity in the lifelike colors of their faces indicates that they have many things in common. The red mouths tell us that love is still a part of their lives. When Klee painted this picture, he and Lily had been married for thirty-three years. Their son Felix would later describe his parent's marriage as follows: "My parents undoubtedly had a good marriage, but they never merged into one. Each remained his own person."

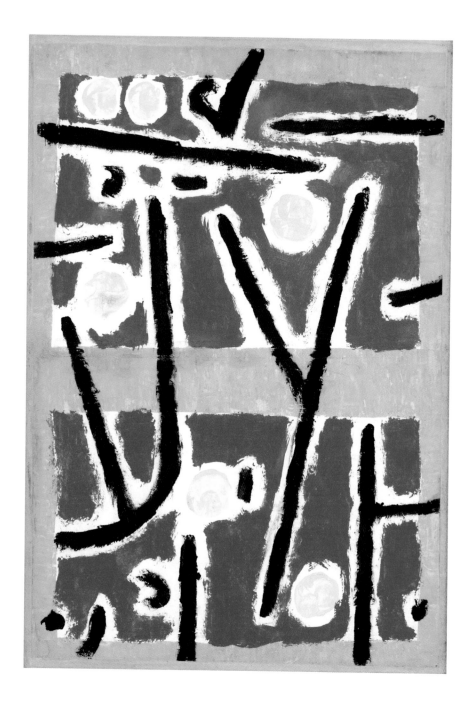

Untitled (Zeichen für Wachstum) (Signs of Growth), 1938

In 1902, the young Klee brought a bergamot plant home from his trip to Italy, which
he reproduced himself. For this, he bent one of the plant's twigs and anchored it in the
earth. Soon, the twig sprouted roots, whereupon Klee separated it from the main plant.
The Y-shaped plant at the center of this picture has two twigs as well, which could be
reproduced by division. The fruits in the picture are reminiscent of another form of
reproduction, through the opening of the fruit and the spreading of the seeds,
which can be seen here in sprouted form. Thus the work's central statement reflects
reproduction and growth through the division of a whole.

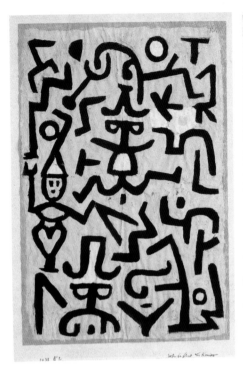

UNDER PRESSURE

Perhaps because he sensed the coming end, Klee began 1939 with enormous creative strength. Lily had already noted during the previous year: "He told me that he could not nearly accomplish all that presses on him." Klee now worked with an extreme concentration, frequently staying up late into the night at his swiveling drawing table, which allowed the physically weakened artist to work while seated.

Werbeblatt der Komiker (Promotional leaflet for comedians), 1938

Is this a work by Keith Haring or A.R. Penck? No, these artists would not be painting similar pictures until fifty years later.

Gesetz (Law), 1938

Bent, branching, mirrored, folded shapes ... Do these symbols describe a law of organic primal forms?

beim blauen Busch (Near the Blue Bush), 1939

Like the main character in Elsa Beskow's classic children's book *Peter in Blueberryland,* this boy may have been magically shrunk, so that the blueberry bush appears like a giant tree. But unlike in the story, there is no one here to help in the picking; the boy is all alone. Writing in a childlike script, Klee scrawled the cryptic message "Stans Dready alla Lone" into the picture, which means "Stands ready, all alone." Loneliness is associated with the farewell written into the poor creature's body: the spread legs form the letter A, the body resembles a D, and the head is an E lying on its side. And so this little being is telling us "ade" ("farewell").

Stelz ich
ein
Bleib
talein

1939 RR1 beim blauen Busch

"Then I shall philosophize on death, which makes amends for that which could not find closure during life. A yearning for death, not as destruction but as a striving for perfection." Paul Klee, 1901

At Easter, Klee was visited by Georges Braque, who much admired Klee and finally wanted to meet him. The planned half hour for this long-desired encounter turned into four hours—and could easily have been days if Klee's strength had not failed him.

Lily, too, had grown increasingly weaker over the past few years; she now spent two months in a sanatorium because of her "utter exhaustion." Caring for her husband, her concern for his state of health, and the situation in Germany had all affected her deeply. In a letter to a friend, she wrote: "Or do you believe that the defamation of my husband would have affected me any less than him?"

In July, Klee and Lily traveled twice to Geneva in order to see an exhibition of works from the Prado. Lily remarked shortly thereafter: "It was the highlight of our summer." In September, the two of them left for an almost two-month holiday on Switzerland's Lake Morat. Their departure was overshadowed by horrifying news of the outbreak of World War Two. Lily wrote of the National Socialists: "The world will only find peace once this clique is gone."

Next to his immense urge to work, Klee's desire to acquire Swiss citizenship grew increasingly more important for him. He wrote letters and personal histories, and justified his departure for Germany. But the authorities took their time. In October, a Swiss police officer wrote that Klee's art represented a threat to Swiss culture. Although Klee received the support of the Berne Kunsthalle's curator Max Huggler, the police officer remained unmoved: the Jewish world in particular profited from Klee's art, he said, and as for the visionary abilities ascribed to Klee by his friends, many people saw it as a sign of mental illness.

tief im Wald (Deep in the Woods), 1939

Deep in the woods, the world is ruled by distinct forces, far removed from Man, such as the mysterious *viriditas*, the green force immanent to the forest, which enchants even plants and flowers.

hungriges Mädchen (Hungry Girl), 1939

Is it hunger for food that plagues this girl, or is it an existential hunger for something we do not know? In extreme desperation, this poor creature stuffs her hand in her mouth—which looks more like the mouth of a wild animal than that of a child. By using the complementary colors of red and green, Klee added even more tension to the expressively bent arm of this being on the verge of insanity.

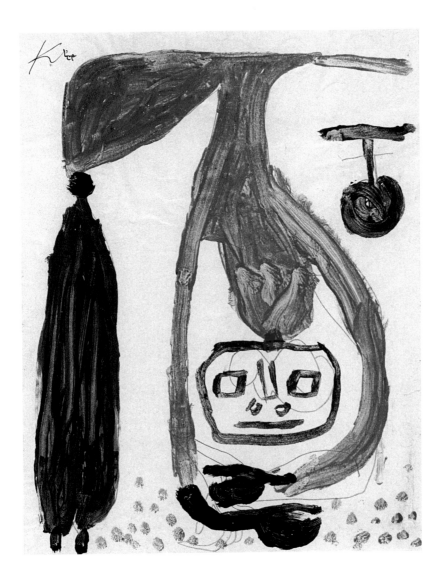

In December, Klee celebrated his sixtieth birthday in the company of close friends and family, including his ninety-year-old father. Around this time, the Kandinskys—who were extremely concerned about Klee's state of health—tried to convince him to visit a famous acupuncturist in Paris, who had already helped Jean Cocteau and Jean Arp and had even relieved Kandinsky of his insomnia. But Klee was too weak for such a trip. And he had to work. Towards the end of the year, he wrote Felix: "My production is taking on increased

herabhängend (Hanging Down), 1939

Sketched with a racing pencil, painted with a rapid brush. When Picasso visited him in 1937, Klee said: "You can turn everything upside down. So much is upside down already." Perhaps Klee had Picasso's words in mind when he painted this picture.

"Oh, that one has become merely Man: half rabble and only half god. An intensely tragic, profound fate. May his entire substance, once formed, lie before me as a document one day. Then I may calmly await the empty–black moment." Paul Klee, 1918

dimensions, and I cannot keep up with my children. They spring forth." For this year, Klee entered 1,253 new items into his catalogue of works—more than at any other point in his life. Of these, 957 were drawings, 253 were colored works on paper, and 43 were paintings. Klee himself called this number a "record performance."

SHOULD EVERYTHING BE KNOWN AFTER ALL?

In mid-January 1940, Klee's father—who had never quite been able to relate to his son's art—passed away. Even in this final year, Klee's creative drive continued unabated. Klee, for whom books had been close companions all his life, had just finished reading the *Oresteia* trilogy by Aeschylus—not just one translation of the ancient tragedy, but three. Writing to Grohmann, Klee reported: "I have now happily read three translations of the *Oresteia*, one after the other. Play by play, scene for scene, with the intention of coming across the right one lying somewhere in-between."

In February, the Kunsthaus Zurich showed a comprehensive exhibition on the occasion of Klee's sixtieth birthday. Klee had personally selected his most recent works for this exhibition.

gesprengt (Blown Up), 1938

No longer a whole, but just individual body parts that do not want to fit together. In 1938 and 1939, Klee repeatedly created drawings of such figures, exploded into separate parts.

*"Of course I don't enter
the tragic path mindlessly;
many of my works
allude to this and say:
It is high time."* Paul Klee, 1940

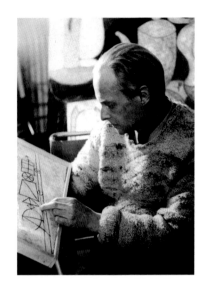

His state of health was very changeable; in the spring, he undertook several trips to Ticino in the hopes of recuperating in the southern climate. In May, he departed on his last trip, traveling to a sanatorium there. Upon his arrival, he wrote to Lily: "I enjoyed captivating scenes of spring on the north side. Ticino is not so sunny right now."

In June, Klee's health took a turn for the worse, but then improved again. Neither Klee nor Lily suspected that he had only a short time left. During these last few weeks, the Swiss citizenship office again asked Klee for more precise reasons for his application. On June 28, he dictated an answer, hoping that his profound wish would be quickly fulfilled. A week later, the city council was prepared to issue Klee citizenship, but it was too late. Paul Klee died early on the morning of June 29 1940 at the Clinica Sant'Agnese in Locarno-Muralto. The immediate cause of death was given as cardiac paralysis resulting from an inflammation of the heart muscle.

In this final year, Klee had managed to create another 366 works.

In May, as Klee had left on his final trip to Ticino, a large painting stood on the easel in his studio. He had not given this work a name. Today it is known as the *Last Still Life*. Into a corner of this painting, Klee had written in pencil, barely visible:

"Should everything be known after all? Ah, I think not!"

Walter Henggeler: Paul Klee with his painting **Bergbahn (Mountain Railway)**, 1939

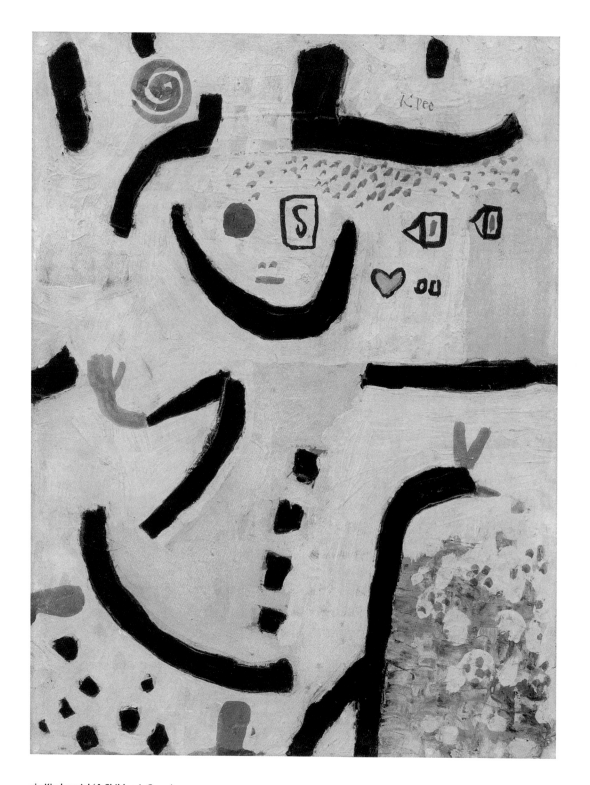

ein Kinderspiel (A Children's Game), 1939

In the final years of his life, Klee again focused intensively on the subject of childhood.
As early as 1909, he had declared that his reputed primitiveness was nothing more than
economy, "that is, ultimate professional awareness."

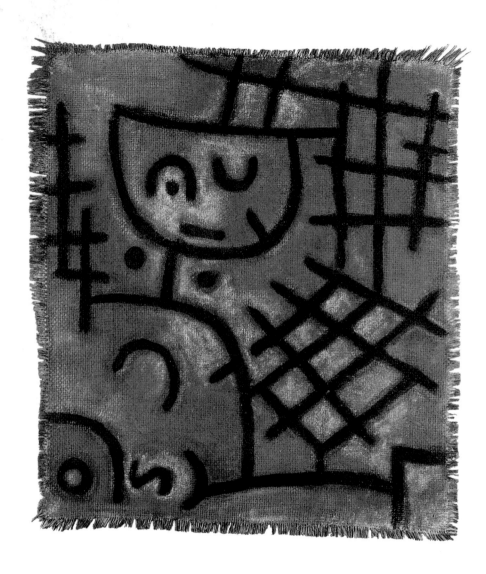

Untitled (Gefangen, Diesseits – Jenseits / Figur) (Captive, This World – Next World / Figure), 1940

This figure is at home neither in this world nor in the next, a condition that makes it feel like a prisoner. Was this how Klee felt shortly before his own death?

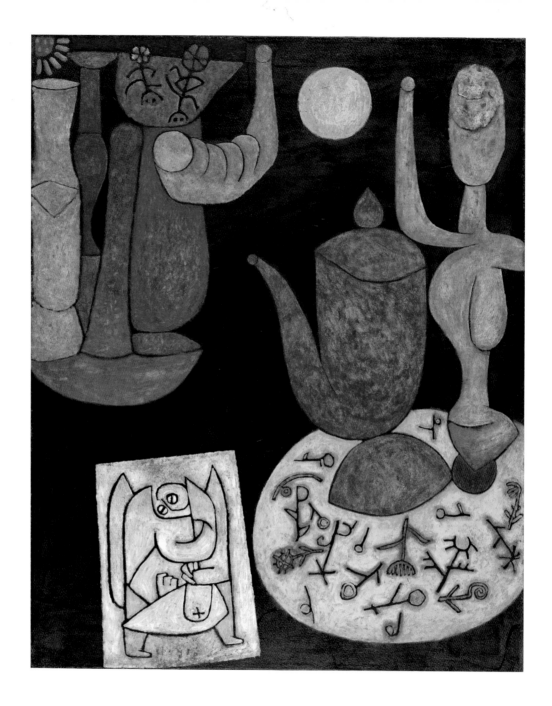

Untitled (Letztes Stillleben) (Last Still Life), 1940

This picture was already on Klee's easel in 1939, and remained there when he departed for his final trip to Ticino in 1940, from which he never returned. He did not give the picture a title or number. In 1917, he had written Lily: "When I am old, very old, then perhaps there will exist a few rooms of my pure mental architecture with several sculptures, the requisite furnishings, and half a hundred pictures…" Perhaps this picture offers an insight into the universe of these private rooms of his mental architecture.

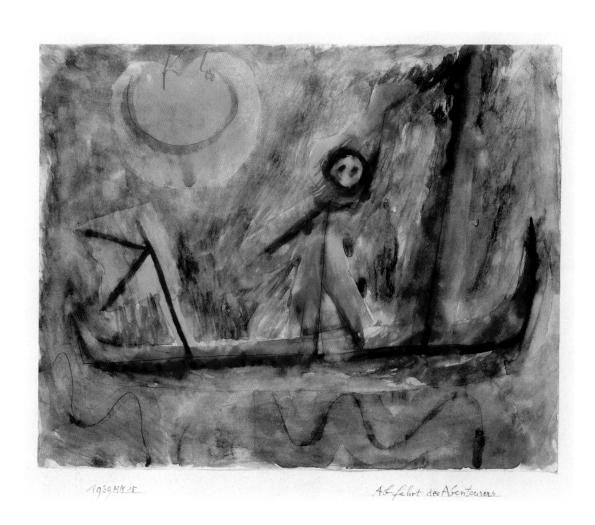

1939 MM 15 Abfahrt des Abenteurers

Abfahrt des Abenteurers (Departure of the Adventurer), 1939

Bidding farewell, the adventurer hoists his sail in order to depart on a solitary voyage.
Where will it take him? On the little flag, we can make out the backwards letter
"K"—perhaps a hint that our traveler's name is Klee.

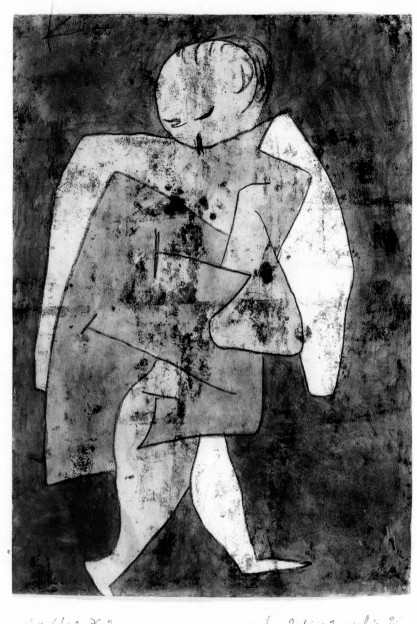

woher? wo? wohin? (Whence? Where? Whither?), 1940

Just a few months before his death, Klee painted this watercolor addressing three basic questions of human existence: From whence comes man when he first sees the light of the Earth, where on Earth does he exist, and whither does he go after his death? Klee did not offer any immediate answers himself, departing this world both enlightened and still inquisitive. And yet this figure—which could be both a child and an old man and whose body is composed of form-dissolving yet form-constituting shapes—seems to be saying: constant change and motion is a quality inherent to man.

LIST OF ILLUSTRATIONS

In the list of illustrations, the numbers that appear after the year correspond to the numbering system used by Klee in his catalogue of works. The spelling of the works' titles reflects as best as possible the spelling contained in Klee's catalogue of works.

p. 1: Paul Klee: *Blau mantel* (*Blue Coat*), 1940, 7 (Z 7), oil and wax paint on paper on card, 22.5 x 27.6 cm, Albertina, Vienna, promised gift of the Carl Djerassi Art Trust II

p. 8: Artist unknown: Epinal print *Azor et Mimi, c.* 1860, 29 x 18.6 cm, Archives Départementales des Vosges, 48 J 9/1_4, © Imagerie d'Épinal, Tous droits réservés

p. 9: Paul Klee: Childhood drawing (*Mimi Presents a Bouquet to Mme. Grenouillet*), undated (1883–1885), pencil on writing paper from cash book, 28.3 x 18.8 cm, private collection, Switzerland, stored at the Zentrum Paul Klee, Berne

p. 11: Paul Klee: Childhood drawing (*Church, the clock with invented numerals*), 1883/1884, 17, pencil and chalk on writing paper on card, 22.5 x 18.1 cm, Zentrum Paul Klee, Berne

p. 13: Paul Klee: Childhood drawing (*Lady with Parasol*), 1883–1885, 15, pencil on red-lined cash-book paper on card, 11.2 x 6.4/8.2 cm, Zentrum Paul Klee, Berne

p. 14: Paul Klee: Childhood drawing (*With House and Staircase*), 1890, colored pencil on paper, 14.9 x 18.3 cm, private collection, Switzerland, stored at the Zentrum Paul Klee, Berne

p. 15: Paul Klee: Childhood painting (*Four Flowers*), *c.* 1889, watercolor on paper, 11 x 14.5 cm, private collection, Switzerland, stored at the Zentrum Paul Klee, Berne

p. 16: Paul Klee: Satirical drawings in a school exercise book (German Literature), 1897, private collection, Switzerland, stored at the Zentrum Paul Klee, Berne

p. 17: Paul Klee: *Blick auf die Junkerngasse* (*View of the Junkerngasse*), 1893, pencil on handmade paper, mounted on thick paper, 7.3 x 13 cm, The Metropolitan Museum of Art, New York, The Berggruen Klee Collection, inv. no. 1984.315.1

pp. 18–19: Paul Klee: Painted wall of his parents' house in Berne, Obstbergweg 6 (not open to the public) (selection), *c.* 1898

p. 20: Paul Klee: *Untitled (Landschaft mit Baumgruppe)* (*Landscape with Groups of Trees*), 1897, pencil on card, 8.3 x 20.4 cm, private collection, Switzerland, stored at the Zentrum Paul Klee, Berne

p. 21: Paul Klee: *Meine Bude* (*My Room*), 1896, pen, brush and pencil on paper, 12.1 x 19.2 cm, Zentrum Paul Klee, Berne

p. 25: Paul Klee: *Selbst* (*Myself*), 1899, 1, pencil on paper on card, 13.7 x 11.3 cm, Zentrum Paul Klee, Berne, gift of Livia Klee

p. 27: Paul Klee: *Untitled (Zwei Fische, ein Angelhaken, ein Wurm)* (*Two Fish, a Hook, a Worm*), 1901, pen and watercolor on card, 16.2 x 23.2 cm, private collection, Switzerland, stored at the Zentrum Paul Klee, Berne

p. 29: Paul Klee: *Untitled (Anatomische Zeichnung der Fussmuskulatur)* (*Anatomical Drawing: Muscles of the Foot*), 1902, pencil on paper, 21.1 x 25 cm, Zentrum Paul Klee, Berne

p. 31: Paul Klee: *Weib u. Tier* (*Woman and Beast*), 1904, 13, zinc etching, 20 x 22.8 cm, Albertina, Vienna, inv. no. DG 1924/684

p. 32: Paul Klee: *Schwangeres Mädchen sitzend; weiblicher Akt mit Andeutung des Beinkleids* (*Pregnant Girl Seated; Female Nude with Suggestion of Leg Coverings*), 1905, 16, pencil and watercolor, contours scored with a needle, on two pieces of checkered paper, entire verso ocher, on card, 12/15.3 x 15.5/17.1 cm, Zentrum Paul Klee, Berne

p. 34: Paul Klee: Childhood drawing (*Man, ?, Chair, Hare*), 1884, 18, pencil and chalk on writing paper on card, 12.3 x 17.3 cm, Zentrum Paul Klee, Berne

p. 36: Paul Klee: *Der Held mit dem Flügel* (*Winged Hero*), 1905, 38, zinc etching, 25.7 x 16 cm, Zentrum Paul Klee, Berne

p. 37: Paul Klee: *Drohendes Haupt* (*Menacing Head*), 1905, 37, zinc etching, 19.7 x 14.5 cm, private collection

p. 39: Paul Klee: *Paul u. Fritz* (*Paul and Fritz*), 1905, 19, watercolor, white background, reverse glass painting, 13 x 18 cm, Zentrum Paul Klee, Berne

p. 41: Paul Klee: *Akt auf der Schaukel* (*Nude on a Swing*), 1906, 15, white paint, intaglio image, multicolor background, reverse-glass painting, 24 x 16 cm, Zentrum Paul Klee, Berne

p. 42: Paul Klee: *m Vater* (*My Father*), 1906, 23, brush and intaglio, white background, reverse-glass painting, 31.8 x 29.3 cm, Zentrum Paul Klee, Berne, gift of Livia Klee

p. 46: Paul Klee: *kleines Erinnerungsbildnis Lily* (*A Small Memento of Lily*), 1905, 21, reverse-glass painting, 18 x 13 cm, Zentrum Paul Klee, Berne

p. 48: Paul Klee: *Bildnisscizze n. Felix* (*Portrait Sketch of Felix*), 1908, 73, watercolor on paper, lower strip in pen, on card, 19.4 x 16.5 cm, The Metropolitan Museum of Art, New York, The Berggruen Klee Collection, inv. no. 1984.315.2

p. 49: Paul Klee: *Man bricht gar leicht den Hals klimmt man hinauf die Leiter Behaglich sitzt man auf der ersten Sprosse* (*S. 42*) (*It's all too easy to break one's neck when climbing up the ladder, it's more comfortable to sit on the first rung [p. 42]*), 1908, pen on paper, 31.4 x 24.1 cm, private collection

p. 50: Paul Klee: *Steinbruch Ostermundingen* (*Quarry of Ostermundingen*), 1908, 74, watercolor on paper on card, 16.1 x 29 cm, Städtische Galerie im Lenbachhaus, Munich, inv. no. G13263

p. 51: Paul Klee: *d. Pianist in Not* (*The Pianist in Need*), 1909, 1, pen and watercolor on paper on card, 16.5 x 18 cm, private collection, Switzerland, stored at the Zentrum Paul Klee, Berne

p. 52: Paul Klee: *blumensteg, Giesskanne u Eimer* (*Flower Stand, Watering Can and Bucket*), 1910, 47, watercolor on paper on card, 13.9 x 13.3 cm, Städtische Galerie im Lenbachhaus, Munich, inv. no. G13116

p. 53: Paul Klee: *Strassen Kreuzung* (*Crossroad*), 1911, 61, pen and brush, wet-on-wet, on paper on card, 12 x 19 cm, Fondazione Antonio Mazzotta, Milan

p. 54: Paul Klee: *Il le perce d'outre en outre* (illustration for Voltaire's *Candide*), 1911, 62, pen on paper on card, 15 x 25.2 cm, Zentrum Paul Klee, Berne

p. 55: Paul Klee: *Junger Mann, ausruhend* (*Young Man, Resting*), 1911, 42, brush and pencil on paper on card, 13.8 x 20.2 cm, private collection, Switzerland

p. 56: Paul Klee: *Laternen* (*Street Lamps*), 1912, 59, pen, brush, watercolor, wet-on-wet, on paper on card, 12.1 x 23.5 cm, E.ON-Ruhrgas AG

p. 57: Gabriele Münter: *Mann im Sessel (Paul Klee)* (*Man in Armchair [Paul Klee]*), 1913, oil on canvas, Pinakothek der Moderne, Munich

p. 58: Paul Klee: *Der Polizeihund wird in Wut versetzt – damit er die Spur verfolgt* (*The Police Dog is Antagonized – So That He Will Follow the Trail*), 1913, Postcard sent by Paul Klee to Franz Marc on 26 September 1913, Franz Marc Museum, Kochel am See, Franz Marc Stiftung

p. 59: Paul Klee: *Ein Hotel* (*A Hotel*), 1913, 120, watercolor on paper on card, 23.5 x 21 cm, The Baltimore Museum of Art, Nelson and Juanita Greif Gutman Collection, inv. no. 1963.16.19

p. 60: Paul Klee: *Hommage à Picasso* (*Homage to Picasso*), 1914, 192, oil on card, 38 x 30 cm, private collection, France

p. 61: Photographer unknown: August Macke and Paul Klee with their guide in Kairouan, April 1914, Westfälisches Landesmuseum für Kunst und Kulturgeschichte, Münster

p. 62: Robert Delaunay: *Fenetre sur la ville* (*Window on the City*), 1914, wax painting on paperboard, 28.8 x 20 cm, Städtische Galerie im Lenbachhaus, Munich

p. 63: Paul Klee: *garten in der tunesischen Europäer Kolonie St. Germain* (*Garden in St. Germain, the European Quarter of Tunis*), 1914, 213, watercolor on paper, verso pen, on card, 21.6 x 27.3 cm, The Metropolitan Museum of Art, New York, The Berggruen Klee Collection, inv. no. 1984.315.3

p. 64: Paul Klee: *Hammamet mit der Moschee* (*Hammamet with the Mosque*), 1914, 199, watercolor and pencil on paper, cut up and recombined, on card, 20.6 x 19.4 cm, The Metropolitan Museum of Art, New York, The Berggruen Klee Collection, inv. no. 1984.315.4

p. 65: Paul Klee: *Motiv aus Hammamet* (*Motif from Hammamet*), 1914, 48, watercolor and pencil on paper on card, 20.3 x 15.7 cm, Kunstmuseum Basel, Kupferstichkabinett, bequest of Richard Doetsch-Benzinger, inv. no. 1960.56

p. 66: Paul Klee: *Badestrand St. Germain bei Tunis* (*Bathing Beach of St. Germain near Tunis*), 1914, 215, watercolor on paper on card, 21.5 x 26.9 cm, Ulmer Museum, on permanent loan from the state of Baden-Württemberg, inv. no. BW1963.28

p. 67: Paul Klee: *Kairuan, vor dem Thor* (*Kairouan, before the Gate*), 1914, 72, watercolor and pencil on paper on card, 13.5 x 22 cm, Moderna Museet, Stockholm, inv. no. NMB1701

p. 68: Paul Klee: *mit d. mauve Dreieck* (*With the Mauve Triangle*), 1914, 103, watercolor and pencil on paper on card, 9.4 x 15.8 cm, Von der Heydt-Museum, Wuppertal, on permanent loan from private collection

p. 69: Paul Klee: *Föhn im Marc'schen Garten* (*Föhn Wind, in Franz Marc's Garden*), 1915, 102, watercolor on paper on card, 20 x 15 cm, Städtische Galerie im Lenbachhaus, Munich, inv. no. G13266

p. 70 l.: Paul Klee: *Trauerblumen* (*Mourning Flowers*), 1917, 132, watercolor and pen on paper on card, 23.3 x 14.8 cm, private collection, Germany

p. 70 r.: Paul Klee: *Zerstörung und Hoffnung* (*Destruction and Hope*), 1916, 55, hand-colored lithograph, 40.5 x 33 cm, Albertina, Vienna

p. 71: Paul Klee: *Spiel der Kräfte einer Lechlandschaft* (*Interplay of Forces of a Lech-river Landscape*), 1917, 102, watercolor on chalk-primed canvas and newspaper on card, 16.4 x 24.3 cm, private collection

p. 72: Paul Klee: *Kosmisch durchdrungene Landschaft* (*Cosmically Penetrated Landscape*), 1917, 76, watercolor and pen on paper on gold paper on card, 21.1 x 26.4 cm, Ulmer Museum, on permanent loan from the state of Baden-Württemberg, inv. no. BW1971.61

p. 73: Paul Klee: *Versunkene Landschaft* (*Sunken Landscape*), 1918, 65, watercolor, gouache and pen on paper, glossy paper strips affixed at top and bottom, on card, 17.6 x 16.3 cm, Museum Folkwang, Essen

p. 74: Paul Klee: *Der bayrische Don Giovanni* (*The Bavarian Don Giovanni*), 1919, 116, watercolor and pen on paper, 22.5 x 21.3 cm, The Solomon R. Guggenheim Museum, New York, inv. no. 48.1172x69

p. 76: Paul Klee: *Kopf aus einem im Lech geschliffenen Ziegelstück* (*Head Formed from a Piece of Brick Smoothed by the River Lech*), 1919, 33, plaster statue, 17.5 cm, Zentrum Paul Klee, Berne

p. 77: Paul Klee: *Rotes Mädchen mit gelbem Topfhut* (*Red Girl with Yellow Bowl-shaped Hat*), 1919, 224, oil transfer and watercolor on paper on card, 23.7 x 18.5 cm, Staatliche Museen zu Berlin, Nationalgalerie, Museum Berggruen, private collection, inv. no. 224

p. 78: Paul Klee: *Abstürzender Vogel* (*Crashing Bird*), 1919, 206, oil transfer, watercolor and pen on paper, lower strip in pen, on card, 16.2 x 18.7 cm, The Metropolitan Museum of Art, New York, The Berggruen Klee Collection, inv. no. 1984.208.4

p. 79: Paul Klee: *nach der Zeichnung 19/75* (*Versunkenheit*) (*After the drawing 19/75 [Absorption]*), 1919, 113, hand-colored lithograph, 23.6 x 16 cm, Albertina, Vienna, promised gift of the Carl Djerassi Art Trust II

p. 80: Paul Klee: *Sumpflegende* (*Swamp Legend*), 1919, 163, oil on card, 47 x 40.8 cm, Städtische Galerie im Lenbachhaus und Kunstbau, Munich, Gabriele Münter- und Johannes Eichner-Stiftung

p. 81: Paul Klee: *Der Blick des Ahriman* (*The Gaze of Ahriman*), 1920, 148, watercolor and gouache on paper, cut up and recombined, on new paper on card, 12.5 x 20.5 cm, private collection, France

p. 82: Paul Klee: *Die Büchse der Pandora als Stilleben* (*Pandora's Box as Still Life*), 1920, 158, oil transfer and watercolor on paper on card, 16.8 x 24.1 cm, Staatliche Museen zu Berlin, Nationalgalerie, Museum Berggruen

p. 83: Paul Klee: *Biografische Skizze* (*Biographical Sketch*) from special issue of *Der Ararat* published for the Paul Klee exhibition at the Goltz Gallery, 1920 (*Der Ararat*, vol. 1, 1920, 2nd special issue *Paul Klee*, p. 20)

p. 85: Paul Klee: *Kamel (in rhythm. Baumlandschaft)* (*Camel [in a Rhythmic Landscape of Trees]*), 1920, 43, oil and pen on chalk-primed gauze on card, 48 x 42 cm, Kunstsammlung Nordrhein-Westfalen, Düsseldorf, inv. no. 1030

p. 87: Paul Klee: *Rosa*, 1920, 129, oil on card, 20.3 x 14.6 cm, Galerie Haas, Zurich (www.galeriehaasag.ch)

p. 89: Paul Klee: *Angelus novus*, 1920, 32, oil transfer and watercolor on paper on card, 31.8 x 24.2 cm, The Israel Museum, Jerusalem, gift of John & Paul Herring, Jo Carole & Ronald Lauder, Fania & Gershom Scholem, inv. no. B 87.994

p. 93: Paul Klee: *(aus dem hohen Lied)* ‹II. Fassung› (*[From the Song of Songs], Version II*), 1921, 179, pen, brush and watercolor on paper, with watercolor and pen border, on card, 16.2 x 17.4 cm, Solomon R. Guggenheim Museum, New York, inv. no. 48.1172x535

p. 97: Paula Stockmar: Paul Klee, portrait on a postcard from the gallery Der Sturm, 1916, Bauhaus Archiv Berlin, inv. no. 8583

p. 98: Paul Klee: *Wo die Eier herkommen und der gute Braten (für Florina-Irene)* (*Where the Eggs and the Good Roast Come from [for Florina-Irene]*), 1921, 6, oil transfer and watercolor on paper on card, 15.6 x 28.9 cm, The Metropolitan Museum of Art, New York, The Berggruen Klee Collection, inv. no. 1987.455.6

p. 99: Paul Klee: *Die Heilige vom innern Licht* (*The Saint of the Inner Light*), 1921, 122, 30.8 x 17.2 cm (paper 38.8 x 26.5 cm), color lithograph, Ketterer Kunst, Munich (www.kettererkunst.com)

p. 100: Paul Klee: *Waldbeere* (*Woodland Berry*), 1921, 92, watercolor and pencil on paper, cut up and recombined, with gouache and pen border, on card, 32 x 25.1 cm, Städtische Galerie im Lenbachhaus, Munich, inv. no. G 15694

p. 101: Paul Klee: *Fuge in Rot* (*Fugue in Red*), 1921, 69, watercolor and pencil on paper, paper strips affixed left and right, on card, 24.4 x 31.5 cm, private collection, Switzerland

p. 102: Paul Klee: *Der Gott des nördlichen Waldes* (*God of the Northern Forest*), 1922, 32, oil and pen on canvas, with watercolor border, on card, 53.5 x 41.4 cm, Zentrum Paul Klee, Berne

p. 103: Photographer unknown: Bauhaus masters (from left to right: Feininger, Kandinsky, Schlemmer, Muche, Klee) at Klee's Weimar studio, 1925

p. 104: Paul Klee: *Postkarte zum Laternenfest am Bauhau* (*Postcard for lantern festival at the Bauhaus*) 1922, lithograph, 8.9 x 14.4 cm, San Francisco Museum of Modern Art, Djerassi Art Trust I

p. 105: Photographer unknown: Paul Klee in his studio at the Weimar Bauhaus, 1925, private collection, Berlin, courtesy Galerie M + R Fricke, Berlin

pp. 106–107: Paul Klee: Group portrait of hand puppets, 1916–1925, Zentrum Paul Klee, Berne, gift of Livia Klee

p. 108: Paul Klee: *Senecio (Baldgreis)*, 1922, 181, oil on chalk-primed gauze on card, 40.5 x 38.4 cm, Kunstmuseum Basel, inv. no. 1569

p. 110 above left: Paul Klee: *Der Seiltänzer* (*The Tightrope Walker*), 1923, 138, lithograph with red clay plate, 44 x 26.8 cm, Ketterer Kunst, Munich (www.kettererkunst.com)

p. 110 above right: Paul Klee: *Die Zwitscher-Maschine* (*The Twittering Machine*), 1922, 151, oil transfer and watercolor on paper, with watercolor and pen border, on card, 41.3 x 30.5 cm, The Museum of Modern Art, New York, Mrs. John D. Rockefeller Jr. Purchase Fund, inv. no. 564.39

p. 110 left: Paul Klee: *Zwei Kräfte* (*Two Forces*), 1922, 23, watercolor on chalk-primed paper, top and bottom watercolor borders, on card, 24.6 x 16.8 cm, Staatliche Museen zu Berlin, Nationalgalerie, Museum Berggruen

p. 111: Paul Klee: *Nord See Insel* (*North Sea Island*), 1923, 180, watercolor on paper, with watercolor and pen border, lower strip in watercolor and pen, on card, 37.1 x 51.8 cm, San Francisco Museum of Modern Art, on permanent loan from the Carl Djerassi Trust I

p. 112: Paul Klee: *Wandbild aus dem tempel der sehnsucht ↖dorthin↗* / (*Mural from the Temple of Desire ↖thither↗*), 1922, 30, oil transfer and watercolor on plaster-primed gauze on card, 26.7 x 37.5 cm, The Metropolitan Museum of Art, New York, The Berggruen Klee Collection, inv. no. 1984.315.33

p. 113: Paul Klee: Entry in Otto Ralfs's guest book, 1923, India ink and pen on paper, 9.5 x 14.7 cm, Städtisches Museum, Braunschweig

p. 114: Paul Klee: *Landschaft mit gelben Vögeln* (*Landscape with Yellow Birds*), 1923, 32, watercolor and chalk on black-primed paper, cut up and recombined, with gouache and pen border, lower strip in watercolor and pen, on card, 35.5 x 44 cm, private collection, Switzerland

p. 115: Paul Klee: *Eros*, 1923, 115, watercolor, gouache and pencil on paper, cut up and recombined, lower strip in watercolor and pen, with gouache and pen border, on card, 33.3 x 24.5 cm, Sammlung Rosengart, Lucerne

p. 116: Paul Klee: *Die Stachel-Schlinge mit den Maeusen* (*The Barbed Snare with the Mice*), 1923, 105, watercolor and gouache on paper, upper and lower strips in watercolor and pen, second lower strip in watercolor and pen, on card, 22.9 x 30.8 cm, The Metropolitan Museum of Art, New York, The Berggruen Klee Collection, inv. no. 1987.455.13

p. 117: Paul Klee: *Sternverbundene* (*Connected to the Stars*), 1923, 159, watercolor and pencil on paper, with watercolor and pen border, lower strip in watercolor and pen, on card, 32.4/32.8 x 48.3/48.7 cm, private collection, Switzerland, stored at the Zentrum Paul Klee, Berne

p. 118: Paul Klee: Reverse side (c. 1923) of *Botanisches Theater* (*Botanical Theatre*), 1934, 219 (U 19) (1924/1934), plywood panel laminated with nettle cloth and covered in pink ash, 50.2 x 67.5 cm, Städtische Galerie im Lenbachhaus, Munich, Gabriele Münter- und Johannes Eichner-Stiftung, inv. no. G 15632

p. 119: Paul Klee: *Botanisches Theater* (*Botanical Theatre*), 1934/1934, 219 (U 19) (1924/1934), oil, watercolor, brush and pen on paper on card on plywood, 50.2 x 67.5 cm, Städtische Galerie im Lenbachhaus, Munich, Gabriele Münter- und Johannes Eichner-Stiftung, inv. no. G 15632

p. 120: Paul Klee: *wie ein Glasfenster* (*Like a Window Pane*), 1924, 290 (Ö 2), oil on plaster-primed gauze on card, nailed onto a stretcher frame, 42.2 x 28.2 cm, Sammlung Rosengart, Lucerne

p. 121: Paul Klee: *der Goldfisch* (*The Goldfish*), 1925, 86 (R 6), oil and watercolor on paper on card, 49.6 x 69.2 cm, Hamburger Kunsthalle, gift of Friends of Carl Georg Heise, inv. no. 2982

p. 122 l.: Two-page spread from the catalogue of Klee exhibition in Paris (Galerie Vavin-Raspail), 1925, Zentrum Paul Klee, Berne

p. 122 r.: Clipping from *San Francisco Examiner*, November 1, 1925

p. 123: Paul Klee: *Schauspieler=Maske* (*Actor=Mask*), 1924, 252, oil on canvas, nailed onto wood, 36.7 x 33.8, The Museum of Modern Art, New York, The Sidney and Harriet Janis Collection, inv. no. 616.67

p. 124: Paul Klee: *Schema Ich-Du-Erde-Welt* (*I-You-Earth-World Diagram*), c. 1924, page from Klee's Pedagogical Estate, pen on paper on card, 33 x 21 cm, Zentrum Paul Klee, Berne

p. 125: Paul Klee: *die Maske mit dem Fähnchen* (*The Mask with the Little Flag*), 1925, 220 (W 0), pencil and watercolor, partially sprayed, on chalk-primed paper on card, 65 x 49 cm, Bayerische Staatsgemäldesammlungen, Staatsgalerie moderner Kunst, Munich, inv. no. 11251

p. 126: Paul Klee: *Rhythmen einer Pflanzung* (*Rhythms of a Plantation*), 1925, 78 (Qu 8), watercolor on paper on card, 23 x 30.5 cm, Musée National d'Art Moderne, Centre Georges Pompidou, Paris, bequest of Nina Kandinsky, inv. no. AM 81-65-878

p. 127: Paul Klee: *die Pflanze und ihr Feind* (*The Plant and its Enemy*), 1926, 74 (Qu 4), pen and watercolor, partially sprayed, on paper on card, 46.7/46.9 x 31.2 cm, Staatliche Kunstsammlungen Dresden, Kupferstich-Kabinett, inv. no. C 1955-18

p. 128: Photographer unknown: Group photograph of Bauhaus masters, 1926, Bauhaus Archiv Berlin

p. 129: Lucia Moholy: Paul Klee in the studio of his master's house in Dessau, 1926, Bauhaus Archiv Berlin, inv. no. 12434/60.1

p. 130 l.: Paul Klee: Arrangement with moss animals on Irish moss, false Irish moss, hornwrack, mid- to late 1920s, with painted plaster border, 11 x 17 cm, Zentrum Paul Klee, Berne, gift of the Klee family

p. 130 r.: Paul Klee: Herbarium page, 1930, pressed plants on primed paper (labeled from left to right: Orobanche, Pinguicula alpina, Solanum dulcamara, Digitalis ambigua, Aconitum lycoctonum, Aconitum nappellus), 46 x 30 cm, Zentrum Paul Klee, Berne, gift of the Klee family

p. **131**: Paul Klee: *Zaubergarten* (*Magic Garden*), 1926, 141 (E 1), oil on plasterboard in wooden frame, 52 x 42.1 cm, The Solomon R. Guggenheim Foundation, Peggy Guggenheim Collection, Venice, inv. no. PG 90

p. **132**: Paul Klee: *schwarzer Fürst* (*Black Prince*), 1927, 24 (L 4), oil and tempera on canvas, 33 x 29 cm, Kunstsammlung Nordrhein-Westfalen, Düsseldorf, inv. no. 16

p. **133**: Paul Klee: *Schiffe im Dunkeln* (*Ships in the Dark*), 1927, 143 (E 3), oil on nettle cloth, 41.5 x 57.5 cm, Bayerische Staatsgemäldesammlungen, Staatsgalerie moderner Kunst, Munich, on loan from private collection, inv. no. L 1652

p. **134 above**: Reingart Voigt: Color study from Klee's class, c. 1929, Bauhaus Archiv Berlin, inv. no. 1996/5.5b

p. **134 below**: Paul Klee: Page from *Bildnerische Gestaltungslehre* (*Visual Design Theory*), c. 1928, pencil on paper, 33 x 20.9 cm, Zentrum Paul Klee, Berne, PN9 M8/1

p. **135**: Paul Klee: *rote Brücke* (*Red Bridge*), 1928, 58 (O 8), watercolor on oil-primed paper, with gouache and pen border, on card, 21.1 x 32.8 cm, Staatsgalerie Stuttgart, Graphische Sammlung, bequest of Annemarie Grohmann, inv. no. C 70/2015

p. **136**: Wolfgang Kleber: The stairway in the Klee master's house today, HOCHTIEF, Essen

p. **137**: Photographer unknown: Three portraits of Paul Klee, Dessau 1928, Stadtarchiv Zürich

p. **138**: Paul Klee: *alte Stadt* (*Überblick*) (*Old Town* [*overall view*]), 1928, 78 (Qu 8), watercolor on white-primed paper on card, 29.5 x 22.4 cm, Kunstmuseum Basel, Kupferstichkabinett, bequest of Richard Doetsch-Benziger, inv. no. 1960.61

p. **139**: Paul Klee: *Lichtbreitung I* (*Light-broadening I*), 1929, 242 (Y 2), watercolor on paper on card, 24.3 x 18 cm, private collection, Switzerland

p. **140 above**: Ernst Kallai: *Der Bauhausbuddha* (*The Bauhaus Buddha*), 1928/1929, collage, whereabouts of original drawing unknown, photograph of drawing c. 1919, Bauhaus Archiv Berlin

p. **140 below**: Paul Klee: *Untitled (Relief in Zigarrenschachtel)* (*Relief in Cigar Box*), 1929, bas-relief; plaster, painted, mounted on lid of tin can placed in a cigar box; metal lid and inside of box primed with plaster and painted in color, 23.5 x 12.5 x 3.2 cm, Zentrum Paul Klee, Berne

p. **141**: Paul Klee: *Katze und Vogel* (*Cat and Bird*), 1928, 73 (Qu 3), oil and pen on plaster-primed gauze on plywood, 38.8 x 53.4 cm, The Museum of Modern Art, New York, inv. no. 300.75

p. **142**: Paul Klee: *Denkmäler bei G.* (*Monuments near G.*), 1929, 93 (S 3), watercolor on plaster-primed canvas on stretcher frame, 69.5 x 50.2 cm, The Metropolitan Museum of Art, New York, The Berggruen Klee Collection, inv. no. 1984.315.51

p. **143**: Paul Klee: *Hauptweg und Nebenwege* (*Highway and Byways*), 1929, 90 (R 10), oil on canvas on stretcher frame, 83.7 x 67.5 cm, Museum Ludwig, Cologne, inv. no. ML 76/3253

p. **144**: Paul Klee: *ad marginem*, 1930, 210 (E 10), watercolor on lacquer-primed card pinned on stretcher frame covered in gauze, 46 x 36 cm, Kunstmuseum Basel, bequest of Richard Doetsch-Benziger, inv. no. G 1960.32

p. **145 l.**: Paul Klee: *andante*, 1931, 33 (K 13), pen on paper on card, 57.2 x 40.5 cm, Albertina, Vienna, promised gift of the Carl Djerassi Art Trust II

p. **145 r.**: Paul Klee: *versiegelte Dame* (*Sealed Lady*), 1930, 62 (P 2), pen and watercolor on paper, lower strip in watercolor and pen, on card, 48.5 x 34.7 cm, Staatliche Museen zu Berlin, Nationalgalerie, Museum Berggruen

p. **146**: Paul Klee: *Bildnis in der Laube* (*Portrait in the Arbor*), 1930, 7 (7), watercolor and gouache on paste-primed paper, upper and lower strips in gouache, on card, 31 x 24.3 cm, Galerie Salis & Vertes, Zurich/Salzburg (www.salisvertes.com)

p. **147**: Paul Klee: *Klippen am Meer* (*Cliffs by the Sea*), 1931, 154 (R 14), oil on primed canvas on stretcher frame, 44.5 x 62 cm, Städtische Galerie am Lenbachhaus, Munich, on permanent loan from the Gabriele Münter- und Johannes Eichner-Stiftung, inv. no. FH 211

p. **149**: Paul Klee: *Drüber und drunter* (*Above and Below*), 1932, 228 (V 8), watercolor on primed paper on card, 47.5 x 29.2 cm, Staatliche Museen zu Berlin, Nationalgalerie, Museum Berggruen, inv. no. 228 (V 8)

p. **150**: Paul Klee: *Ad Parnassum*, 1932, 274 (X 14), oil, stamped lines, dots stamped in white and subsequently painted over, on casein paint on canvas on stretcher frame, original painted wood frame, 100 x 126 cm, Kunstmuseum Bern, on permanent loan from Freunde des Kunstmuseums Bern, inv. no. G 1427

p. **151**: Paul Klee: *Umfangen* (*Encircled*), 1932, 1932, 67 (M 7), oil on canvas on stretcher frame, 84 x 64 cm, Staatliche Museen zu Berlin, Nationalgalerie, private collection, inv. no. F.V.150

p. **153**: Paul Klee: *Maske Furcht* (*Mask: Fear*), 1932, 286 (Y 6), oil on burlap on stretcher frame, 100.4 x 57.1 cm, The Museum of Modern Art, New York, Nelson A. Rockefeller Fund, inv. no. 854.78

p. **155**: Paul Klee: *Menschenjagd* (*Manhunt*), 1933, 115 (Qu 15), pencil on paper on card, 23/23.3 x 32.3 cm, Zentrum Paul Klee, Berne

p. **159**: Paul Klee: *Europa*, 1933, 7 (K 7), watercolor on paper on card, 49 x 38.2 cm, Kunsthalle Bielefeld, bequest of Herta Koenig, inv. no. C 878

p. **160**: Paul Klee: *Blühendes* (*Flowering*), 1934, 199 (T 19), oil on primed canvas on stretcher frame, 81.5 x 80 cm, Kunstmuseum Winterthur, bequest of Clara and Emil Friedrich-Jezler, inv. no. 1184

p. **161**: Paul Klee: *Vogelscheuche* (*Scarecrow*), 1935, 145 (R 5), oil canvas on stretcher frame, 71 x 55 cm, Museum Moderner Kunst Stiftung Ludwig Wien

p. **162**: Paul Klee: *Löwenmensch* (*Lion Man*), 1934, 2 (2), watercolor on paper on card, 47.6 x 30.6 cm, San Francisco Museum of Modern Art, on permanent loan from the Djerassi Art Trust

p. **163**: Paul Klee: *Schweizer Landschaft* (*Swiss Landscape*), 1919, 46, watercolor on chalk-primed linen on paper on card, 21 x 24.2 cm, location unknown

p. **164 above.**: Paul Klee: *Gezeichneter* (*Marked Man*), 1935, 146 (R 6), oil and watercolor on oil-primed gauze on card pinned onto stretcher frame, 32 x 29 cm, Kunstsammlung Nordrhein-Westfalen, Düsseldorf, inv. no. 39

164 below: Paul Klee: *Formel eines Krieges* (*Formula of a War*), 1936, 2 (2), oil and watercolor on paper, pen-and-pencil raster, on card, 47.8 x 62.8 cm, private collection, France

p. **166**: Paul Klee: *Revolution des Viaductes* (*Revolution of the Viaduct*), 1937, 153 (R13), oil on oil-primed cotton on stretcher frame, 60 x 50 cm, Hamburger Kunsthalle, Hamburg, inv. no. 2899

p. **167**: Paul Klee: *Bilderbogen* (*Pictured sheet with pictures*), 1937, 133 (Qu 13), oil on canvas on stretcher frame, 59 x 56 cm, The Phillips Collection, Washington, inv. no. 0999

p. **168**: Paul Klee: *Blüten der Nacht* (*Flowers of the Night*), 1938, 313 (T 13), pastel on burlap on card, 43 x 33.5 cm, Sammlung Ernst Beyeler, Basel

p. **169**: Paul Klee: *ein Weib für Götter* (*A Woman for Gods*), 1938, 452 (A 12), colored paste and watercolor on paper on card, 44.5 x 61 cm, Fondation Beyeler, Riehen/Basel

pp. **170–171**: Paul Klee: *Insula dulcamara*, 1938, 481 (C 1), oil and colored paste on newspaper on burlap on stretcher frame, original frame, 88 x 176 cm, Zentrum Paul Klee, Berne

p. **173**: Paul Klee: *Engel im Kindergarten* (*Angel in the Kindergarten*), 1939, 968 (AB 8), pencil on paper on card, 29.5 x 21 cm, Zentrum Paul Klee, Berne

p. **174**: Paul Klee: *alte Ehe* (*Old Married Couple*), 1939, 505 (AA 5), watercolor and chalk on chalk/paste-primed burlap on card, 33 x 47.6 cm, Norton Museum of Art, West Palm Beach, gift of R.H. Norton, inv. no. 53.94

p. **175**: Paul Klee: *Untitled (Zeichen für Wachstum)* (*Signs of Growth*), 1938, colored paste on card, 47 x 33 cm, Sprengel Museum, Frankfurt, on loan from the Sammlung Commerzbank (formerly Sammlung Dresdner Bank)

p. **176 l.**: Paul Klee: *Werbeblatt der Komiker* (*Promotional Leaflet for Comedians*), 1938, 42 (E 2), colored paste on newspaper on card, 48.6 x 32.1 cm, The Metropolitan Museum of Art, New York, The Berggruen Klee Collection, inv. no. 1984.315.57

p. **176 r.**: Paul Klee: *Gesetz* (*Law*), 1938, 38 (D 18), colored paste on newspaper on card, 48.5 x 32.5 cm, Bayerische Staatsgemäldesammlungen, Staatsgalerie moderner Kunst, Munich, on loan from private collection, inv. no. L 1660

p. **177**: Paul Klee: *beim blauen Busch* (*Near the Blue Bush*), 1939, 801 (RR 1), colored paste on paper on card, 26.5 x 21 cm, Wilhelm Hack-Museum, Ludwigshafen, inv. no. 458.32

p. **178**: Paul Klee: *tief im Wald* (*Deep in the Woods*), 1939, 554 (CC 14), tempera and watercolor on oil-primed canvas on stretcher frame, 50 x 43 cm, Kunstsammlung Nordrhein-Westfalen, Düsseldorf, inv. no. 52

p. **179**: Paul Klee: *hungriges Mädchen* (*Hungry Girl*), 1939, 671 (JJ 11), colored paste and pencil on paper on card, 27.1 x 21.3 cm, Zentrum Paul Klee, Berne, gift of Livia Klee

p. **180**: Paul Klee: *herabhängend* (*Hanging Down*), 1939, 674 (JJ 14), colored paste and pencil on paper on card, 27 x 21.4 cm, Zentrum Paul Klee, Berne, gift of Livia Klee

p. **181**: Paul Klee: *gesprengt* (*Blown Up*), 1938, 440 (Z 20), chalk on paper on card, 29.8 x 20.8 cm, Zentrum Paul Klee, Berne

p. **182**: Walter Henggeler: Paul Klee with his painting *Bergbahn* (*Mountain Train*), 1939

p. **183**: Paul Klee: *ein Kinderspiel* (*A Children's Game*), 1939, 385 (A 5), colored paste and watercolor on card, 42.8 x 32.3 cm, Staatliche Museen zu Berlin, Nationalgalerie, Museum Berggruen, inv. no. 385 (A 5)

p. **184**: Paul Klee: *Untitled (Gefangen, Diesseits – Jenseits / Figur)* (*Captive, This World – Next World / Figure*), 1940, oil and colored paste on paste-primed burlap, 55.2 x 50.1 cm, Fondation Beyeler, Riehen/Basel, inv. no. 73.3

p. **185**: Paul Klee: *Untitled (Letztes Stillleben)* (*Last Still Life*), 1940, oil on canvas on stretcher frame, 100 x 80.5 cm, Zentrum Paul Klee, Berne, gift of Livia Klee

p. **186**: Paul Klee: *Abfahrt des Abenteurers* (*Departure of the Adventurer*), 1939, 735 (MM 15), watercolor and pencil on paper on card, 21.5 x 27 cm, private collection, Germany

p. **187**: Paul Klee: *woher? wo? wohin?* (*Whence? Where? Whither?*), 1940, 60 (X 20), watercolor, ocher and chalk on paper on card, 29.7 x 20.8 cm, private collection, Switzerland

p. **192**: Paul Klee: *Abschied nehmend* (*Taking Leave*), 1938, 352 (V 12), colored paste on paper on card, 50.7 x 7.3/9.3 cm, Zentrum Paul Klee, Berne

INDEX

© Prestel Verlag, Munich · London · New York 2011

© for the works illustrated by the artists, their heirs or assigns, with the exception of the following: Lucia Moholy and Gabriele Münter by © VG Bild-Kunst, Bonn 2011, Robert Delaunay by © L & M Services B.V. The Hague 20110221

The illustrations in this publication have been kindly provided by the museums, institutions and archives mentioned on pp. 188–190, or taken from the Publisher's archives, with the exception of the following:
pp. 18/19, 106/107: Dominique Uldry; p. 56: Jens-U. Nober; pp. 72, 103: akg-images; p. 77: bpk/Museum Berggruen, Privatbesitz/Jens Ziehe; pp. 82, 110 below, 145 right, 149, 183: bpk/Nationalgalerie, Museum Berggruen, SMB/Jens Ziehe; pp. 122 right: Andreas Erbslöh; p. 123: The Museum of Modern Art, New York/Scala, Florenz; p. 126: CNAC/MNAM Dist. RMN/ Droits réservés; p. 133: Blauel/Gnamm/ARTOTHEK ; p. 138: Martin Bühler, Kunstmuseum Basel; p. 144: Colorphoto Hinz, Aschwil-Basel; p. 151: bpk/Jörg P. Andres; p. 159: Marcus Schneider; p. 162: San Francisco Museum of Modern Art/ Ben Blackwell; p. 164 below: Daniel Mille; p. 175: Commerzbank AG; p. 176 right: Bayer&Mitko/ARTOTHEK; p. 182: Picture-Alliance/Keystone

Front cover: Paul Klee: *Landschaft mit gelben Vögeln* (*Landscape with Yellow Birds*), 1923 (detail), see p. 114
Back cover: Paul Klee: *Senecio (Baldgreis)*, 1922 (detail), see p. 108
p. 2: Paul Klee: *Sternverbundene* (*Connected to the Stars*), 1923 (detail), see p. 117
p. 4: Lucia Moholy: Paul Klee in the studio of his master's house in Dessau, 1926 (detail), see p. 129
p. 6: Paul Klee: Painted wall of his parent's house in Berne, 1898 (detail), see p. 18
p. 22: Paul Klee: *Der Held mit dem Flügel* (*Winged Hero*), 1905 (detail), see p. 36
p. 44: Paul Klee: *Versunkene Landschaft* (*Sunken Landscape*), 1918 (detail), see p. 73
p. 94: Paul Klee: *Bildnis in der Laube* (*Portrait in the Arbor*), 1930 (detail), see p. 146
p. 156: Paul Klee: *Untitled (Letztes Stillleben)* (*Last Still Life*), 1940 (detail), see p. 185

Prestel Verlag, Munich
A member of Verlagsgruppe Random House GmbH

Prestel Verlag
Neumarkter Strasse 28
81673 Munich
Tel. +49 (0)89 4136-0
Fax +49 (0)89 4136-2335

www.prestel.de

Prestel Publishing Ltd.
4 Bloomsbury Place
London WC1A 2QA
Tel. +44 (0)20 7323-5004
Fax +44 (0)20 7636-8004

Prestel Publishing
900 Broadway, Suite 603
New York, NY 10003
Tel. +1 (212) 995-2720
Fax +1 (212) 995-2733

www.prestel.com

Library of Congress Control Number is available; British Library Cataloguing-in-Publication Data: a catalogue record for this book is available from the British Library; Deutsche Nationalbibliothek holds a record of this publication in the Deutsche Nationalbibliografie; detailed bibliographical data can be found under: http://dnb.d-nb.de

Prestel books are available worldwide. Please contact your nearest bookseller or one of the above addresses for information concerning your local distributor.

Editorial direction: Claudia Stäuble, Sabine Gottswinter
Translated from the German by: Stephan von Pohl
Copyedited by: Christopher Murray
Picture research: Regina Herr, Katharina Knüppel
Production: Astrid Wedemeyer
Art direction: Cilly Klotz
Design and layout: Sofarobotnik, Augsburg & Munich
Typesetting: zwischenschritt, Rainald Schwarz, Munich
Origination: Reproline Mediateam, Munich
Printing and binding: Druckerei Uhl, Radolfzell

Verlagsgruppe Random House FSC-DEU-0100
The FSC®-certified paper *Hello Fat Matt* produced by Condat has been supplied by Deutsche Papier

Printed in Germany

ISBN 978-3-7913-4526-0